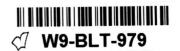
THE HEART OF A BOY

Celebrating the Strength and Spirit of Boyhood

KATE T. PARKER

WORKMAN PUBLISHING · NEW YORK

Library of Congress Cataloging-in-Publication Data is available.

ISBN 978-1-5235-0551-7 (PB)
ISBN 978-1-5235-0663-7 (HC)

Design by Lisa Hollander

Workman books are available at special discounts when purchased in bulk for
premiums and sales promotions as well as for fund-raising or educational use.
Special editions or book excerpts can also be created to specification.
For details, contact the Special Sales Director at the address below, or send
an email to specialmarkets@workman.com.

Workman Publishing Co., Inc.
225 Varick Street
New York, NY 10014-4381
workman.com

WORKMAN is a registered trademark of Workman Publishing Co., Inc.

Printed in China
First printing April 2019

10 9 8 7 6 5 4 3 2 1

Visit workman.com/theheartofaboy to find a parents' and teachers' discussion
guide for this book.

This is for Mike,
whose endless support and
giant heart make everything possible.

And for Mason,
who kept asking where his book was, too.

CONTENTS

"**STRENGTH...**
IS SOMETHING WE TEND TO
RESPECT IN OTHERS, DESIRE FOR
OURSELVES, AND WISH FOR OUR
CHILDREN. SOMETIMES, THOUGH, I WONDER IF
WE CONFUSE STRENGTH
WITH OTHER WORDS—
LIKE 'AGGRESSION' AND
EVEN 'VIOLENCE.'
REAL STRENGTH
IS NEITHER MALE
NOR FEMALE;
BUT IT IS, QUITE SIMPLY, ONE OF
THE FINEST CHARACTERISTICS
THAT A HUMAN BEING
CAN POSSESS."

—FRED ROGERS

INTRODUCTION

The goal of my first photography project, *Strong Is the New Pretty*, was to explore and celebrate girls' inner and outer strength. So when I first considered expanding its scope to include boys, I said, *This isn't for me. I'm a mom of girls*. Still, I couldn't shake the thought, particularly after hearing from parents, grandparents, and the very girls who had responded to my images of confident, fearless, and inspirational females. *Where are the boys?* they wanted to know. In the end, however, it was the queries from boys that got to me: *Where's my book, Miss Kate? Don't you want to take my picture? When are you going to photograph me?*

I had originally thought that the only voices not being heard belonged to girls. The boys? They were fine. We heard them loud and clear, *right*? But as I explored the idea further, my perspective shifted. I looked at my nephews. My friends' sons. Their friends and *their* nephews and sons. My daughters' boy friends (not boyfriends, not just yet). Inclusion and acceptance are at the core of all my work, and the truth was, I was excluding a whole population based on my belief that our boys' voices didn't need the amplification that our girls' voices did. Me? Someone who is looking for fairness and inclusion all around? I hadn't seen it! But their voices did, and do, need to be heard, for different reasons and in different ways. Maybe there *was* a need for a book that did the same thing for boys that *Strong Is the New Pretty* aimed to do for girls. Maybe it was time to expand the definition of what it means to be a boy, too.

I started photographing boys in an attempt to show the richness and diversity of boyhood. I believe that all of us should be granted the

space to find our passion, our true self, our source of pride. So, *The Heart of a Boy* was born, and the journey began.

I traveled all around the country meeting amazing boys of all ages. They humbled and inspired me at every turn: quarterbacks, comic-book artists, talented singers and dancers, cancer survivors. Boys who aspire to be president, boys who would never allow a heart transplant to keep them from riding dirt bikes. Boys who know overwhelming physical and emotional pain, and yet greet each day with a smile. Boys with qualities that aren't commonly celebrated . . . vulnerability, gentleness, kindness, compassion. I was moved by them, like I was moved by the boy who, seeing his own family's struggle, donated money to ensure that parents of babies in the NICU could eat for free during hospital stays. I was moved by all these boys, and by their energy, their confidence, their excitement, their innate boy-ness.

As I delved into this project, I realized why this book and conversation are so very necessary. With my girls, I witnessed firsthand how society tries to shoehorn girls and women into a very narrow set of expectations. But, these days, thankfully, there are many books, articles, TV shows, and even merchandise available to guide my girls as they seek to find their voices. With boys, there's significantly less, even though our boys *need* this conversation. It's time to discuss how to raise our sons to become good people, and to talk about defining masculinity in a way that is less narrow and limiting. We expect our boys to be strong, confident, and fearless; anything outside that norm is often viewed as feminine or unacceptable. You see this perpetuated in how we treat and raise our young men. The vulnerability, kindness, and softness that I so admired in the boys I was photographing aren't generally applauded. In a world where phrases like *man up*, *bro code*, and *boys don't cry* are regularly portioned out in the direction of our sons, I wanted our boys to know that they didn't need to hide their gentler side. That just like our girls,

who they are at their core is okay—and even better than okay, it is something to be celebrated.

I attempted to capture boyhood in all its forms, from confident and wild to curious and kind. Just like *Strong Is the New Pretty*, this book aims to honor kids for who they are and help them understand that their value resides in how they treat others. Some boys are fearless, some are vulnerable. Some are quiet, some are wild; some are leaders, and some are thinkers. Some are all of these and more! They each have their own gifts and unique powers; we need to allow our young men the space to figure out what those are.

We all want love and acceptance for who we are. It's not a girl message or a boy message, it's a human message.

"TO ME THE DEFINITION OF TRUE MASCULINITY— AND FEMININITY, TOO— IS BEING ABLE TO LIE IN YOUR OWN SKIN COMFORTABLY."

—VINCENT D'ONOFRIO

THE HEART IS
VULNERABLE

Society has conditioned us to perceive vulnerability as a bad thing—that it's unsafe and weak, that it leaves you open. But, that's just it. The amazing thing about being vulnerable is that it *does* leave you open. Sure, it may open you up to criticism at times (which, as parents, is a hard thing to subject our kids to), but it also opens you (and us) to so many good things. So many new things. So many amazing things. Being open means you get to try, feel, love, and experience things that you would not experience if your heart were closed.

Look at Will (page 21), who isn't afraid to admit his feelings of sadness or worry. Or Caden (page 22), who is proud to own his past. In acknowledging their perceived weaknesses, they empower themselves.

And yet rather than celebrate the strength it takes to open oneself up, society still looks at vulnerability as a weakness, especially in boys and young men. As parents and teachers, as coaches and friends, we need to encourage our boys to take chances, be unstable, and try new things. They'll learn what it means to succeed and fail, to live with uncertainty. It is in that space that compassion is born.

Catching pop flies is really hard right now. I'm trying my best, but it's really tricky.

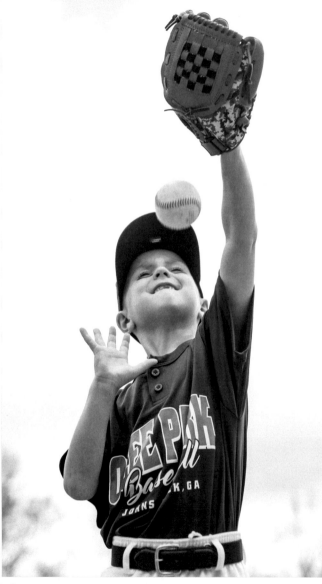

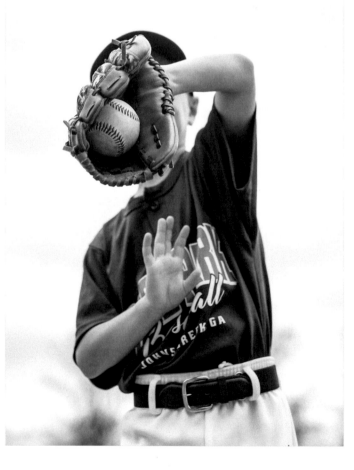

JAICE AGE 7

When I get bored, I bite my nails. When there are times when I'm doing nothing, I try to do something.

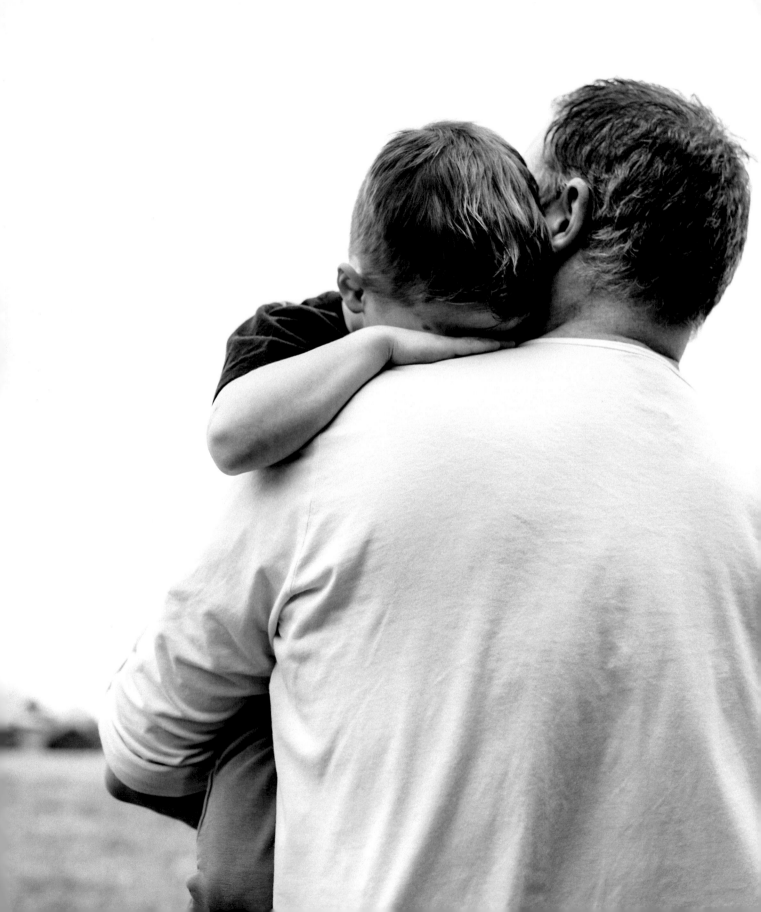

JUDE AGE 5

I have Duchenne's Muscular Dystrophy, and it affects my muscles and makes it hard to move sometimes. Sometimes I cry when my body can't do things. . . . I get mad. Lots of people don't know about it so I explain it to them. I like to talk to people so they understand. I like when people understand. Understanding is the most helpful thing.

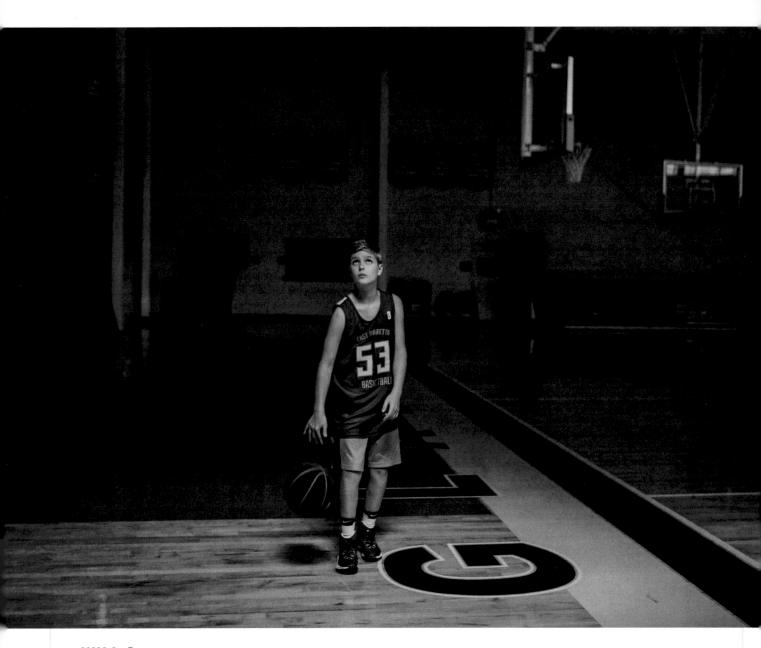

WILL S. AGE 12

Being strong to me means
believing in yourself and not
putting other people down.

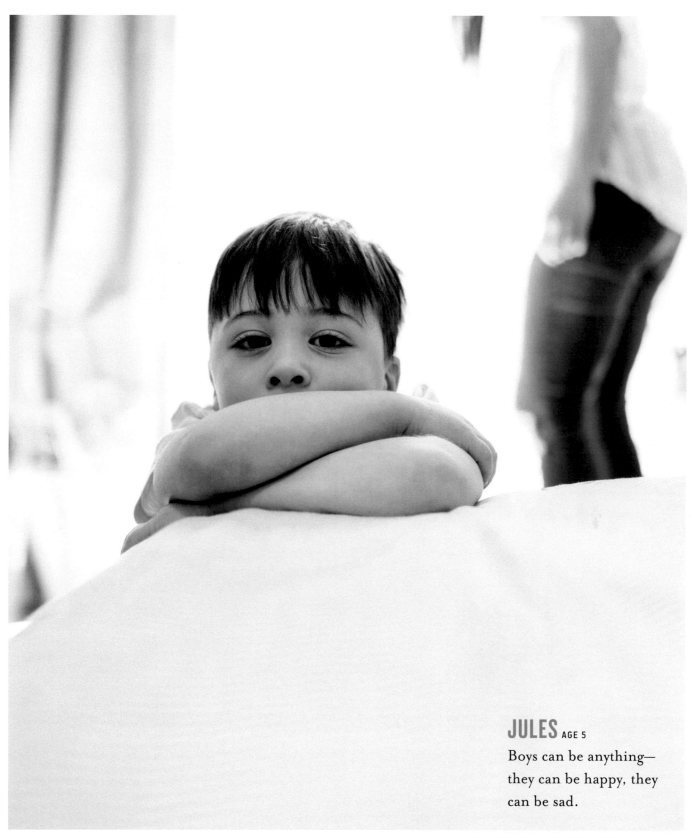

JULES AGE 5

Boys can be anything—
they can be happy, they
can be sad.

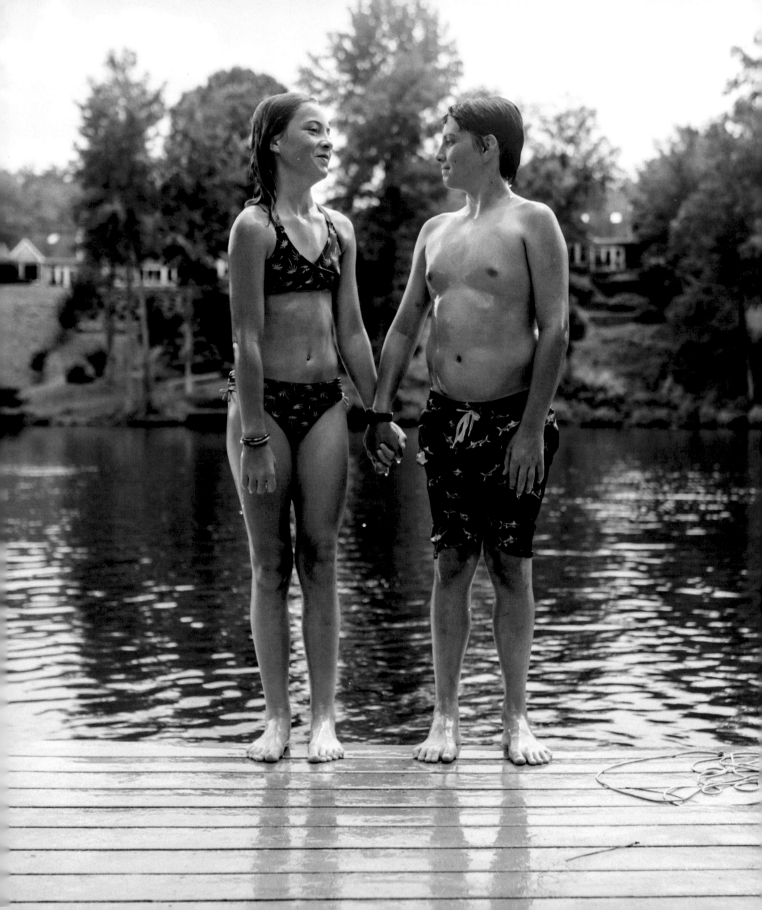

NOAH AGE 11

Ella and I have been friends since we were three years old. I'm comfortable around her because she likes me for who I am. I'm able to be myself when I'm with her.

MATTHEW AGE 10

I like soccer, football, and I have a dog named Maggie. I am proud of who I am.

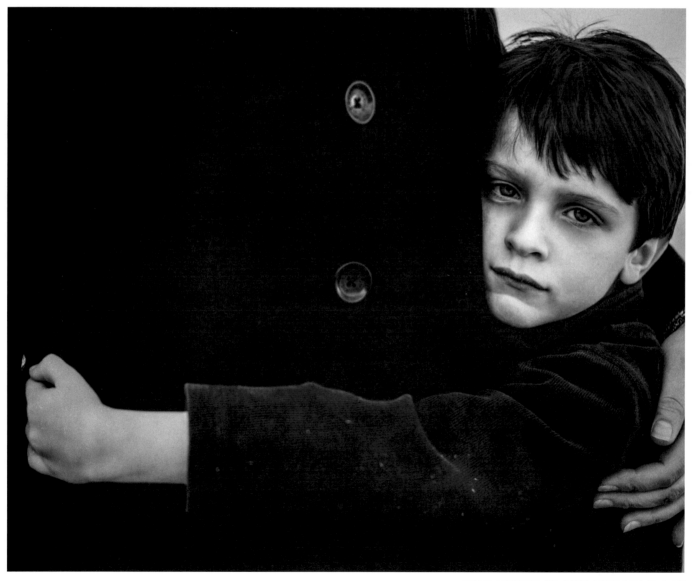

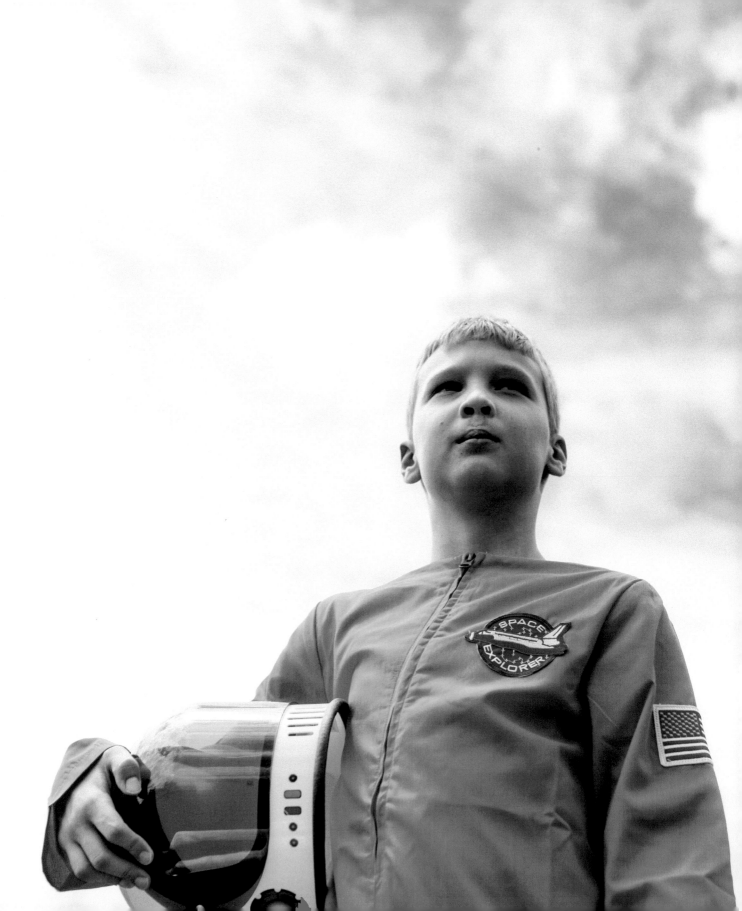

CHARLIE AGE 9

When I grow up I want to build the impossible for NASA and maybe one day go into space.

RYAN AGE 12

I am not physically the strongest, but I am mentally very strong and I think I am a great leader. So I don't fit into the norm of being physically tough and strong, but I feel like I fit into the "new norm," where boys and girls are leaders.

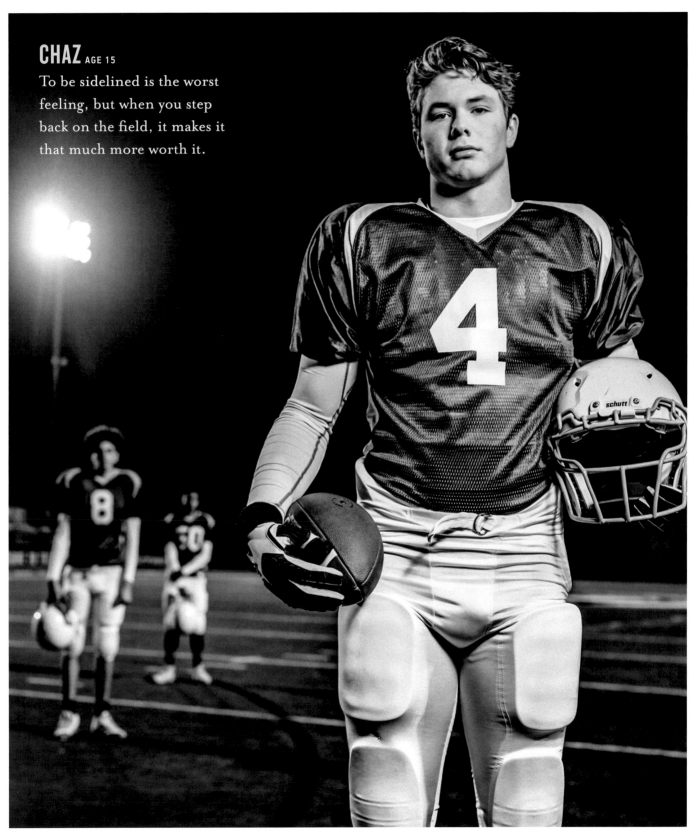

CHAZ AGE 15

To be sidelined is the worst feeling, but when you step back on the field, it makes it that much more worth it.

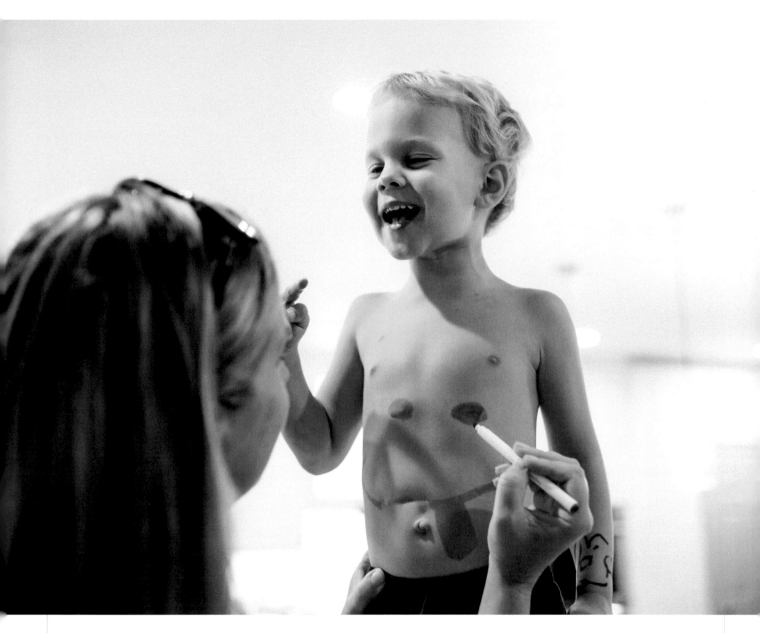

GEORGE AGE 5

My mom makes my scar
into a happy face.

I am learning that I am the
only person exactly like me.

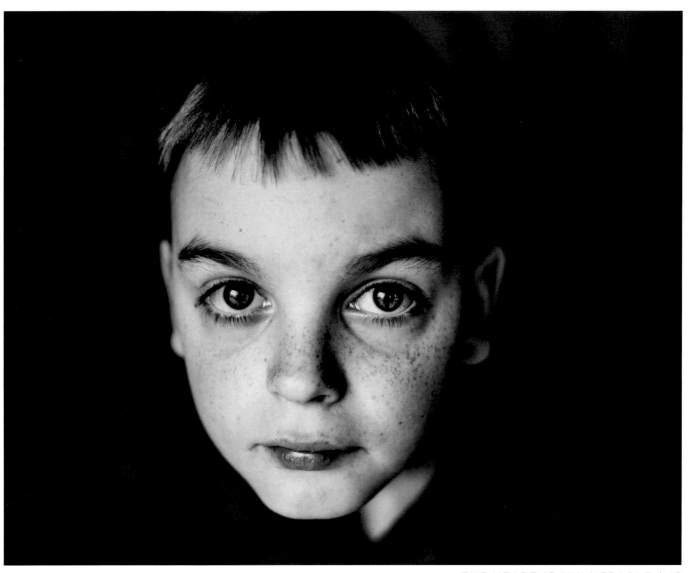

CAMERON AGE 12

I can't imagine life without
my sister.

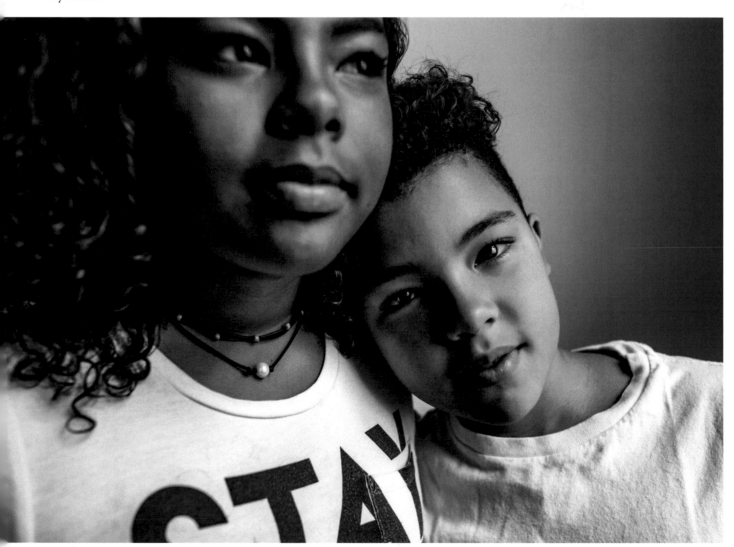

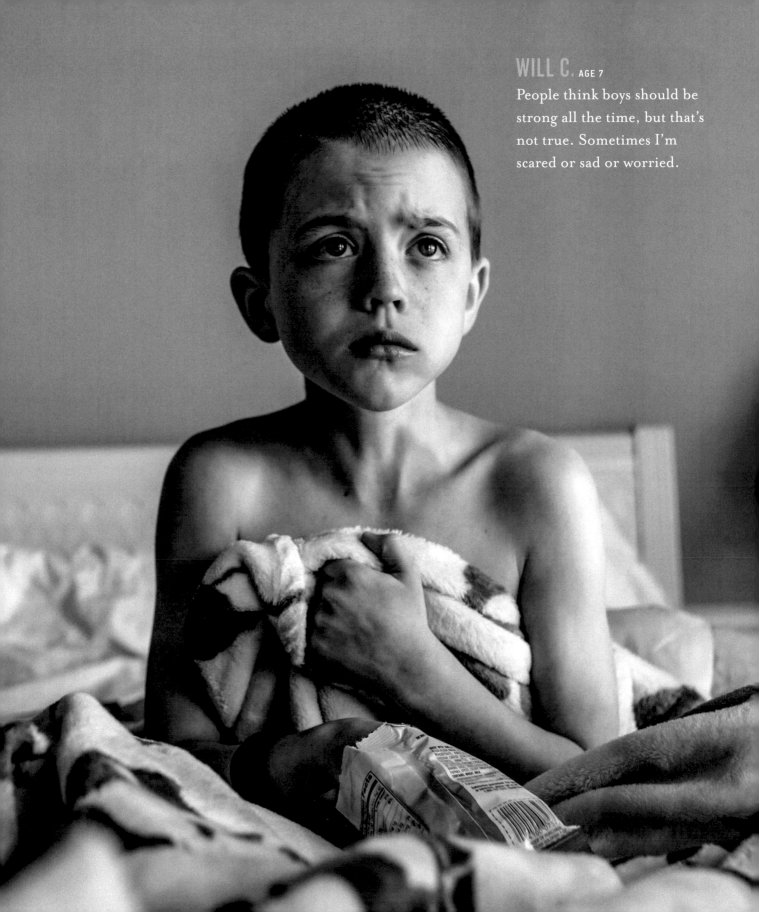

WILL C. AGE 7

People think boys should be strong all the time, but that's not true. Sometimes I'm scared or sad or worried.

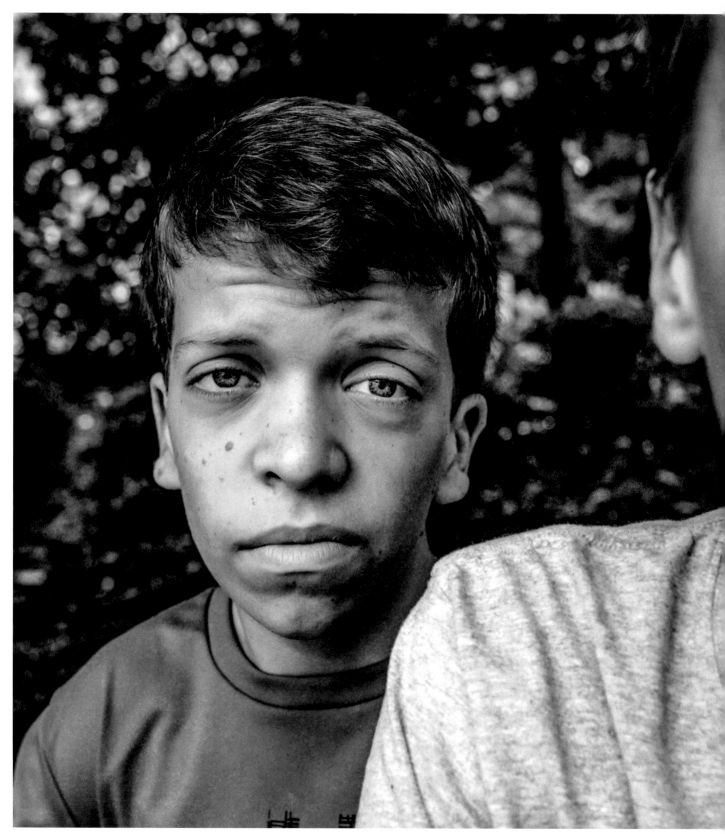

CADEN AGE 13

When I was ten, I suffered sudden cardiac arrest. It really made me appreciate my life.

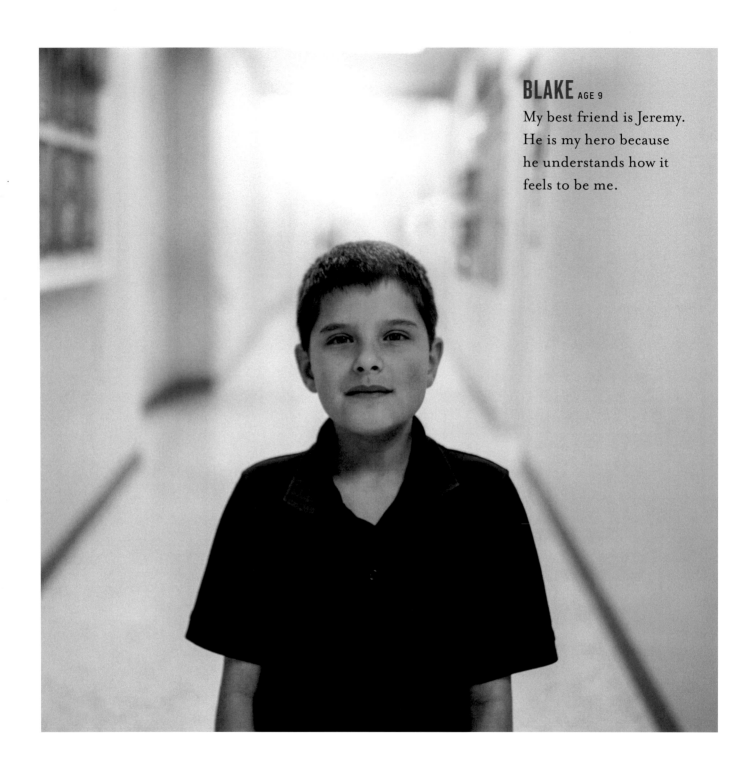

BLAKE AGE 9

My best friend is Jeremy. He is my hero because he understands how it feels to be me.

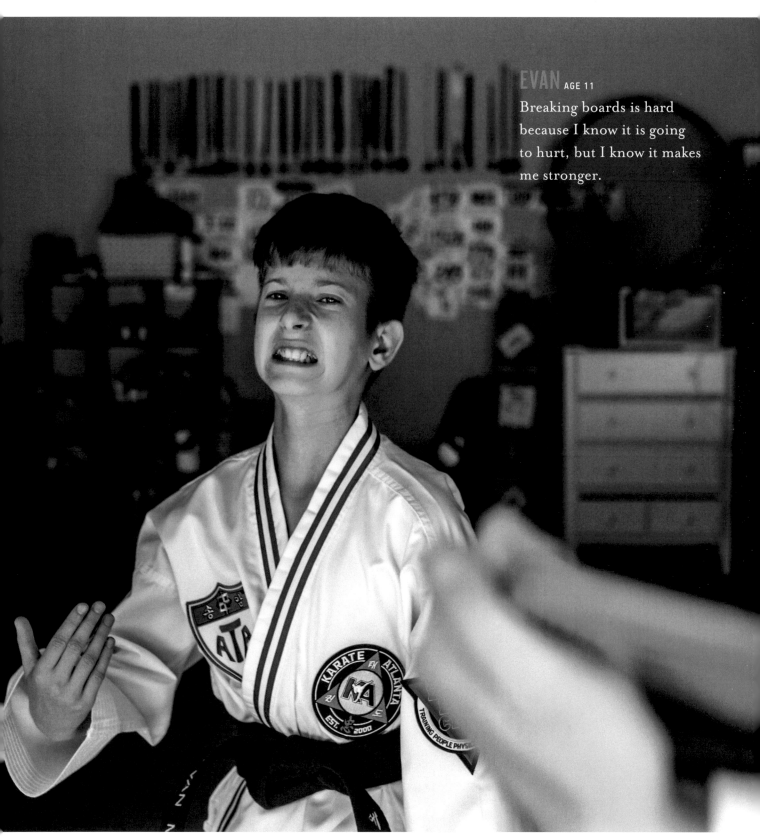

EVAN AGE 11

Breaking boards is hard because I know it is going to hurt, but I know it makes me stronger.

"FIND OUT WHERE JOY RESIDES, AND GIVE IT A VOICE FAR BEYOND SINGING. FOR TO MISS THE JOY IS TO MISS ALL."

—ROBERT LOUIS STEVENSON

THE HEART IS
JOYFUL

Take a moment and picture the people, the activities, the moments, and the places that fill your heart. Who are they? What are they? Where are they? Maybe you're smiling right now just thinking about them. Recognizing what makes your heart happy and fills you up with joy is an important source of strength for all of us.

But from the moment our young sons hear "boys don't cry" or "act like a man," they begin to be conditioned to withdraw and create limits to their emotional range. Their frustration and sadness are buried, and their joy is dimmed. As they grow into adulthood, society continues to usher them into stoicism and emotional detachment, which is ultimately a false sense of strength.

We all deserve the freedom to seek happiness in our lives and fill up as much as possible with laughter, smiles, love, and especially joy. The boys in this chapter find their joy in so many ways—through giving back, through time with family, through athletics, through art. Wyatt (page 32) finds his joy in dancing. Xavier (page 39) is "happy in his whole body" when he's on the soccer field. Part of raising strong boys is embracing the things that bring our sons joy, whatever that is, and rejecting the stereotyped model of masculinity that can be so damaging. Our boys know how to seek and create joy; let's allow them to do so. We have much to learn from their examples.

NIKOLAI AGE 6

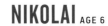

When you find someone you don't really know and then you ask them questions and if they're kind of like you, that makes them your friend. Sometimes when you make friends, you grow up knowing them.

AXEL AGE 5

I love life . . . it seems very good to me.

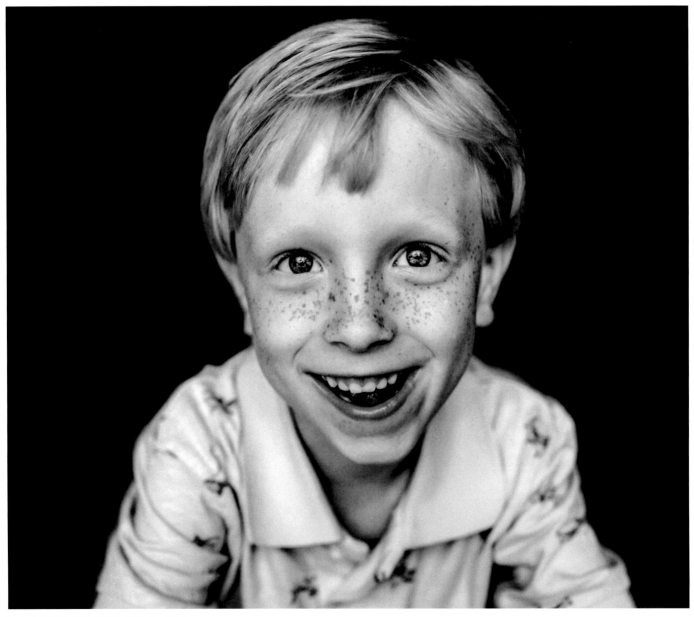

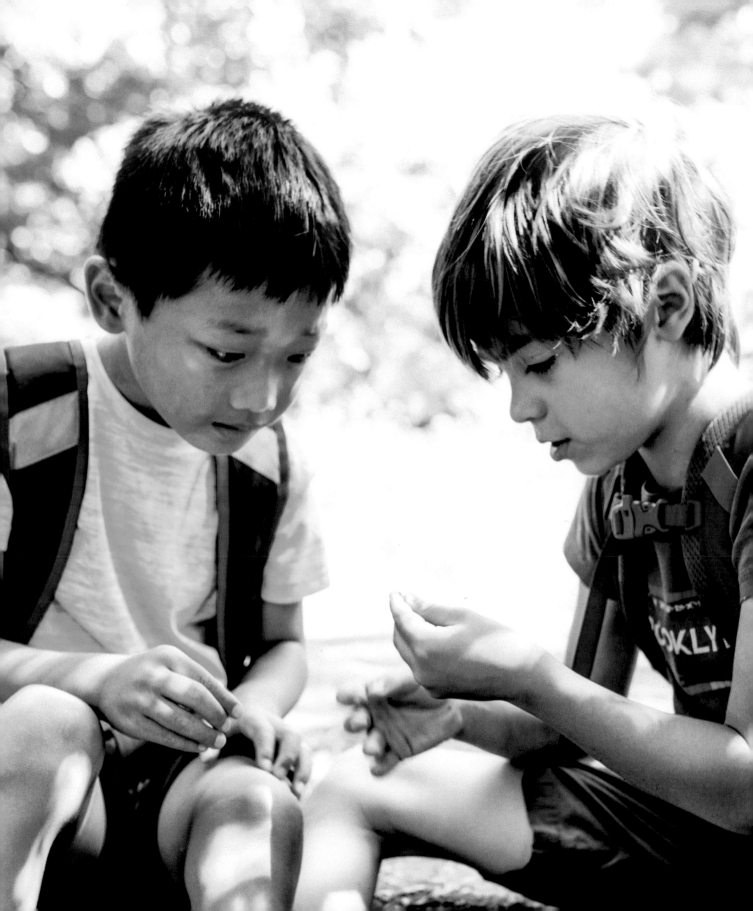

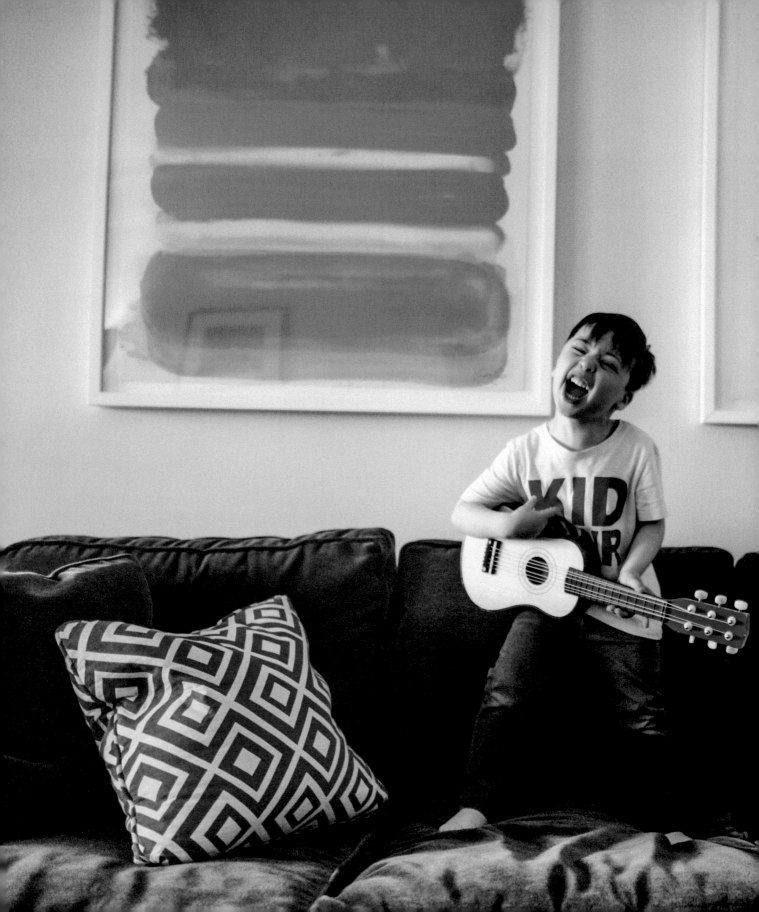

JULES AGE 5

I really love that when I'm playing
music I can be super happy or sad.
I can play quick, I can play slow.
I can play music for all the moods.

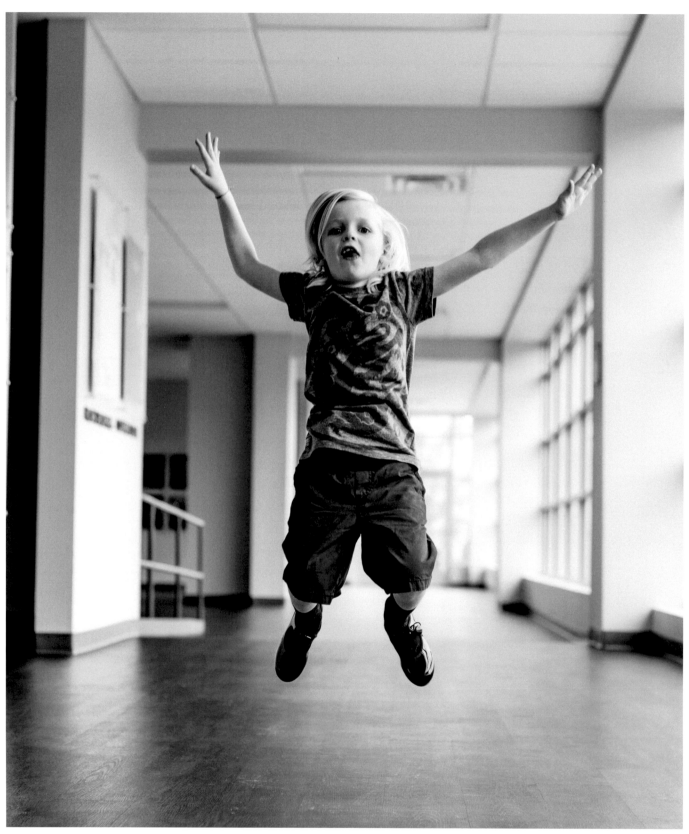

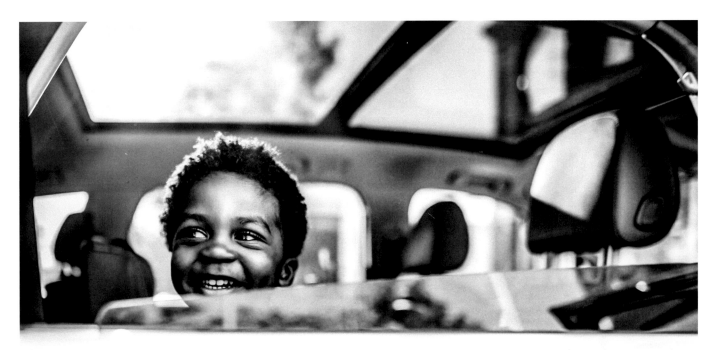

SAM AGE 5

I love cars so much. I know the name and model of most everyone's car in my family.

WYATT AGE 7

I like soccer. I like baseball. I like to dance, too. The best part is tap dancing because it is fun and it makes me feel good.

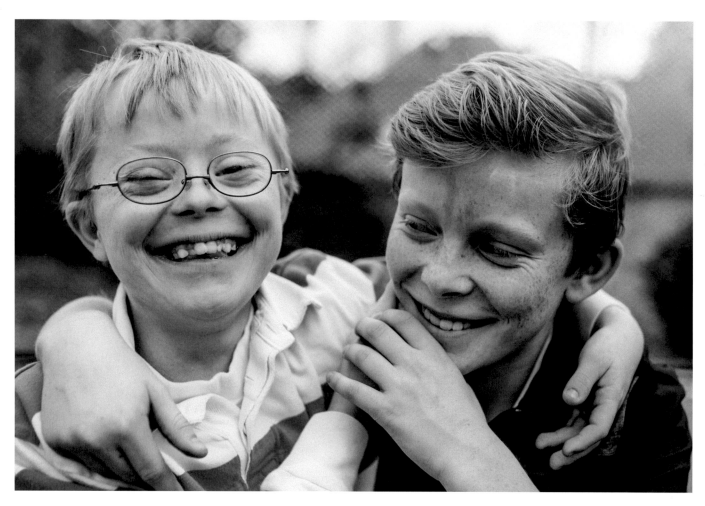

IKE AGE 13

Strong is not being afraid to show your
brother how much you care about him.

HENRY AGE 8

The best thing about sports is
getting to make new friends.
That is the hardest part, too . . .
trying to make new friends.

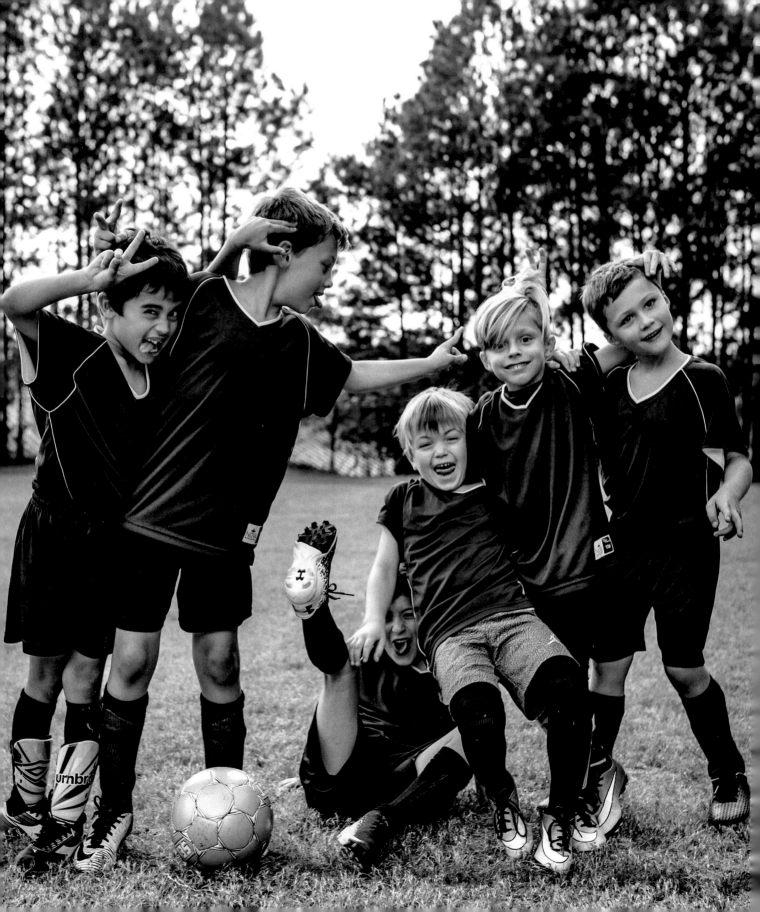

SEAN AGE 13

Go with the flow and
let the fun take over.

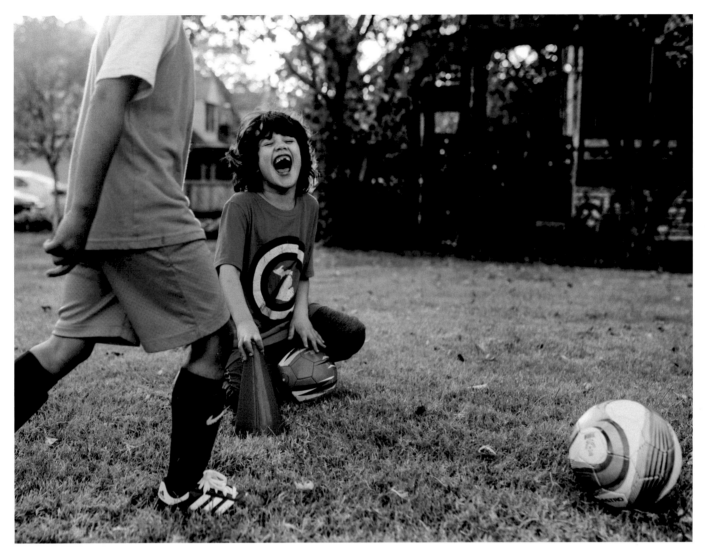

XAVIER AGE 5

When I play soccer, I feel so happy in my whole body. It's my most favorite thing to do.

PARKER AGE 11

I don't do a lot of sports like my friends do because I like different activities than normal sports. I just like doing things like zip-lining, rock climbing, videography, and directing.

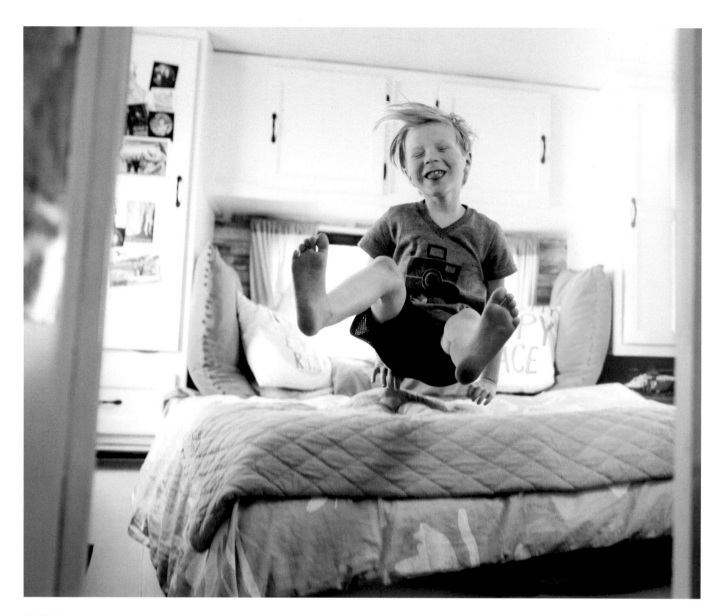

OISIN AGE 6

Life isn't about staying home, it's about traveling, too. My family is spending a year seeing the whole country in our motor home.

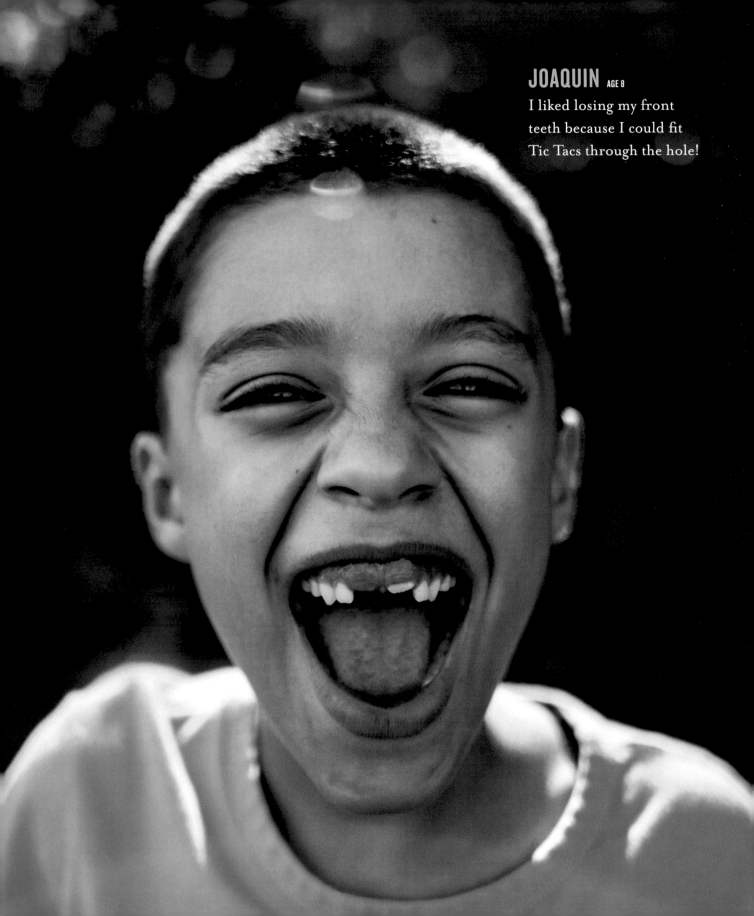

JOAQUIN AGE 8

I liked losing my front teeth because I could fit Tic Tacs through the hole!

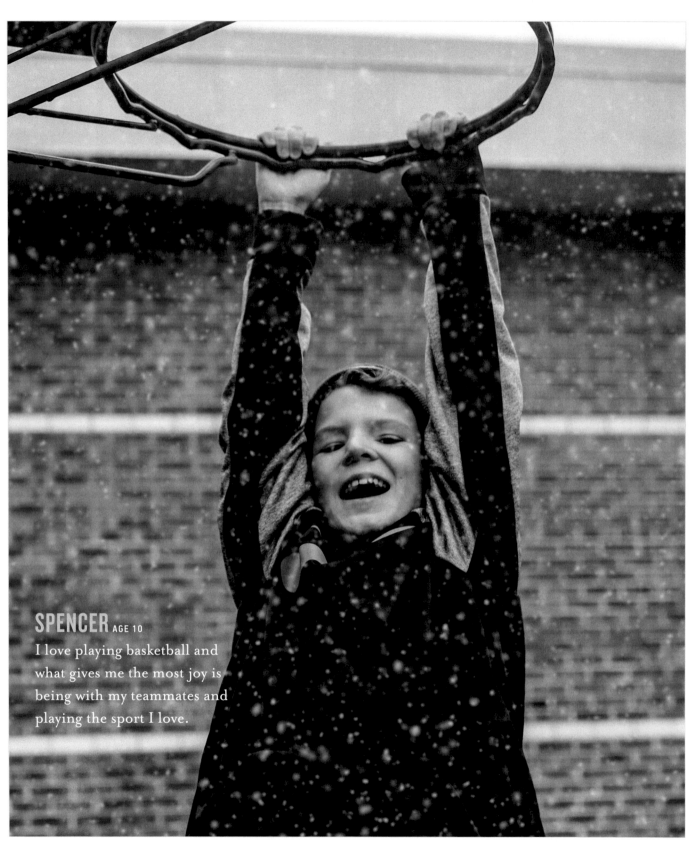

SPENCER AGE 10

I love playing basketball and
what gives me the most joy is
being with my teammates and
playing the sport I love.

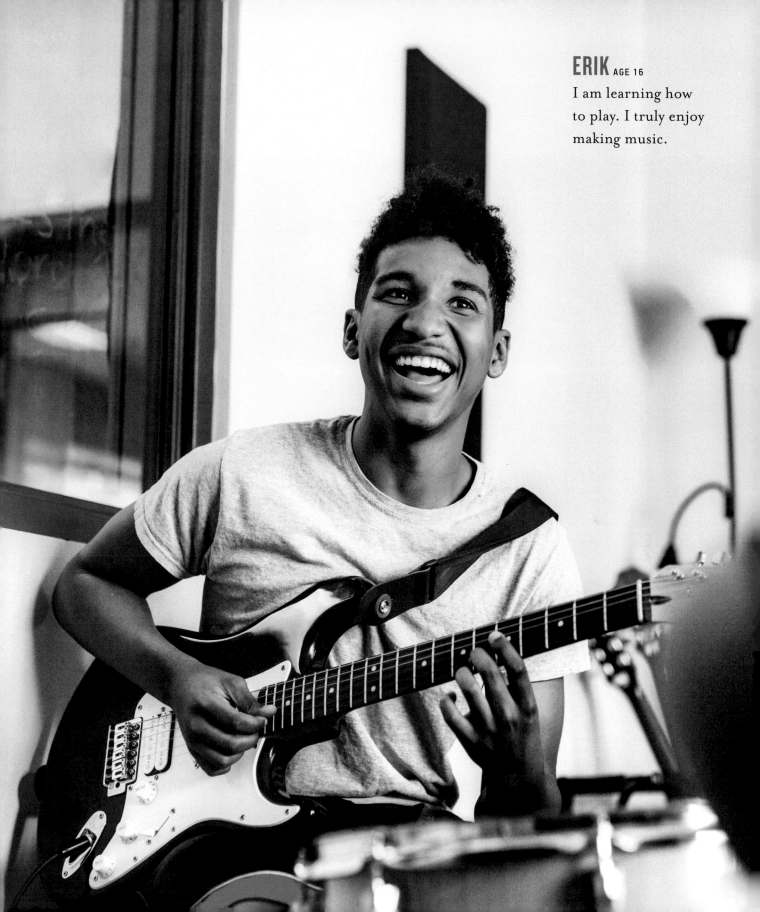

ERIK AGE 16

I am learning how
to play. I truly enjoy
making music.

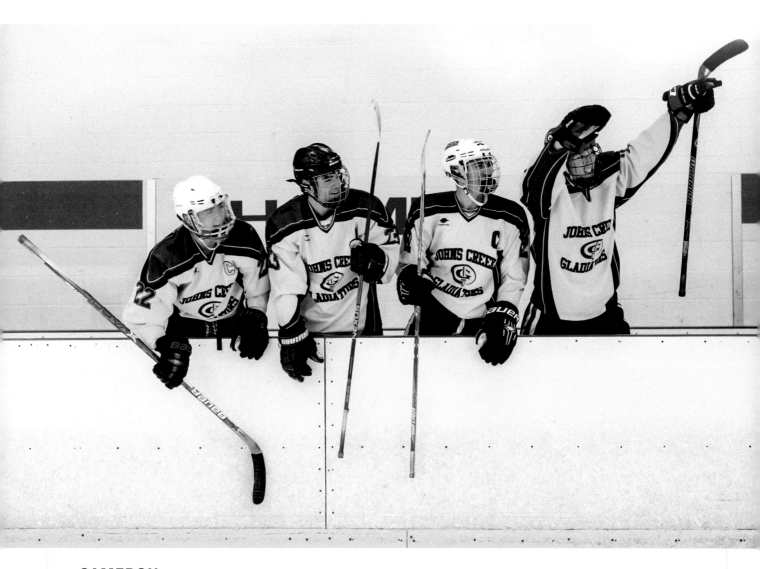

CAMERON AGE 19

Goals happen really quickly
and they're great, but it's
getting back to your team
celebrating on the bench that
you remember forever.

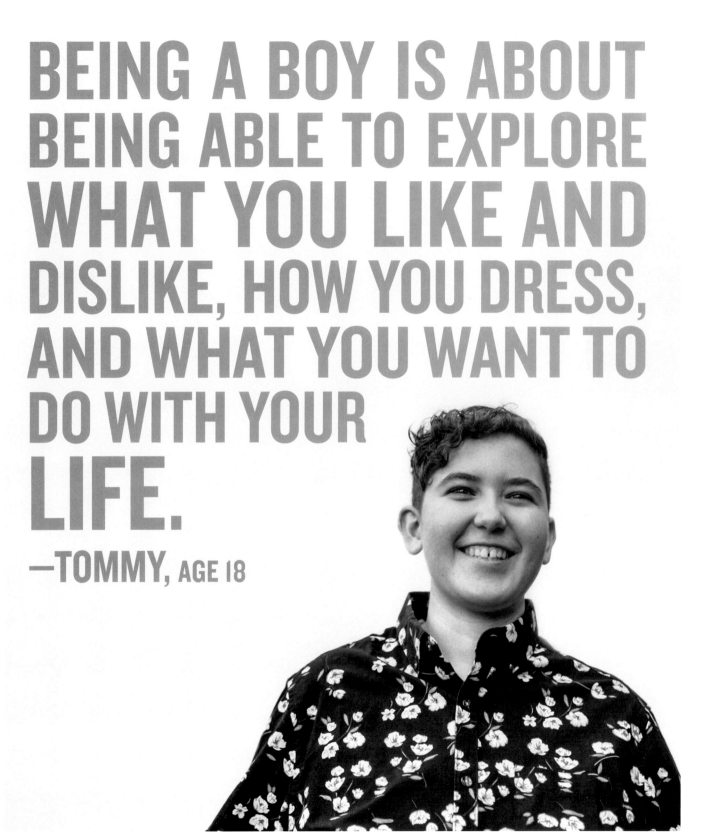

BEING A BOY IS ABOUT BEING ABLE TO EXPLORE WHAT YOU LIKE AND DISLIKE, HOW YOU DRESS, AND WHAT YOU WANT TO DO WITH YOUR LIFE.

—TOMMY, AGE 18

BROOKS AGE 8

I am who I am. I'm not afraid to be myself even when I'm with my friends. They know I won't just do what everyone else does. I like that about me.

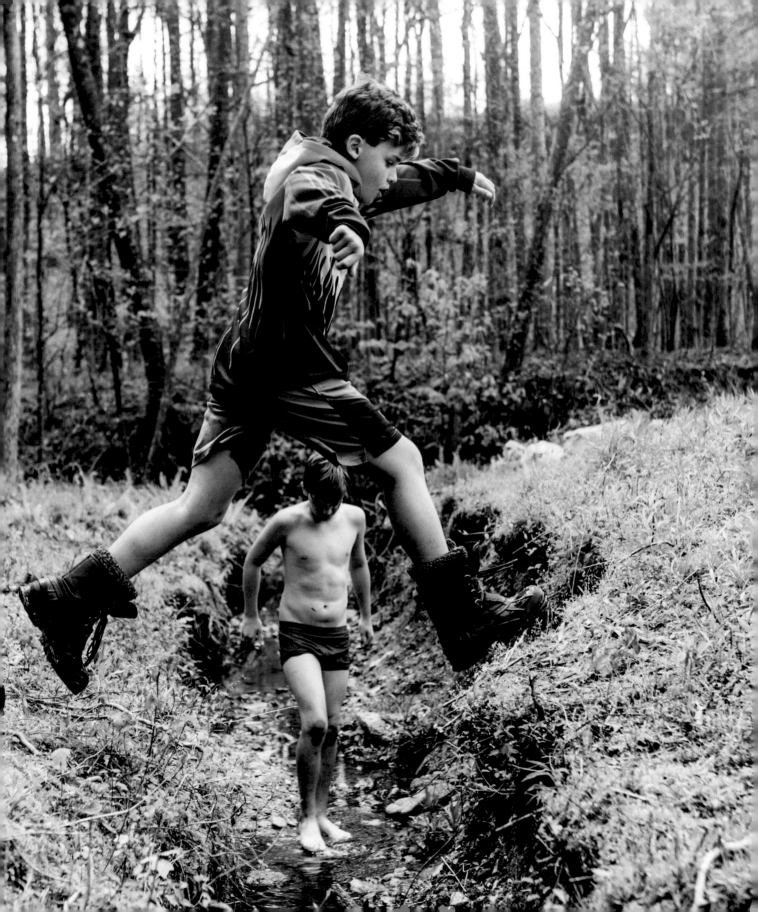

"TENDERNESS AND KINDNESS ARE NOT SIGNS OF WEAKNESS AND DESPAIR, THEY ARE MANIFESTATIONS OF STRENGTH AND RESOLUTION."

—KHALIL GIBRAN

THE HEART IS
DEDICATED

What do you love? What are you passionate about? What makes you excited? What keeps your interest longer than anything else? Consider yourself very lucky if you have answers to these questions.

The things that make your heart beat faster are your passions, the gifts life has given you. Maybe it's football, like it is for Jack (page 56). Or reading, as it is for Camden (page 71). Or maybe you want to protect the environment, like Liam does (page 64). But whatever the things, people, and activities that boys love, we need to allow our boys to spend their time there.

So many things in life are out of our control. We don't choose if we win the race. Or if we get the job. Or the part in the play. What we *do* control is how hard we work. That's it. We can control our effort.

When boys are fully invested in the things that they love, the outcome becomes less important. What matters are the days and weeks and months they got to spend doing something they love.

BRYAN AGE 17

Wrestling is a sport full of pain and
scars, but once you make it to the
top, those scars turn into medals and
awards.

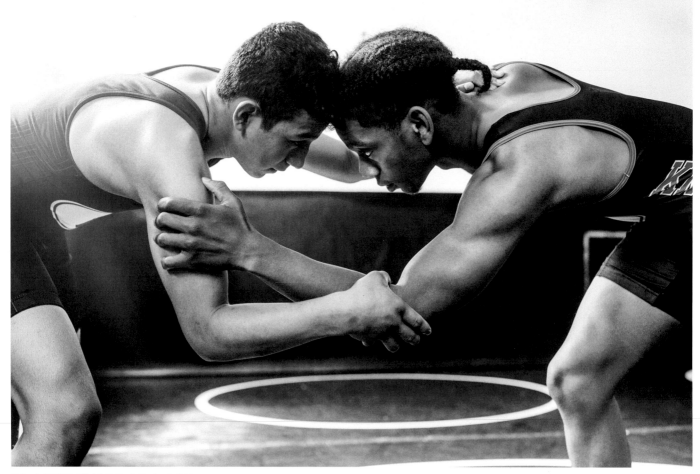

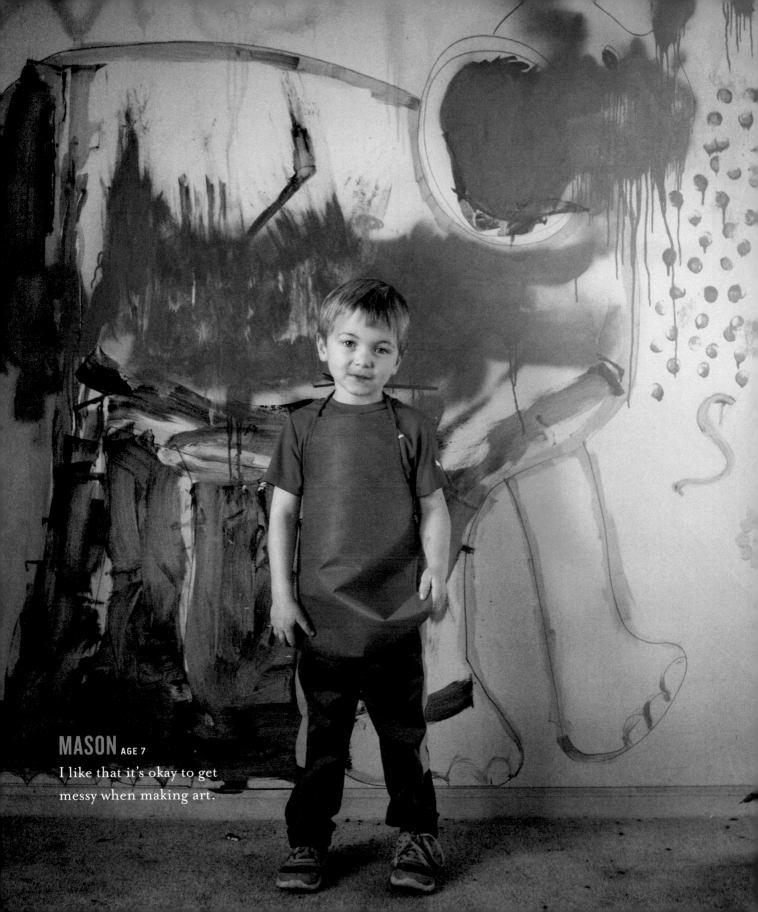

MASON AGE 7

I like that it's okay to get
messy when making art.

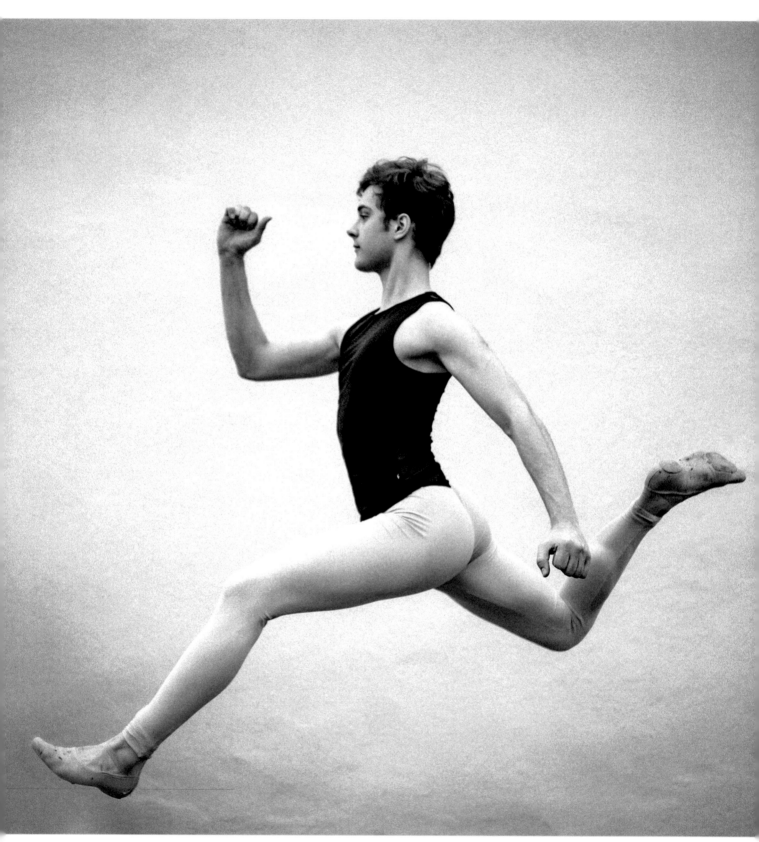

ANDREW AGE 18

Dance requires the dedication to give your all every day, the tenacity to pick yourself up when you fall, and the determination to push through whatever life throws at you.

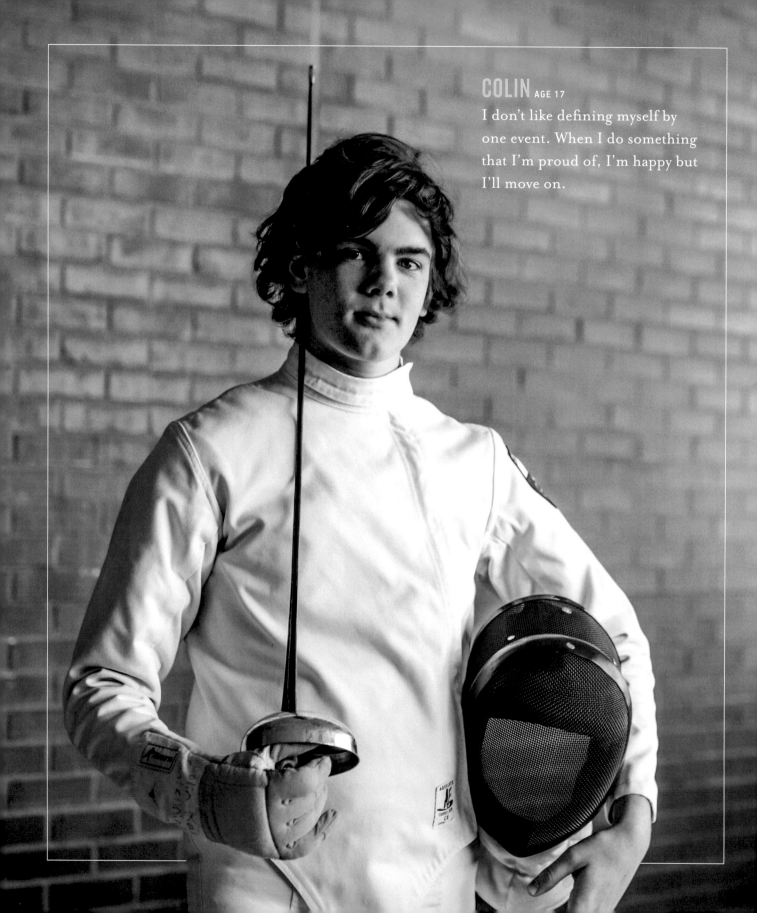

COLIN AGE 17

I don't like defining myself by one event. When I do something that I'm proud of, I'm happy but I'll move on.

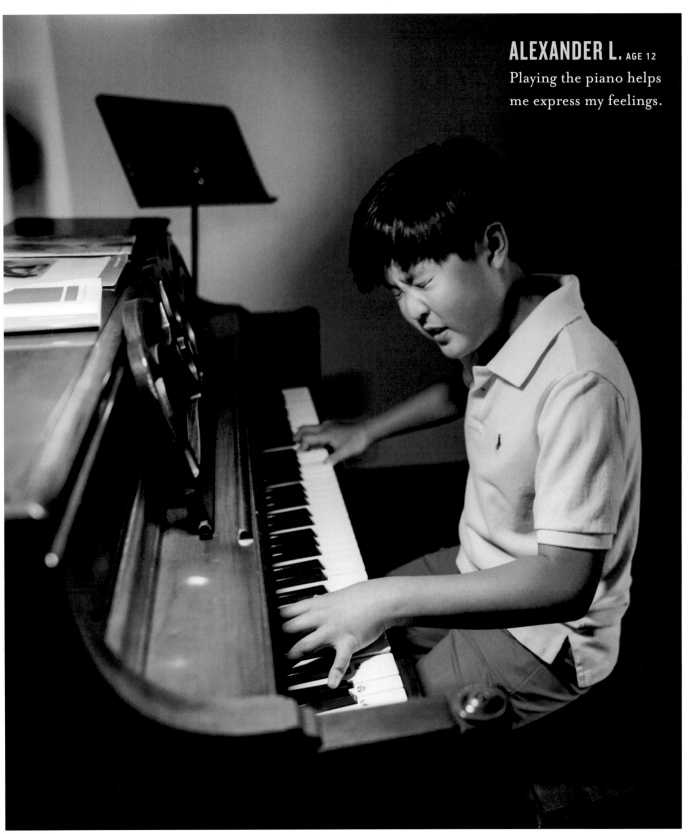

ALEXANDER L. AGE 12

Playing the piano helps
me express my feelings.

JACK B. AGE 17

The best part of football is the team aspect. I love being able to hit a running back and help him up because it's just all part of the game.

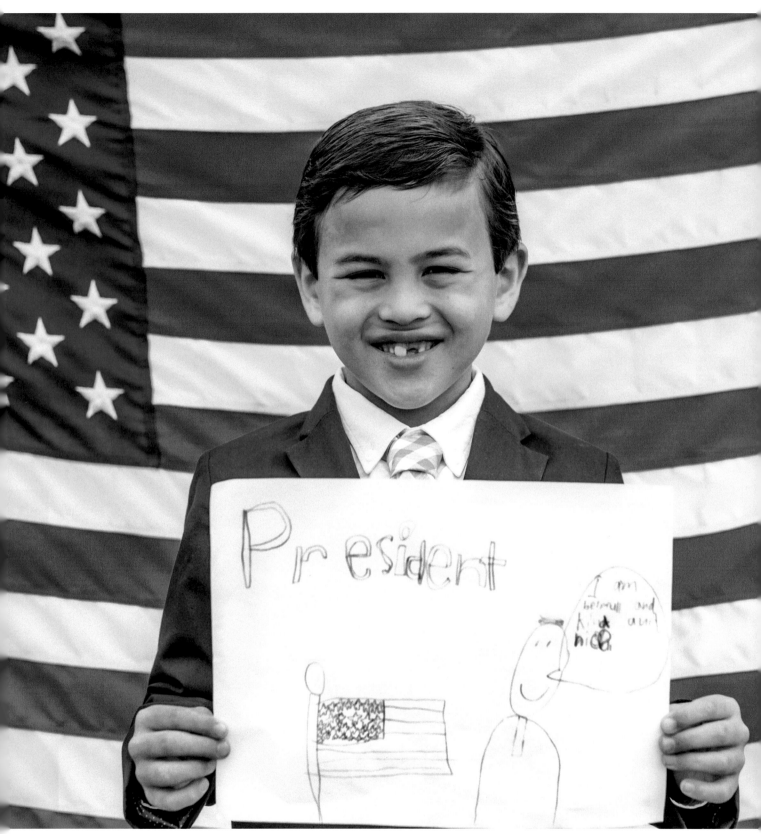

RYAN AGE 7

I want to be president because
I am helpful, kind, and nice.

OWEN AGE 9

Brownie batter and
basketball do mix!

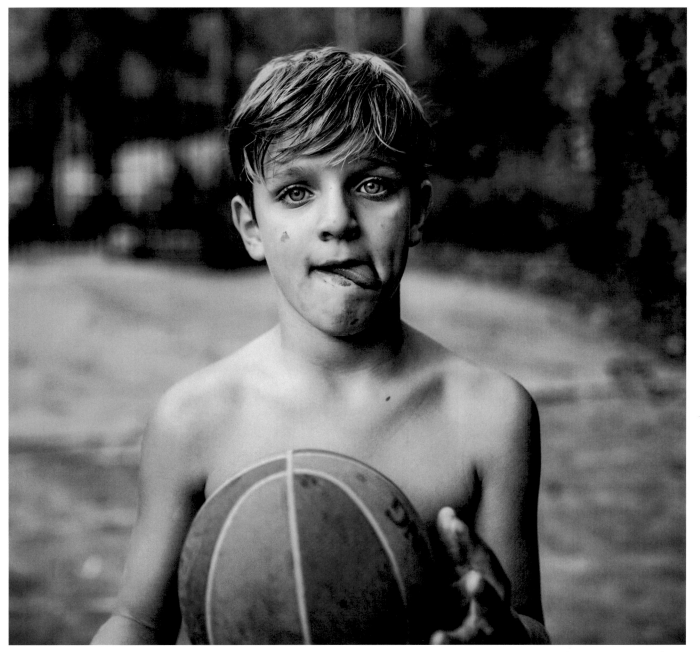

BRIAN AGE 14

I love being in the air. I like seeing
the surprise when people realize
that I fly this plane. They usually
don't believe me! I don't feel
nervous at all when I fly.

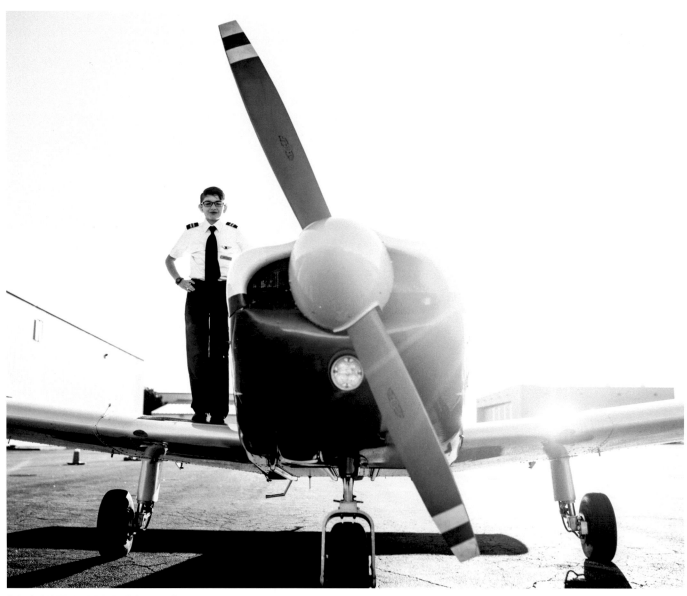

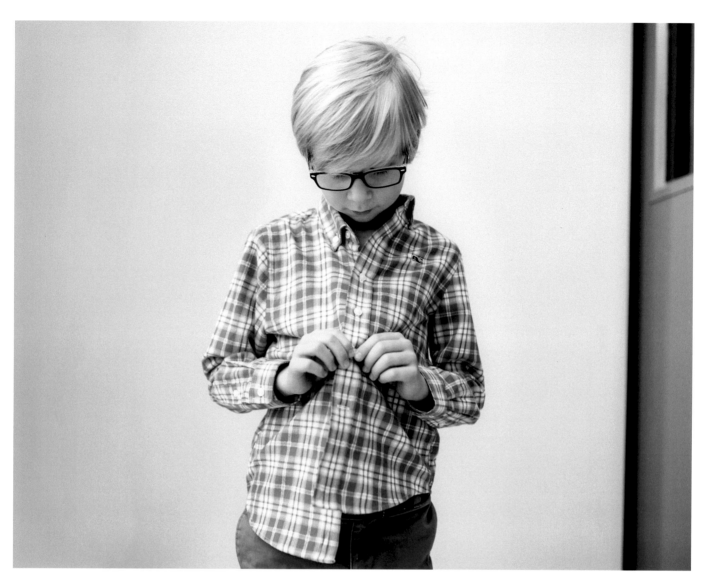

BAYLOR AGE 7

Sometimes I let my best friend win in a race to make him feel better, but only by an inch.

ANDERSON AGE 11

Baseball is a lot of fun. I love the sport
because I can play with my friends
and teammates. The hardest part is
that I can't run as fast as the other kids
because of my knee disability. So I have
to try much harder to keep up.

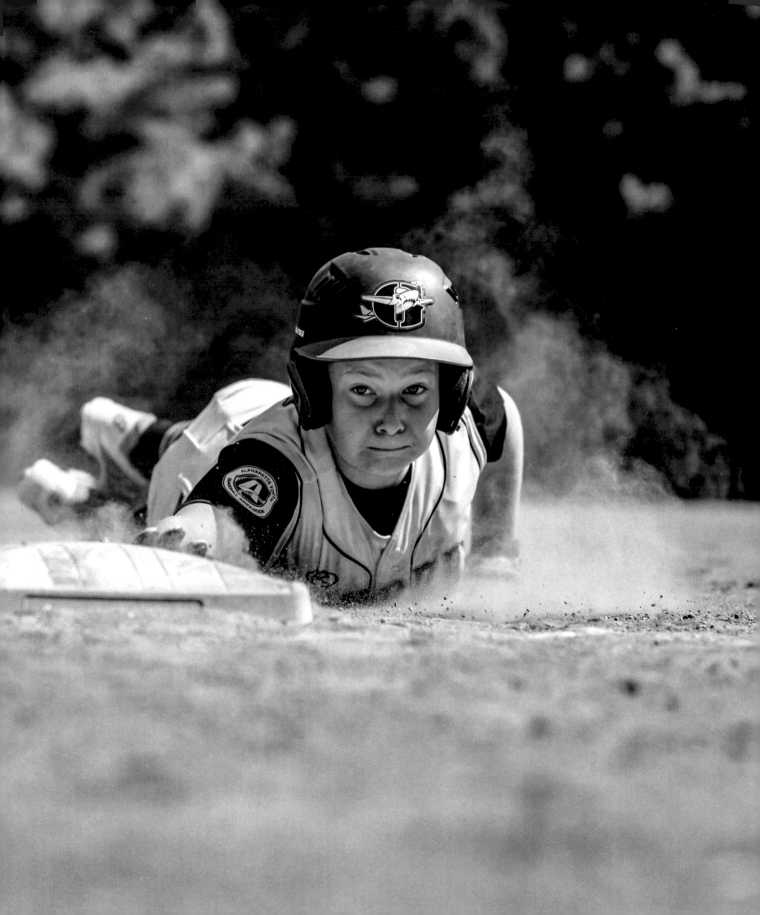

I AM DOING MY PART TO HELP SAVE OUR PLANET. IF I CAN HELP EVEN ONE PERSON MAKE A CHANGE, THAT IS A WIN!

—LIAM, AGE 12

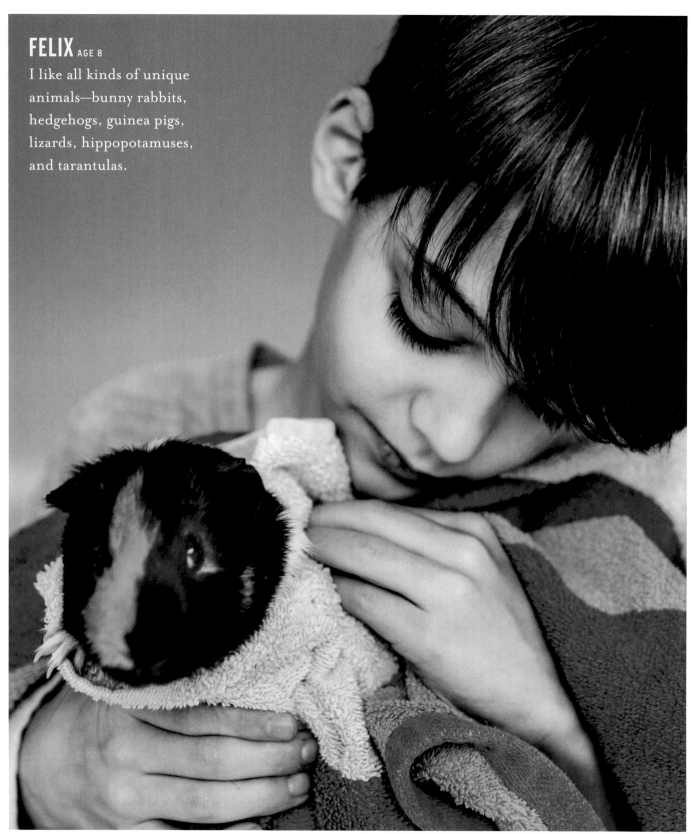

FELIX AGE 8

I like all kinds of unique animals—bunny rabbits, hedgehogs, guinea pigs, lizards, hippopotamuses, and tarantulas.

JEB AGE 19

During one of my first Boy Scout meetings, an older boy taught me how to properly fold a flag. I was taught how to be solemn, show respect, and honor what the flag stands for. Two years later I was teaching a group of scouts, which included my younger brothers, the lessons I had learned.

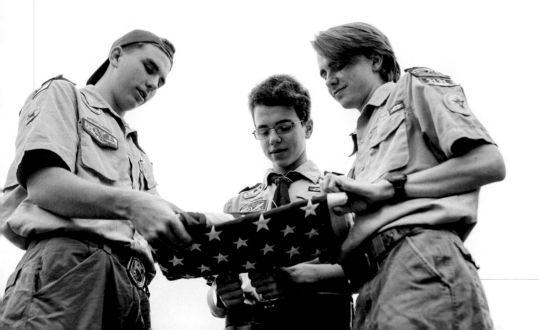

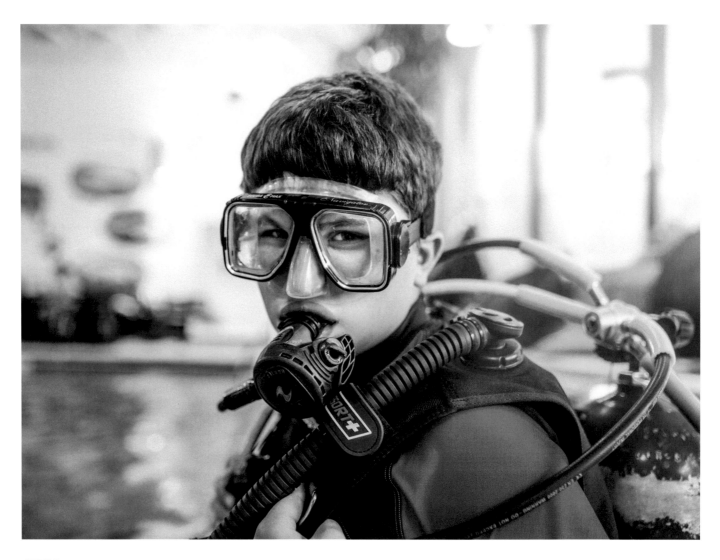

BEN AGE 13

I feel misunderstood sometimes because I have Asperger's. Being underwater and seeing the marine life relaxes me and makes me calm. The worst part is putting on all the scuba gear.

NICHOLAS AGE 13

When I'm drawing, my characters come alive, and it's as if they are right there speaking directly to me.

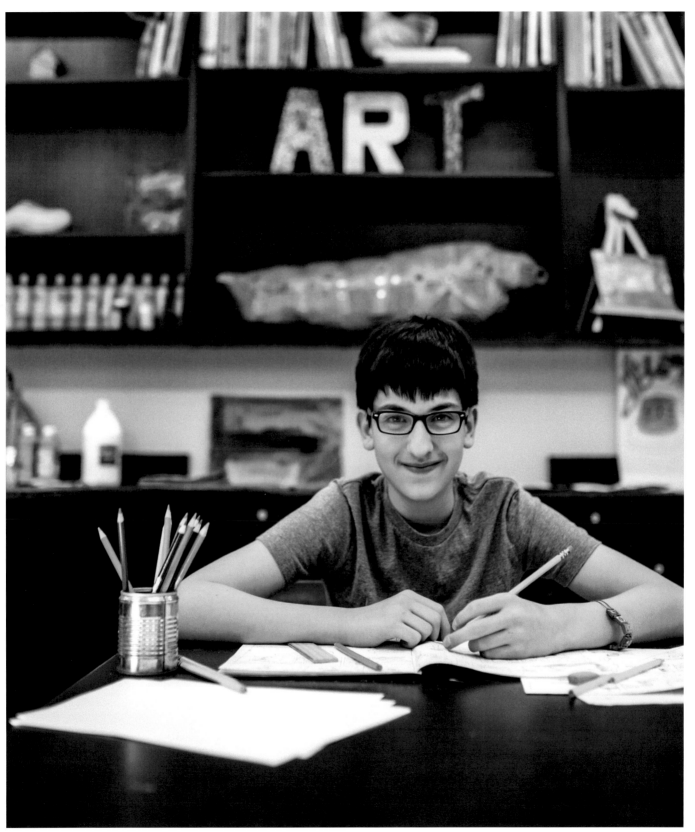

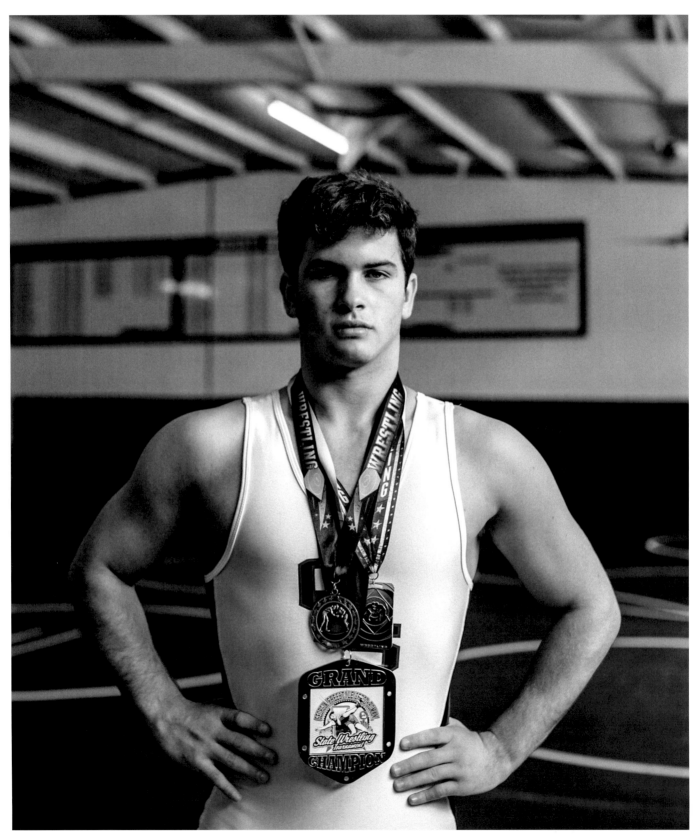

JOSH AGE 15
Go hard, work hard,
and keep striving.

CAMDEN AGE 10
I can be anything when I
read, even a mouse dressed
in a superhero suit.

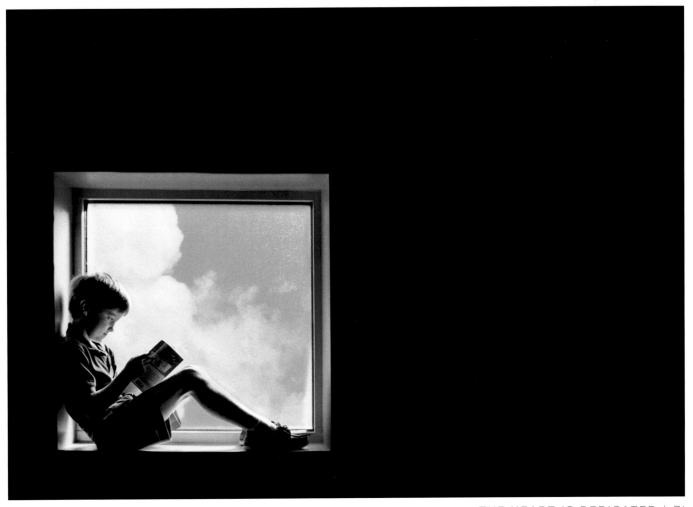

"IT IS A HAPPY TALENT TO KNOW HOW TO PLAY."

—RALPH WALDO EMERSON

THE HEART IS
PLAYFUL

One of the joys of parenthood is being able to rediscover play through our children. We've lived long enough to know that life can be hard and that it's easy to get worn down by our responsibilities and disappointments. And while we, as parents, do our very best to shield our kids from pain, they do carry burdens and often feel them intensely. They may still be discovering how to understand and process those emotions, but they also already have the best antidote: Play. And it's something they're way better at than adults; after all, play is their work. It's how they learn to make sense of the world and how they practice navigating it.

Just hearing the word *play* makes me smile and feel a bit lighter. It allows my heart to take over and my mind to rest. It's hard to recall the last time I made a game out of thin air as my kids do daily. Kids haven't yet become conditioned to think that a stick is just a stick—it's a fishing pole, a magic wand, a pencil, a conductor's baton. Which is one of the reasons that being playful is so good for us. Playing allows fun to be the priority. It is so important these days, to set aside responsibilities and have fun. Laugh. Be silly.

Can you toss your umbrella aside and play in the rain like Hall (page 91)? Or fly like Bodhi (page 84)? Our kids are watching and learning from us always, and if we can be brave enough to take a lesson or two from them, they will in turn be encouraged to play and learn and find joy every day.

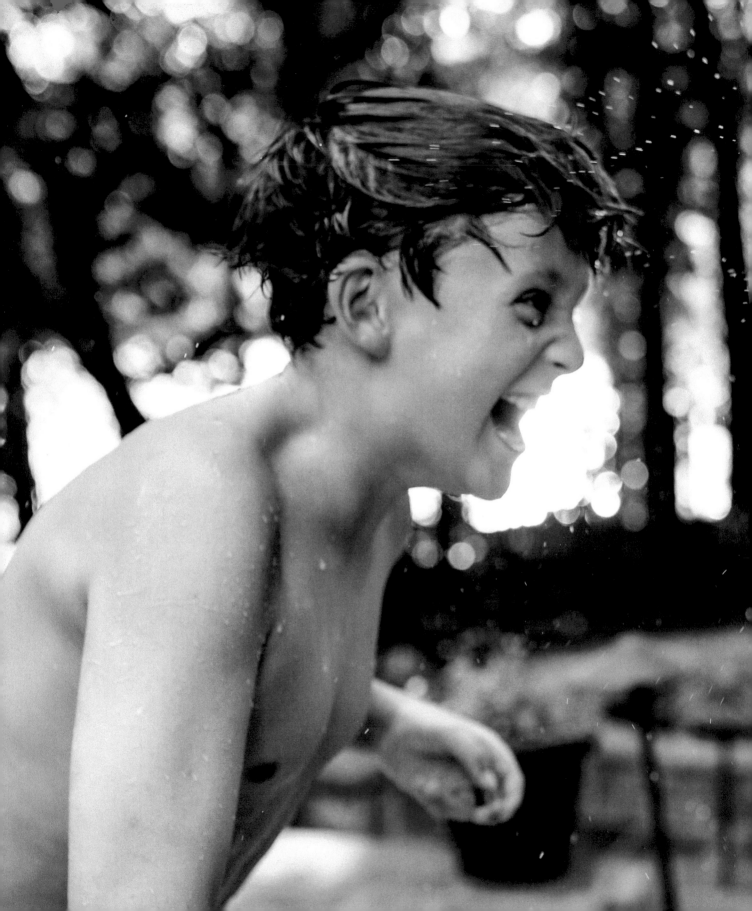

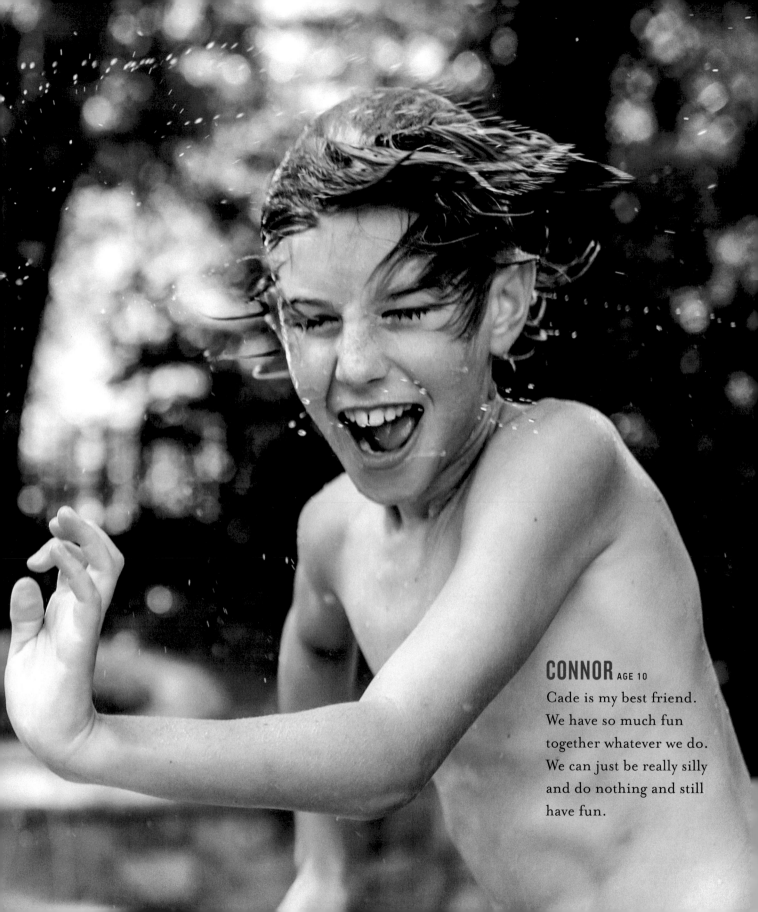

CONNOR AGE 10

Cade is my best friend.
We have so much fun
together whatever we do.
We can just be really silly
and do nothing and still
have fun.

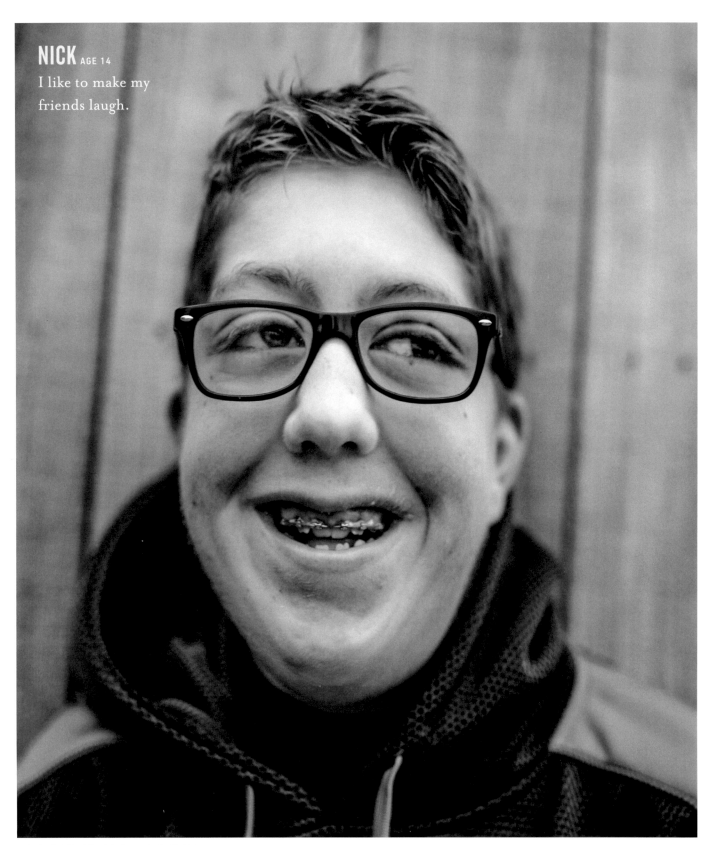

NICK AGE 14

I like to make my
friends laugh.

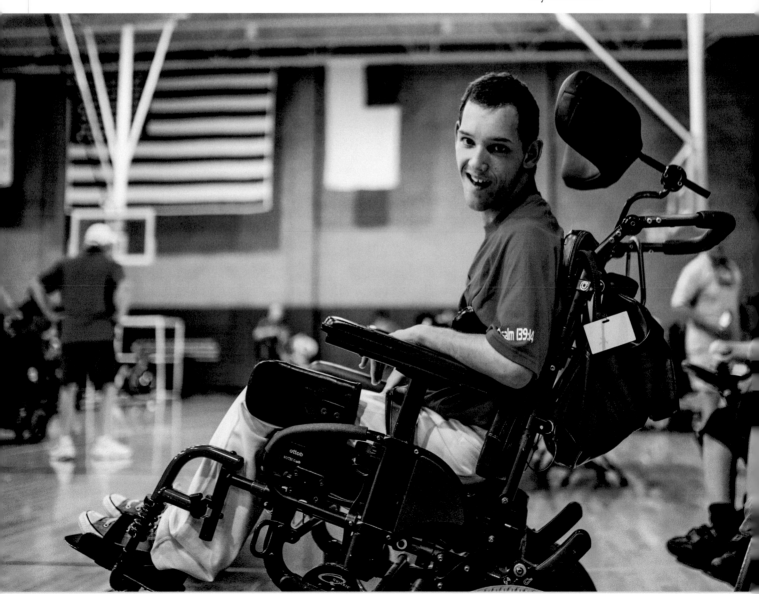

JASON AGE 19

I love playing sports and being part of a team with my friends.

NOLAN AGE 15

You need to be kind to others. You need to respect differences and be objective. Never carry your opinion as fact and always listen and be open-minded. Share information that could be helpful to others and never be greedy. Try to be perfect, but know you never will be. In short, be a good person.

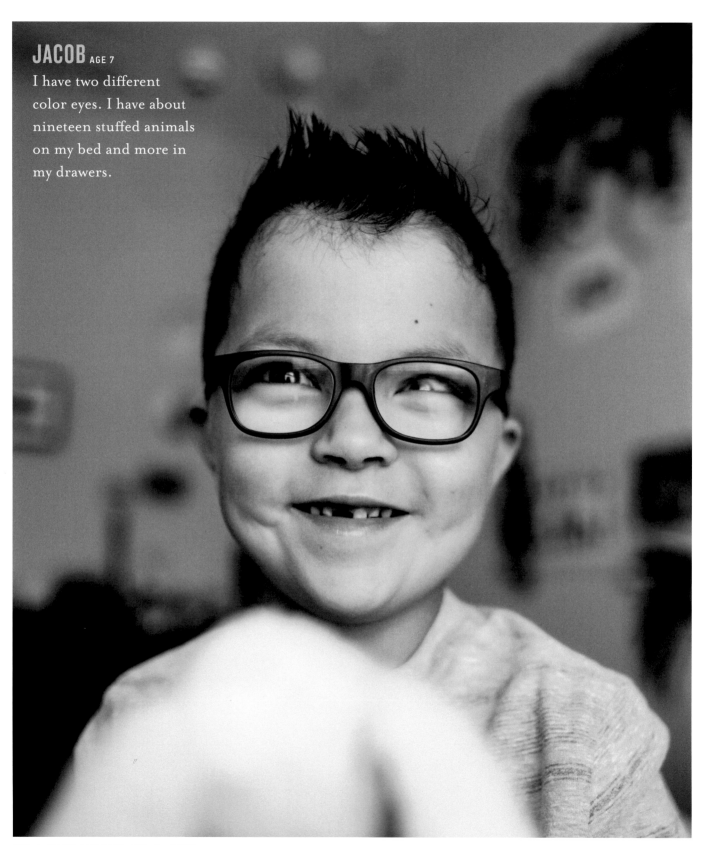

JACOB AGE 7

I have two different color eyes. I have about nineteen stuffed animals on my bed and more in my drawers.

ROBERT AGE 10

I always make it a point to tell my opponents "good game" whether we win or lose. I always try to be a good sport.

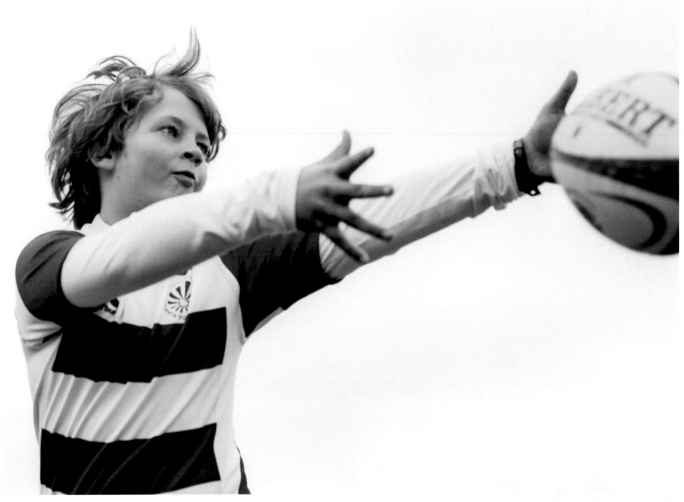

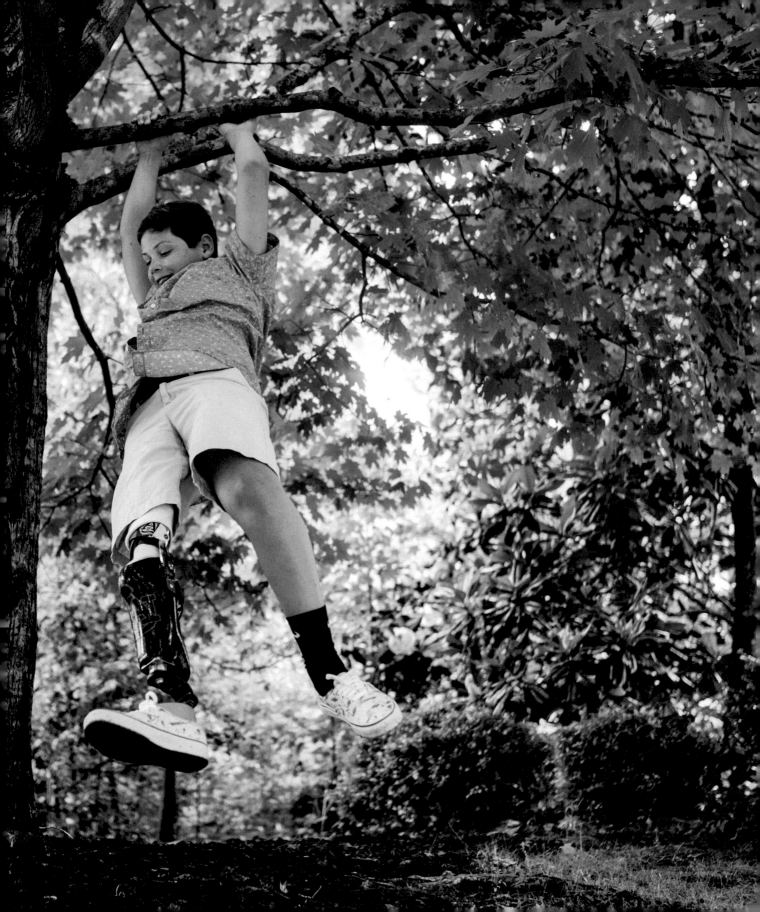

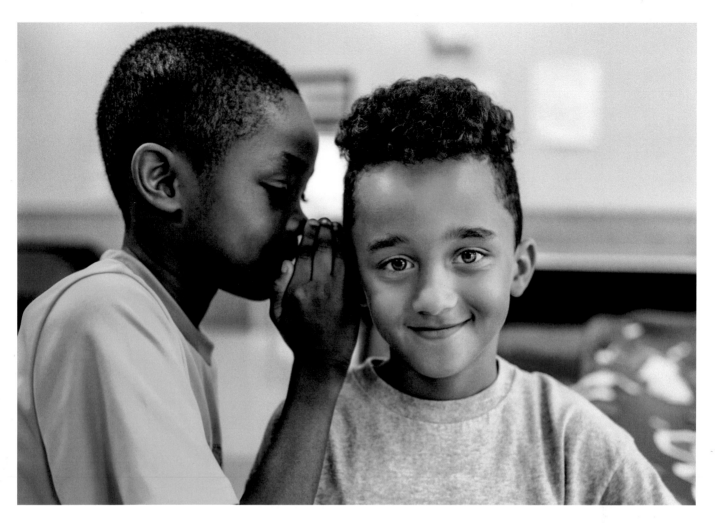

ALVIN AGE 8

My mom always tells me to make good choices in my friends. I think I do.

JUDE AGE 13

I've learned that you've got to make the most of everything and have fun where you can. I appreciate the simple things like going outside in my yard and running around.

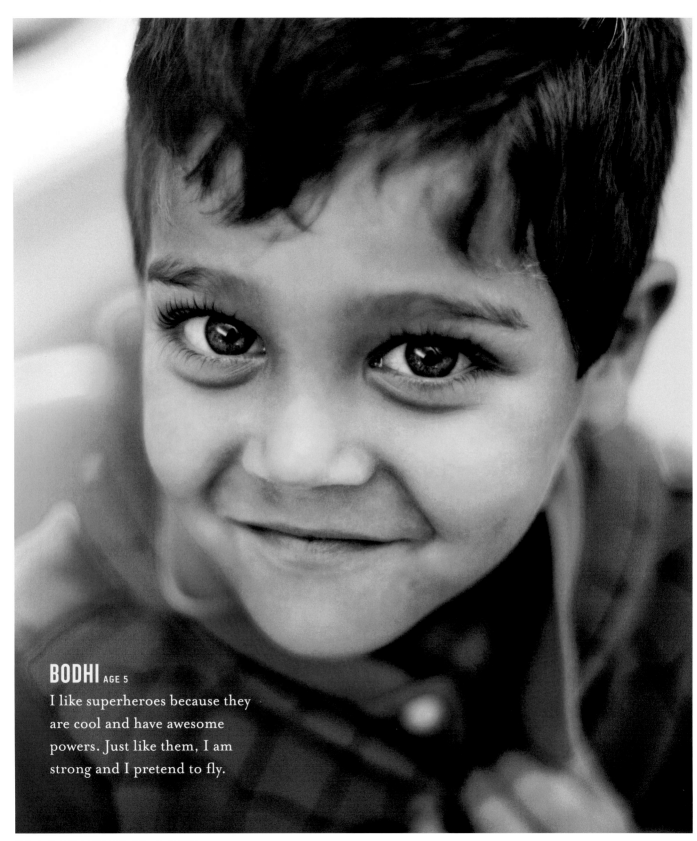

BODHI AGE 5

I like superheroes because they are cool and have awesome powers. Just like them, I am strong and I pretend to fly.

JAVI AGE 6

This is my funny world.

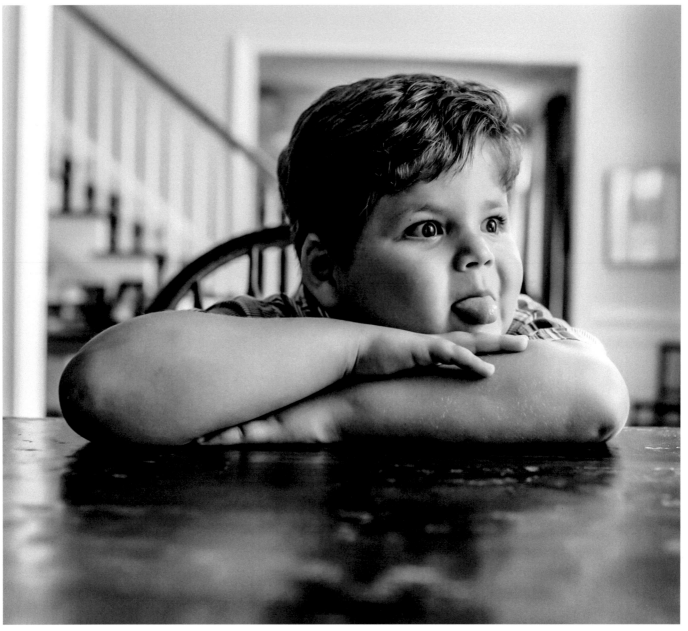

NATE AGE 10

My brother didn't choose to have autism. Autism chose him. He takes it well though. It doesn't mean we shouldn't love him.

HENRY AGE 8

Ready, set, go!
Easter egg hunt is on.

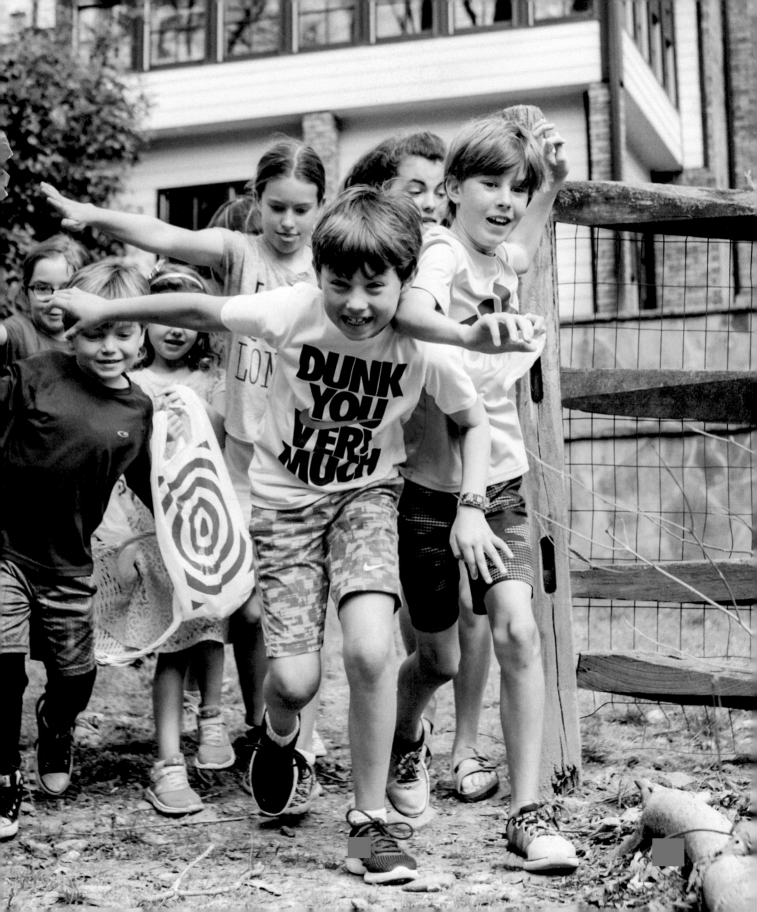

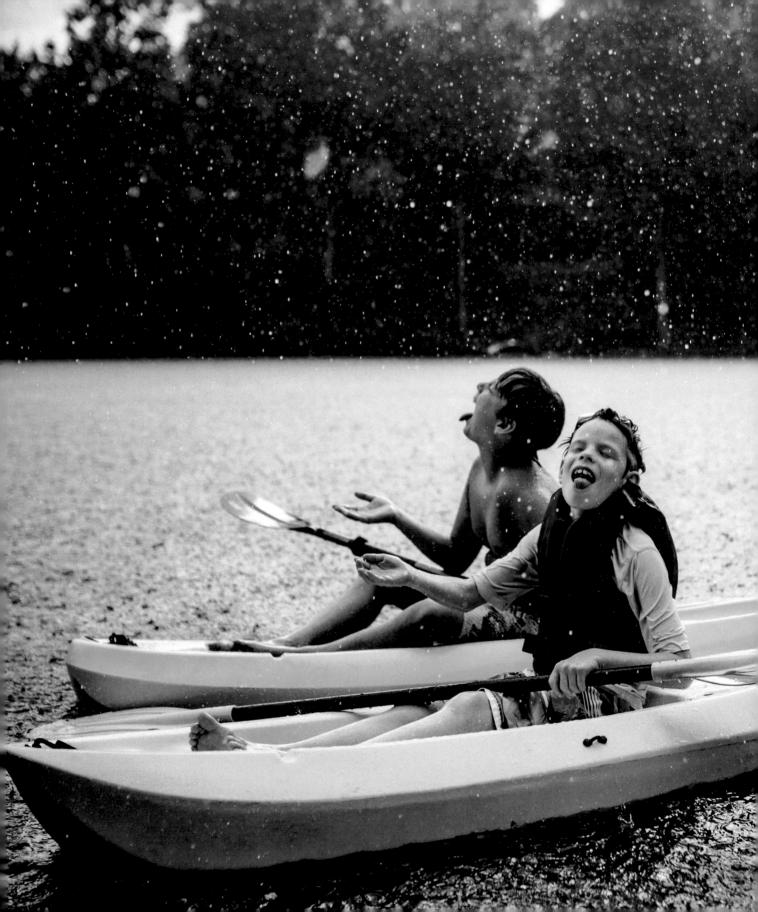

HALL AGE 9

You have to taste the rain.

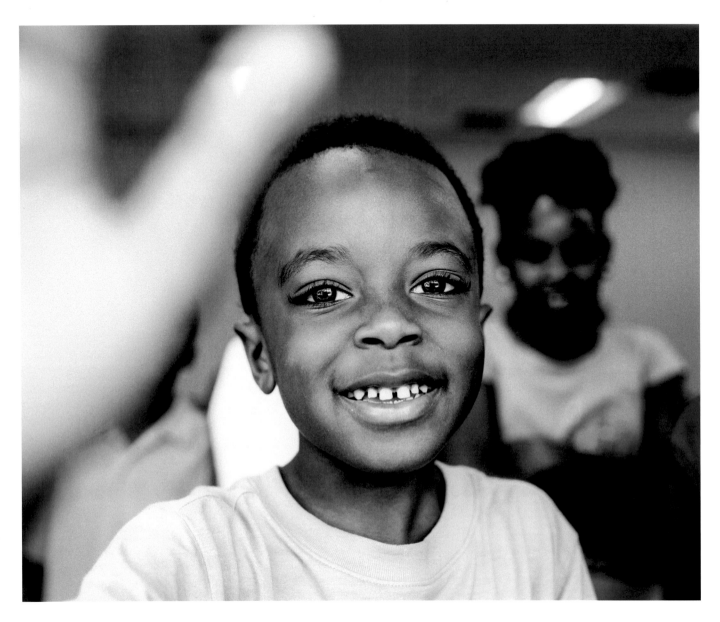

RAMEL AGE 7

Tomorrow is today—
let's have fun!

JADON AGE 10

You get what you get
and you don't get upset.

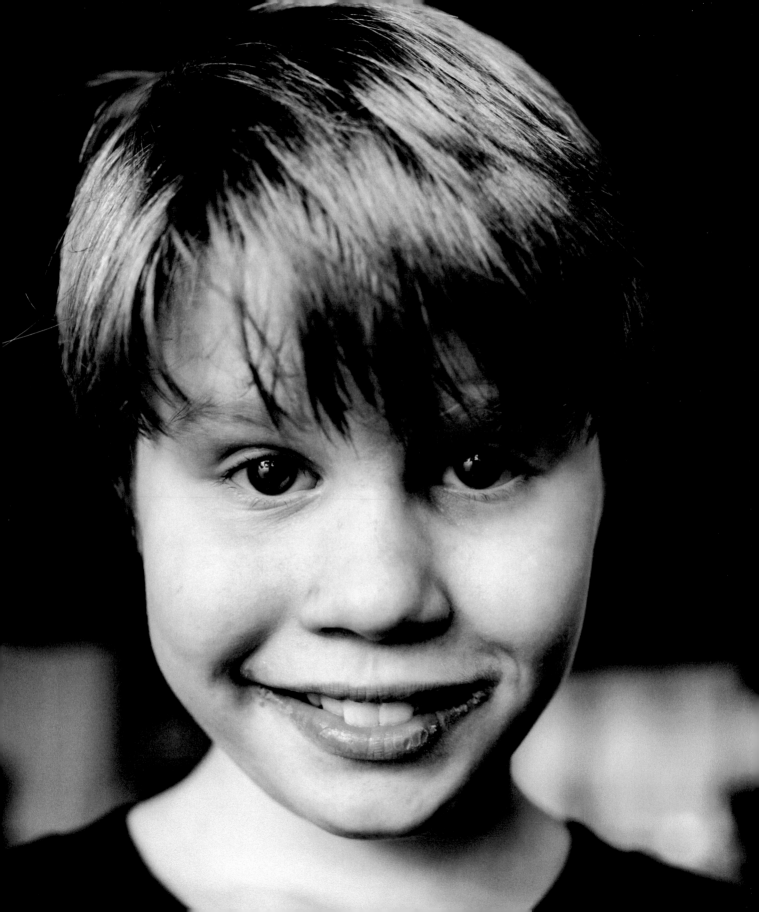

"YOU CAN'T RUN AWAY FROM WHO YOU ARE, BUT WHAT YOU CAN DO IS RUN TOWARD WHO YOU WANT TO BE."

—JASON REYNOLDS

THE HEART IS
CREATIVE

It is not just the artists or musicians who have the lock on creativity. We all have imaginations. We are all big thinkers. We are all creative when given the right outlet. The thing about being creative is that it is like a muscle: The more you use and exercise it, the more conditioned and powerful it gets. You get more ideas, stronger ideas, and crazier, more amazing ideas. And it's far from a one-size-fits-all model: Creativity can take the form of a new solution to an age-old problem. Or a simple shift in perspective that makes something previously impossible, possible. Creativity can be found in as simple an action as looking up from dribbling a soccer ball and seeing (or creating) that open pass. It's present in that pause while writing a sentence or drawing a picture in a story and knowing or figuring out what word or line comes next. And creativity is there during that tough confrontation with a playground bully, when a compassionate, not angry, approach makes it possible to diffuse the situation, not escalate it.

Creativity can be expressed in so many beautiful ways, like Hudson's seeking out a way to express himself athletically through cycling (page 103) after his doctors told him he couldn't play contact sports, or Rohaan's culinary skills (page 102). We each have our own brand of creative. And we all deserve the opportunity to discover where we shine.

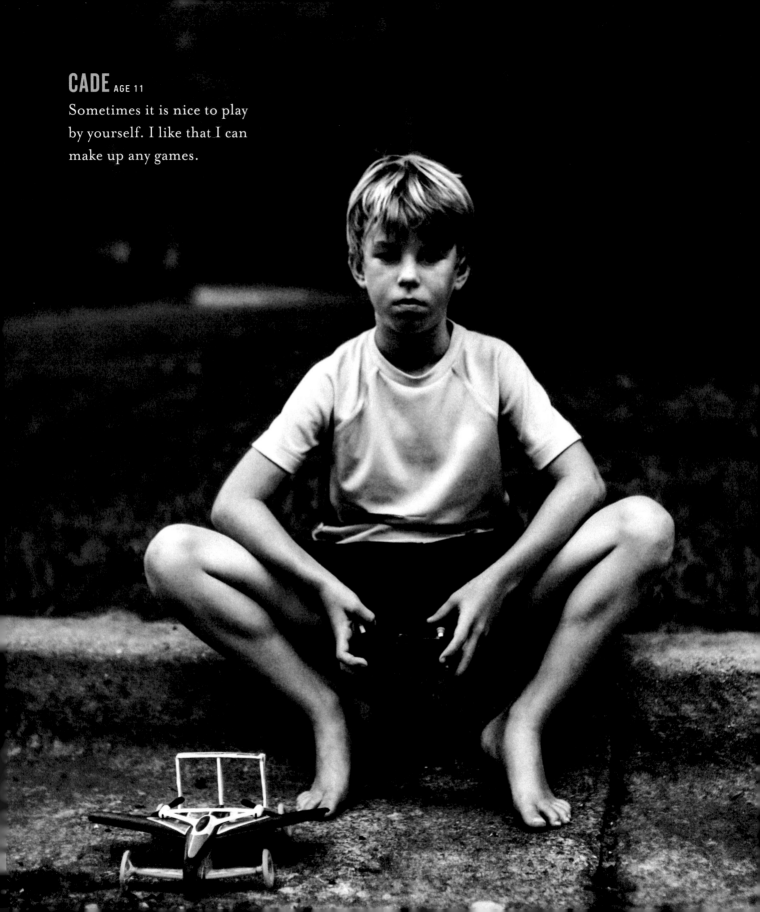

CADE AGE 11

Sometimes it is nice to play
by yourself. I like that I can
make up any games.

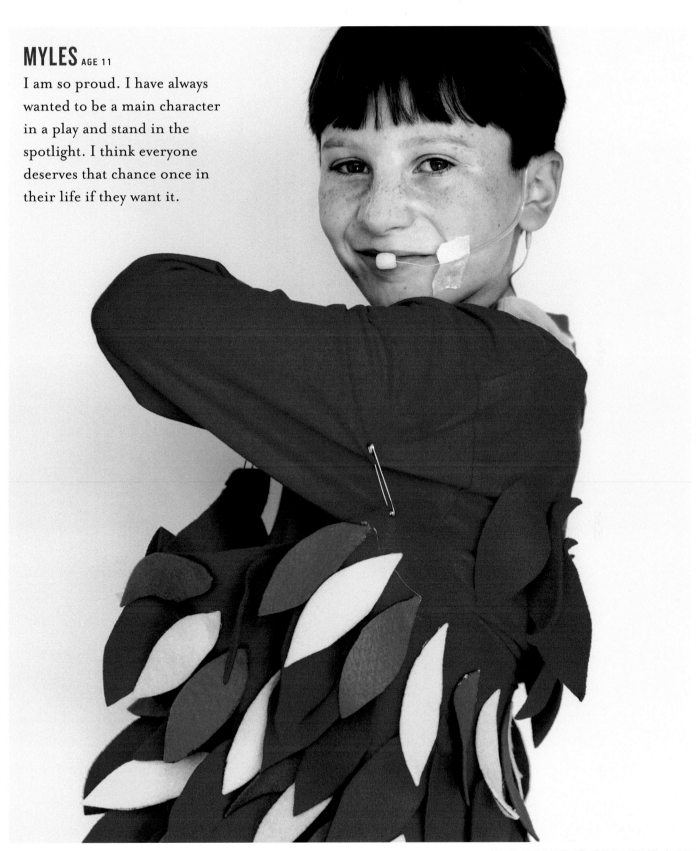

MYLES AGE 11

I am so proud. I have always wanted to be a main character in a play and stand in the spotlight. I think everyone deserves that chance once in their life if they want it.

JEREMY AGE 9

Strong is being brave by
standing up for yourself.

GUS AGE 4

I'm proud I wear glasses even
though I don't like them.

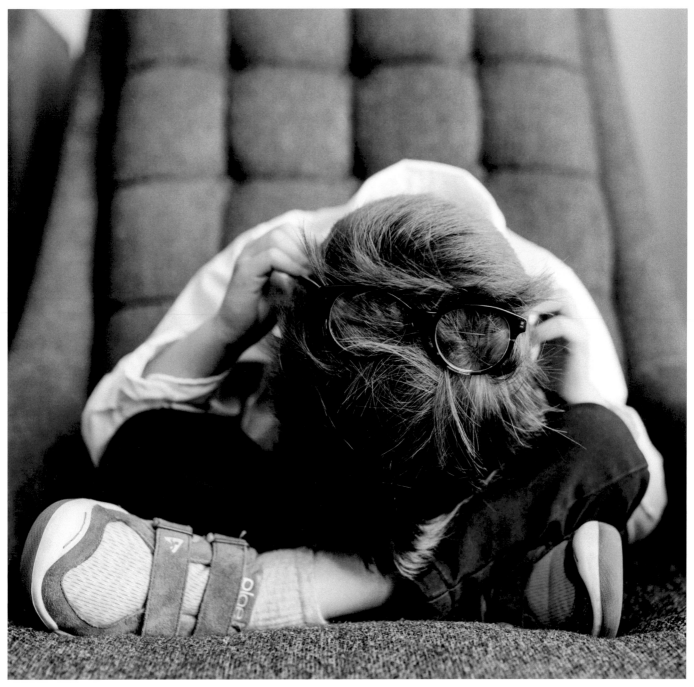

ALBERTO AGE 19

Art has been a big part of my life. I use it to express myself in my solitude, when I don't have anyone to talk to. It's helped me express things that I usually wouldn't say in a social environment, and it keeps me relaxed when I feel stressed.

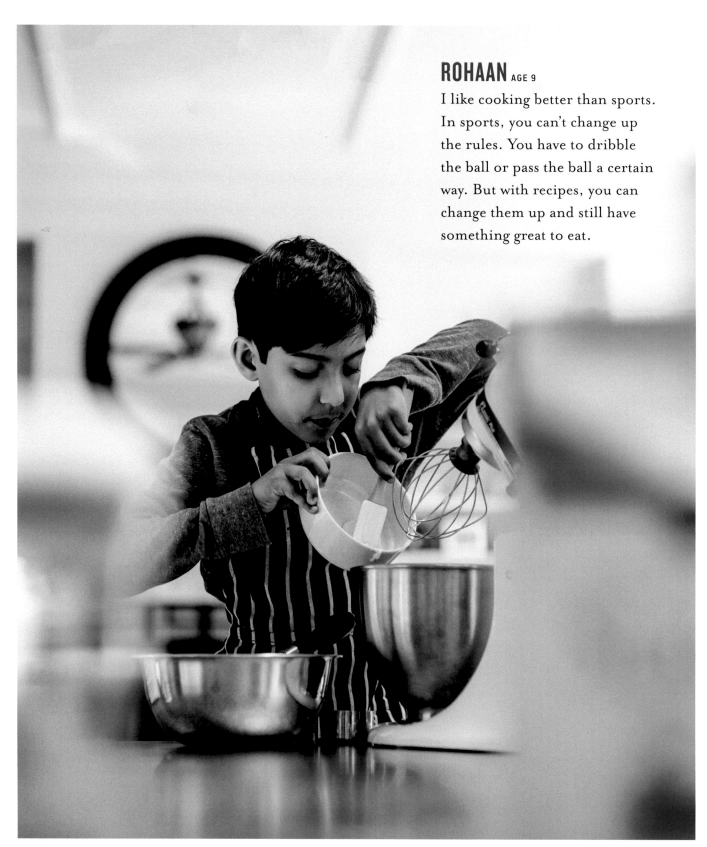

ROHAAN AGE 9

I like cooking better than sports. In sports, you can't change up the rules. You have to dribble the ball or pass the ball a certain way. But with recipes, you can change them up and still have something great to eat.

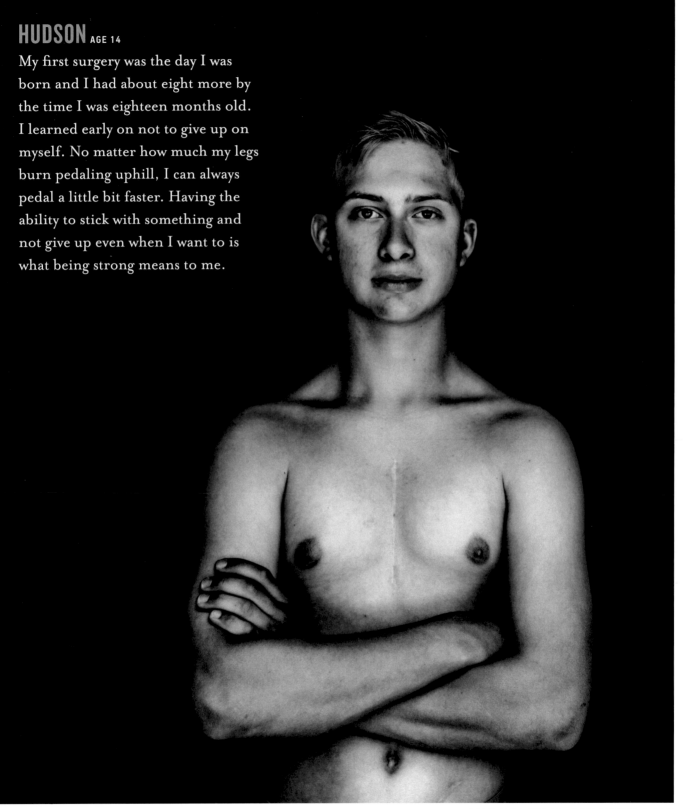

HUDSON AGE 14

My first surgery was the day I was born and I had about eight more by the time I was eighteen months old. I learned early on not to give up on myself. No matter how much my legs burn pedaling uphill, I can always pedal a little bit faster. Having the ability to stick with something and not give up even when I want to is what being strong means to me.

COLBY AGE 13

Mufasa represents everything
I aspire to be: humble, strong,
wise, and caring.

WILL AGE 7

I'm amazing because I'm strong and
fast and funny and kind and good.

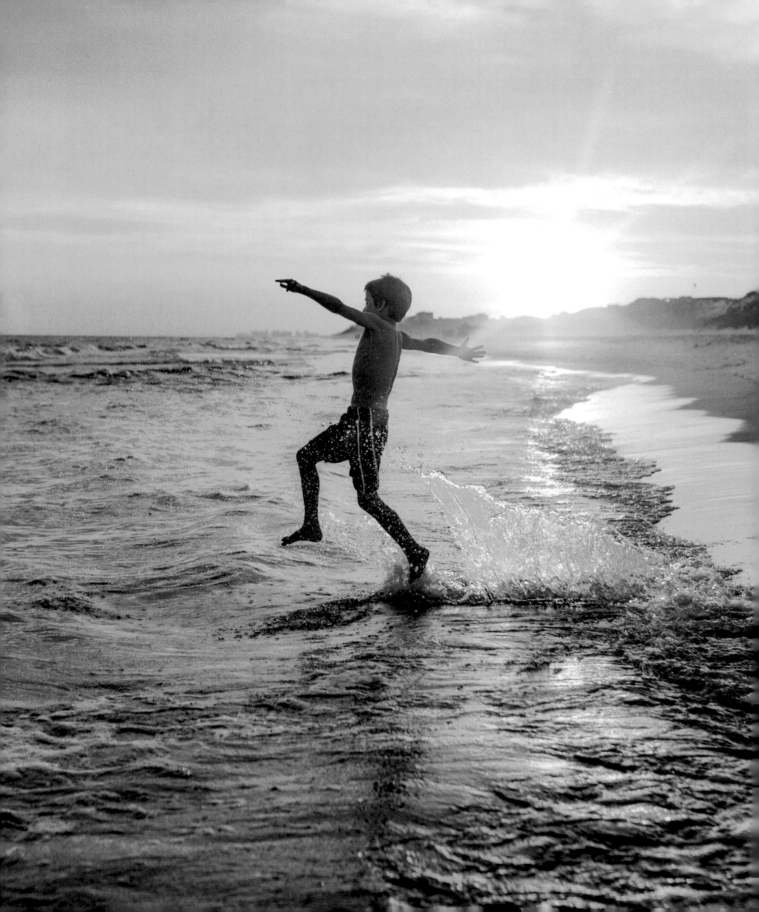

NOAH AGE 10

I have fun acting as a character because I can have a different personality.

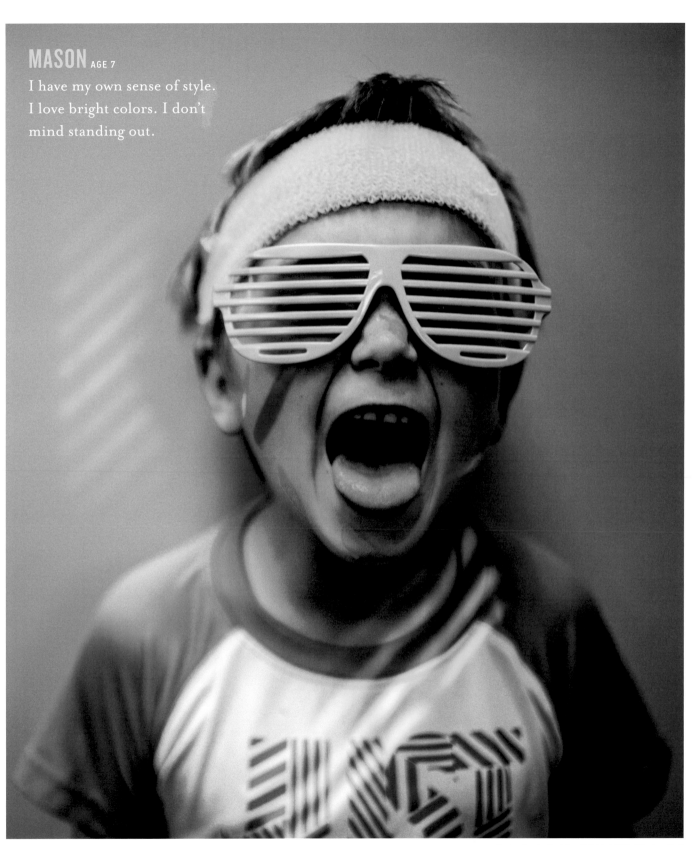

MASON AGE 7

I have my own sense of style.
I love bright colors. I don't
mind standing out.

OISIN AGE 6

I prefer to be my own self because when I am . . . I just am.

I DON'T BELIEVE THAT BOYS DON'T CRY. BECAUSE I CRY SOMETIMES.

—RYAN, AGE 7

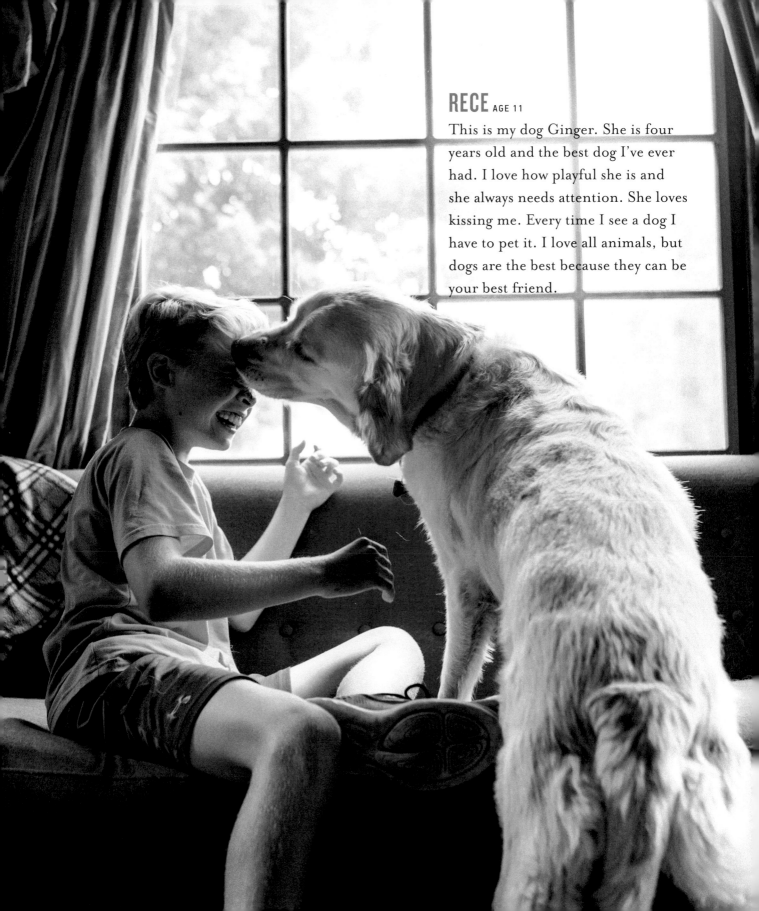

RECE AGE 11

This is my dog Ginger. She is four years old and the best dog I've ever had. I love how playful she is and she always needs attention. She loves kissing me. Every time I see a dog I have to pet it. I love all animals, but dogs are the best because they can be your best friend.

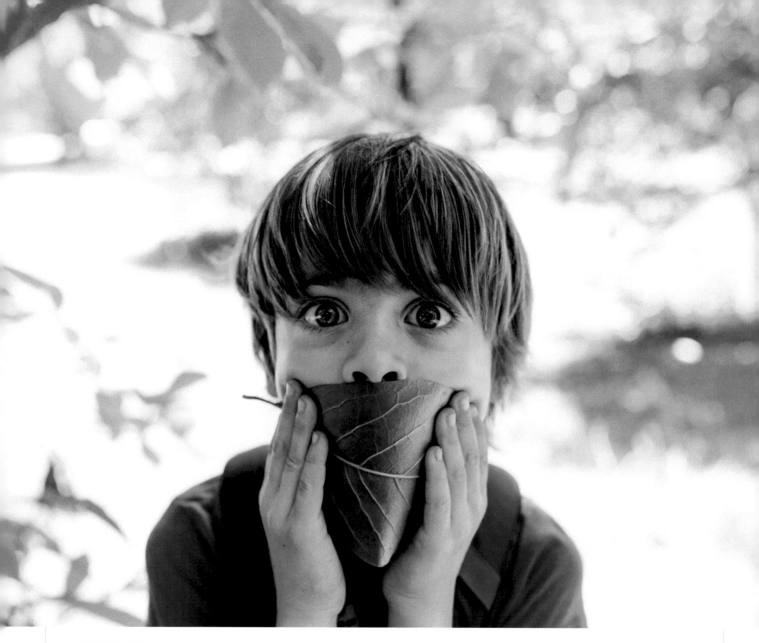

NIKOLAI AGE 6

I like that nature made frogs and caterpillars and butterflies—especially the viceroy and monarchs, and sharks— especially white-tipped reef sharks and black-tipped reef sharks.

SAM AGE 5

I just fell. But I got back up.

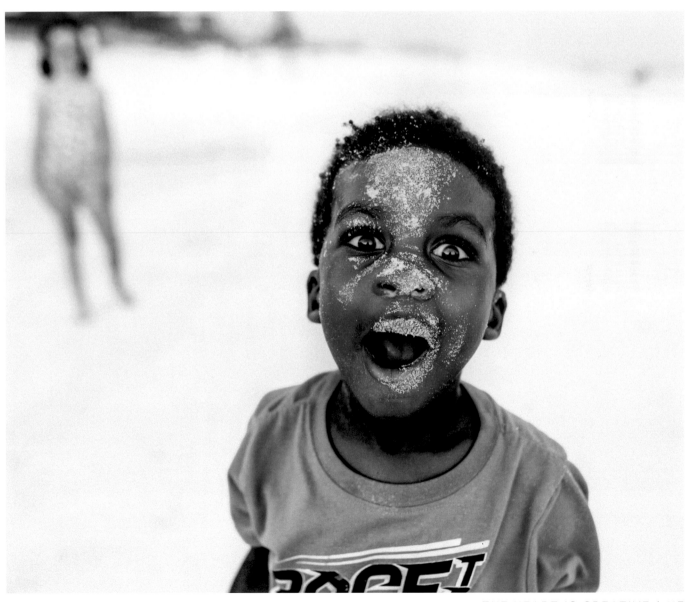

"THE IDEA THAT WE **ALWAYS** MUST BE **STRONG** REALLY PRESSES US DOWN, KEEPS US ALL FROM GROWING."

—DONALD GLOVER

THE HEART IS
RESILIENT

We all know on an intellectual level that failure is a given. Whether it's heartbreak, a disappointing test result or job interview, an unexpected diagnosis, a flubbed audition, a social stumble—it's inevitable. And it can be even worse, when you feel as though you have let someone close to you down.

We also know, intellectually, that it's not that act of failing that defines us; it's how we respond that is the true measure of character. But it doesn't make it easier. The lessons I learned from the boys I photographed in this chapter are about the strength it takes to stand up again (and again and again) after life has knocked the air out of you. Resilience lies in the act of getting back up. It's when you're confronted with the phrase *everything happens for a reason,* and you're not quite buying it.

The boys in this chapter are inspiring because, no matter the size of the hardship they face, they muster enough spirit not only to survive but to keep going—and sometimes that's what it takes to live one's truth in a less than forgiving environment (see Erik, page 126), or to pursue one's dream after a physical setback like a heart transplant (see Bronco, page 123). Sometimes it's our hardest challenges that allow us to find and share our true strength.

JUDE AGE 5

Sometimes kids say, "Look at what I
can do," and they run fast and jump
and play lots of sports. I am strong
because I can talk and use my words.
I like to meditate and do yoga and
that makes me strong. My strong is
different and that's okay.

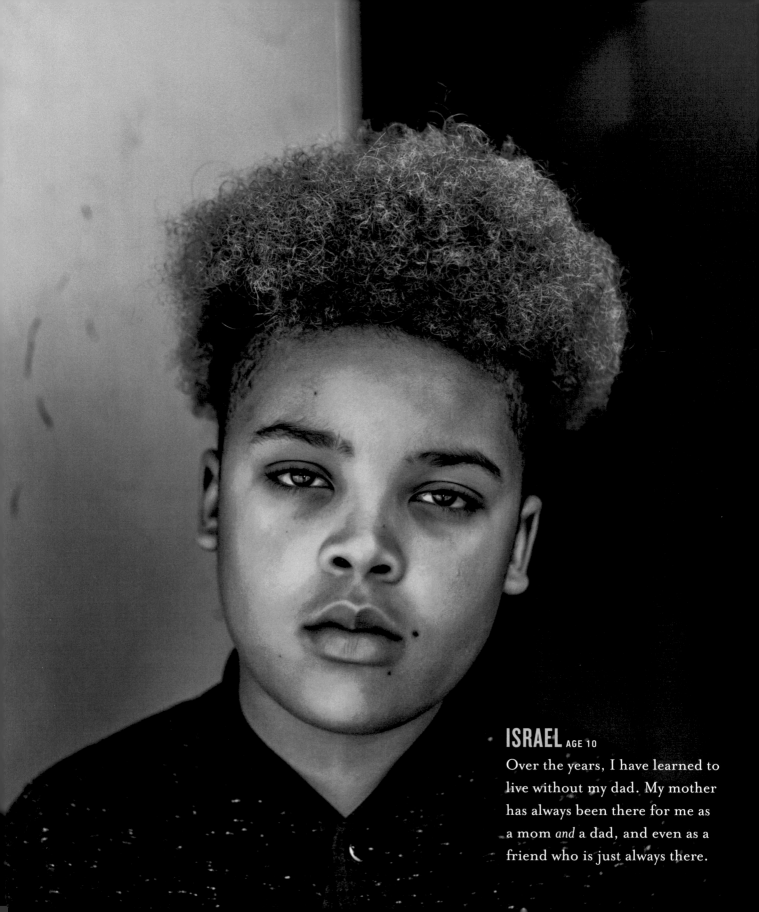

ISRAEL AGE 10

Over the years, I have learned to live without my dad. My mother has always been there for me as a mom *and* a dad, and even as a friend who is just always there.

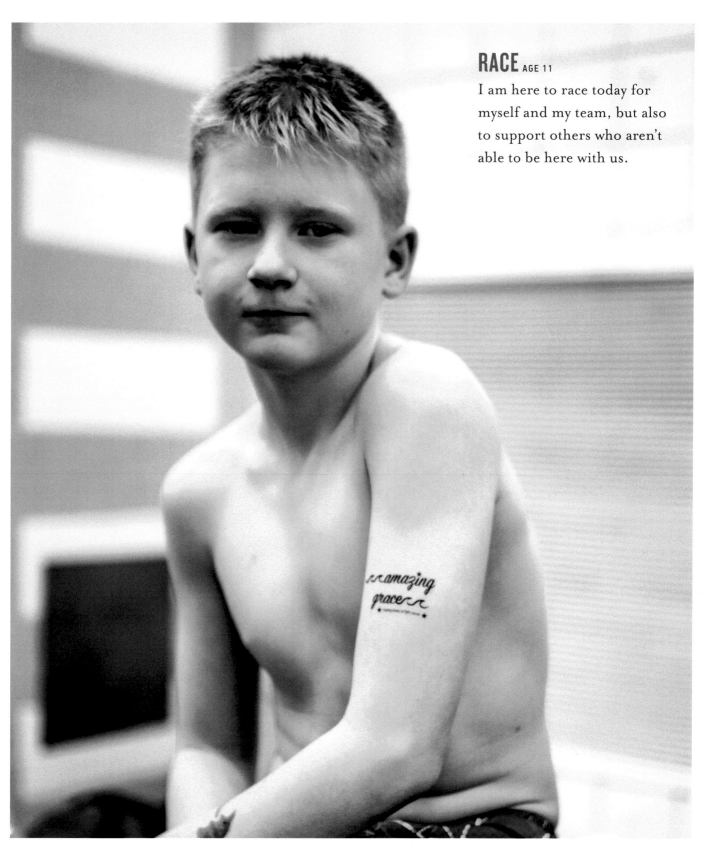

RACE AGE 11

I am here to race today for myself and my team, but also to support others who aren't able to be here with us.

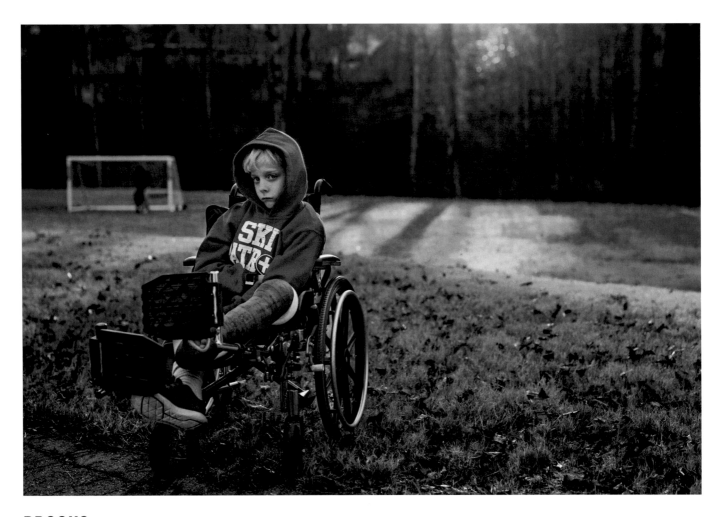

BROOKS AGE 8

Breaking my leg was the worst thing ever.
I missed running around and still can't
run as fast as I used to, but I did learn that
I really like making comics. I made twenty-
three comics with 293 pages of full color
while I was recovering.

BRONCO AGE 12

I ride dirt bikes. I had a
heart transplant. I beat
cancer. I play football.

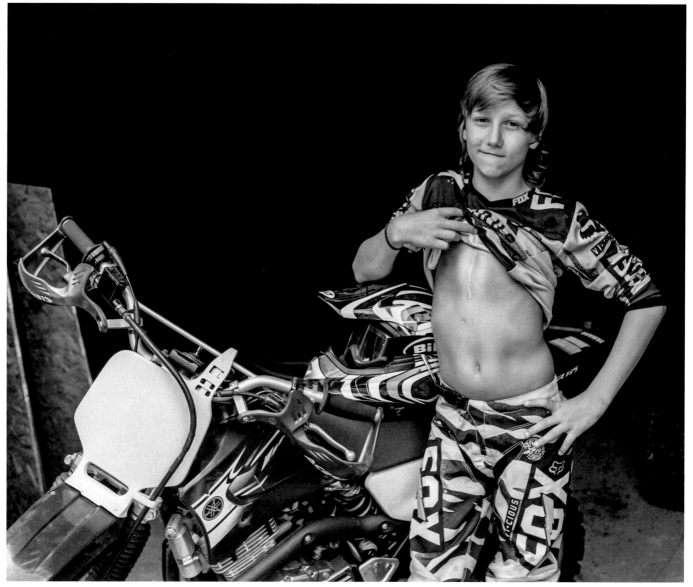

ETHAN AGE 12

I am most proud of facing cancer with bravery and positivity. Both of those were a challenge on the bad days. It's scary to lose so many things all at once. I had to take a break from sports and acting because I was just too tired to do it. I lost a few friends and gained more. Even though it was hard, I came out on the other side of it better and stronger.

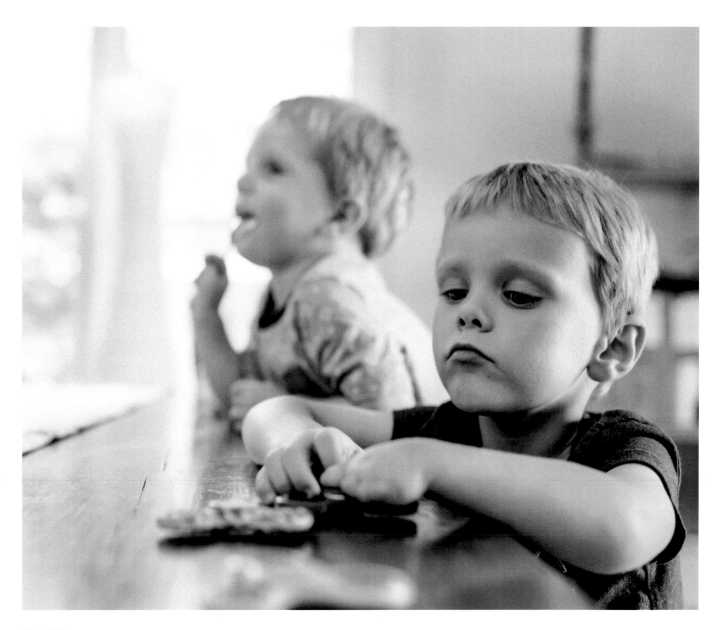

GREY AGE 5

I have a "lucky fin" like
Nemo. It makes me pretty
special and pretty awesome.
It's also super strong.

ERIK AGE 17

Strong to me means living as your true authentic self without fear of judgment or ridicule. I believe that the most powerful strength is the kind that inspires others to be strong beside you.

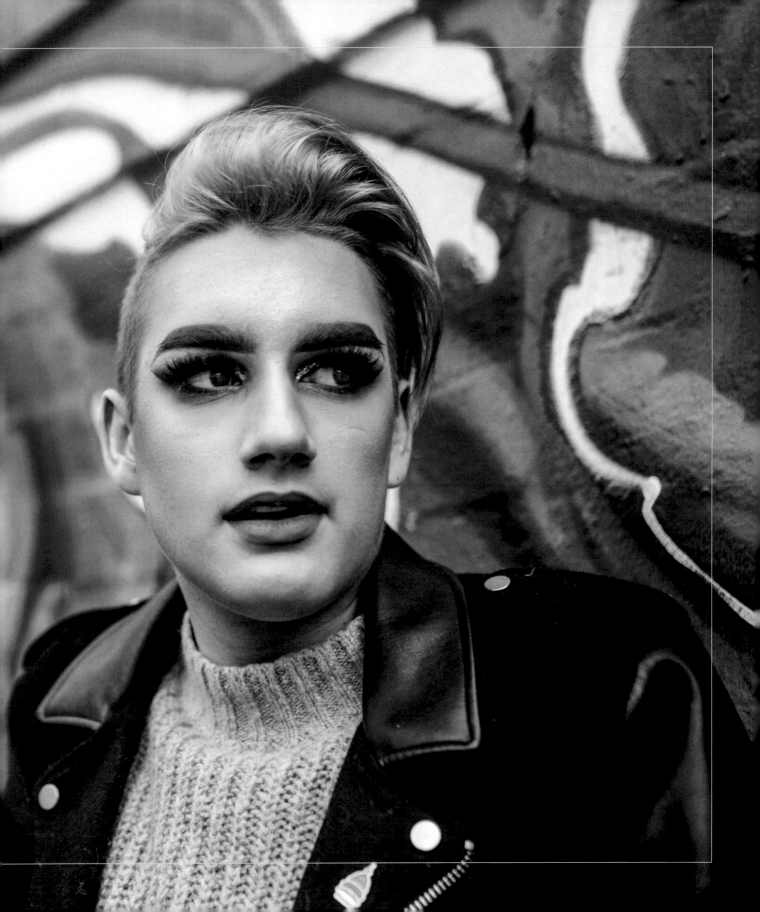

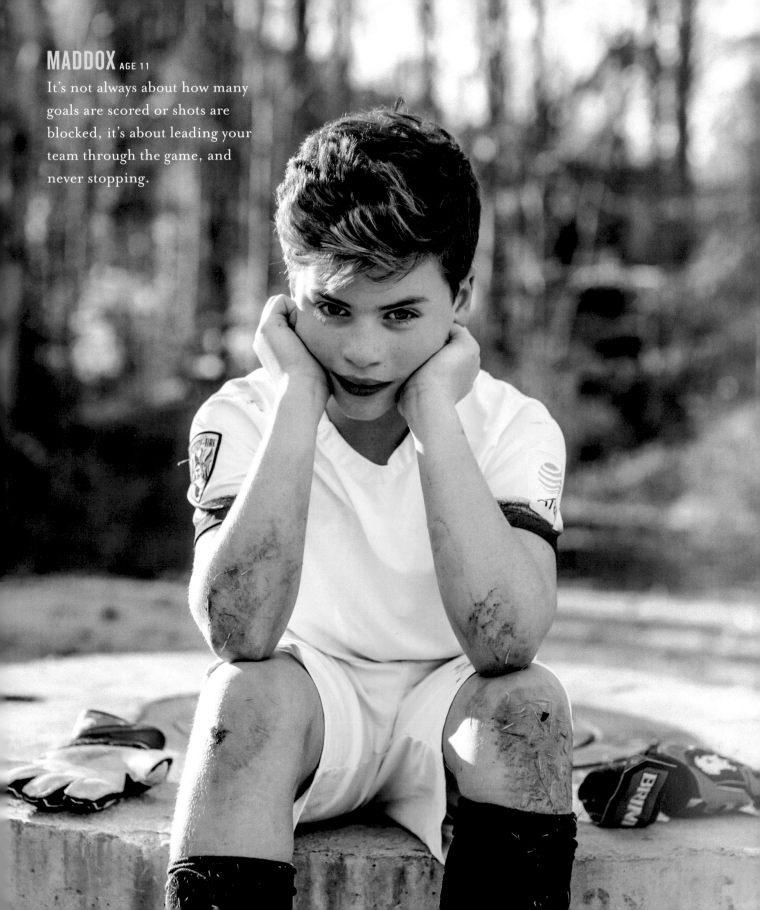

MADDOX AGE 11

It's not always about how many goals are scored or shots are blocked, it's about leading your team through the game, and never stopping.

ALL MY LIFE I WAS NOT TALL ENOUGH, NOT STRONG ENOUGH, NOT FAST ENOUGH. BUT I WAS MOTIVATED.

—Max, AGE 17

MAHIN AGE 7

I am not the fastest or the strongest.
I don't like to play sports that much.
But I love making art. There are so
many things to draw.

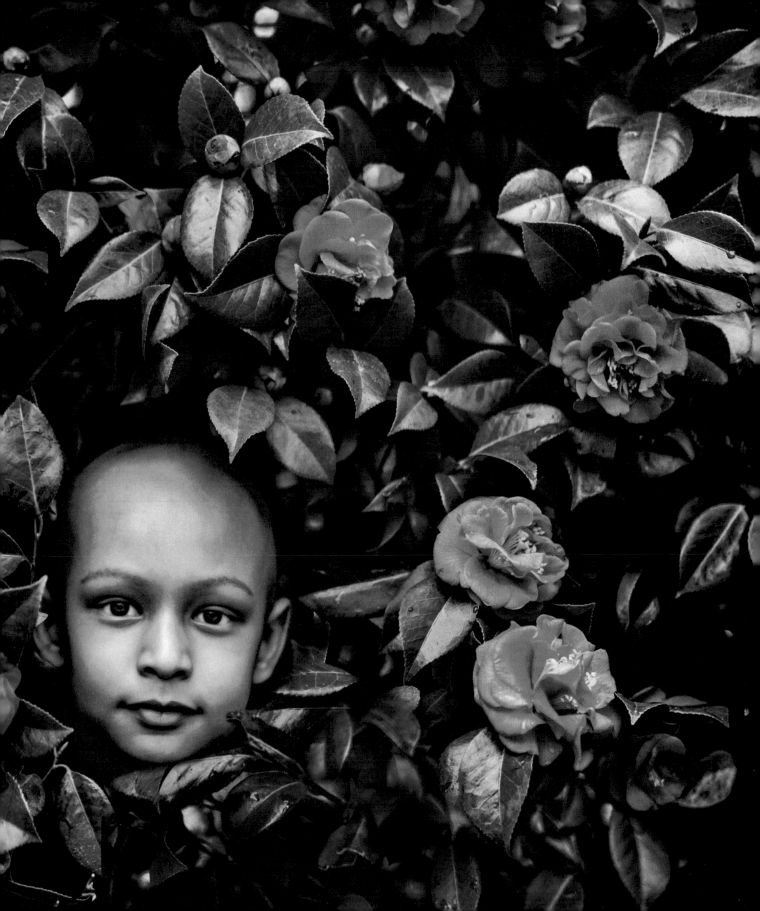

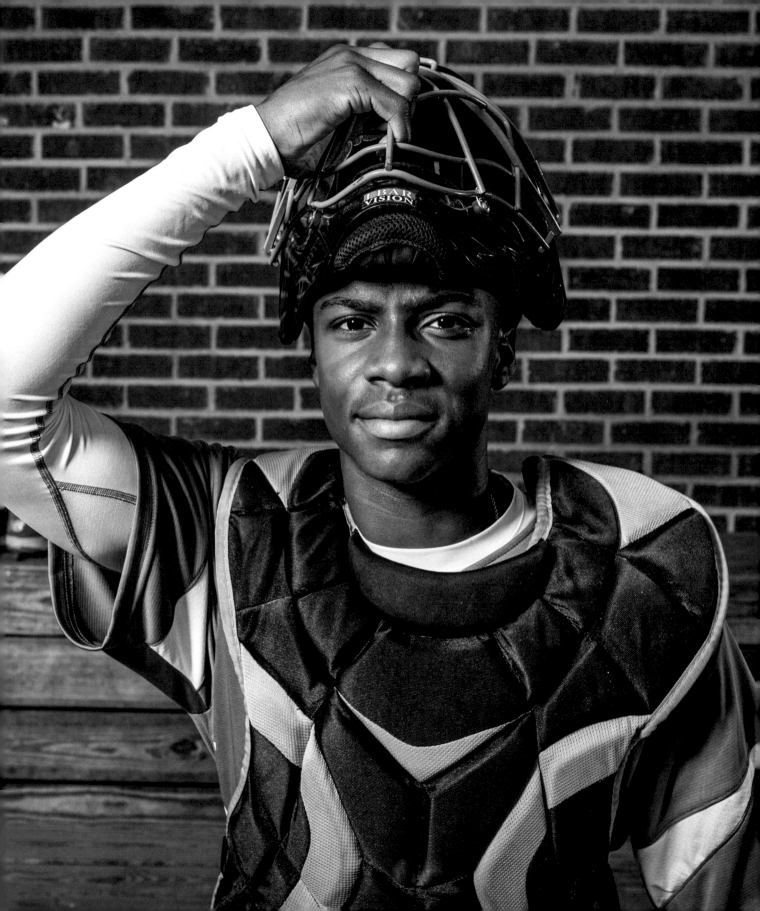

NICK AGE 17

I am just coming back from
a horrible knee injury. I was
determined that I would catch
again. I refused to be defeated.

MASON AGE 7

It's okay to cry.

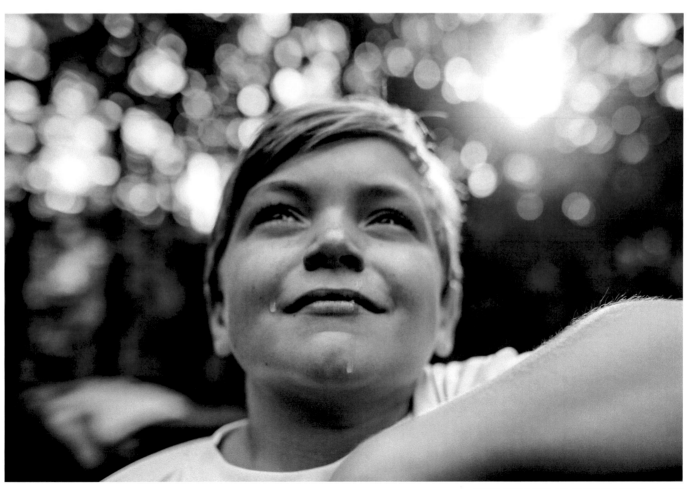

CRUZ AGE 9

I love to jump and climb,
so maybe I could be the first
Asian Spider-Man.

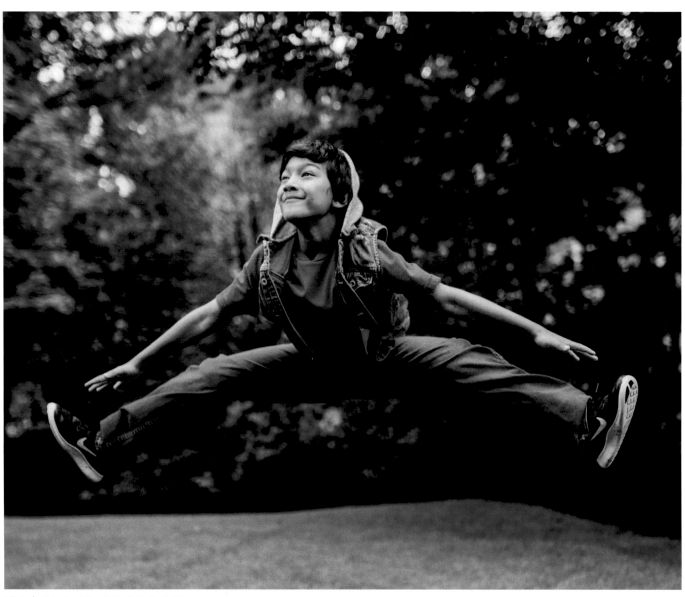

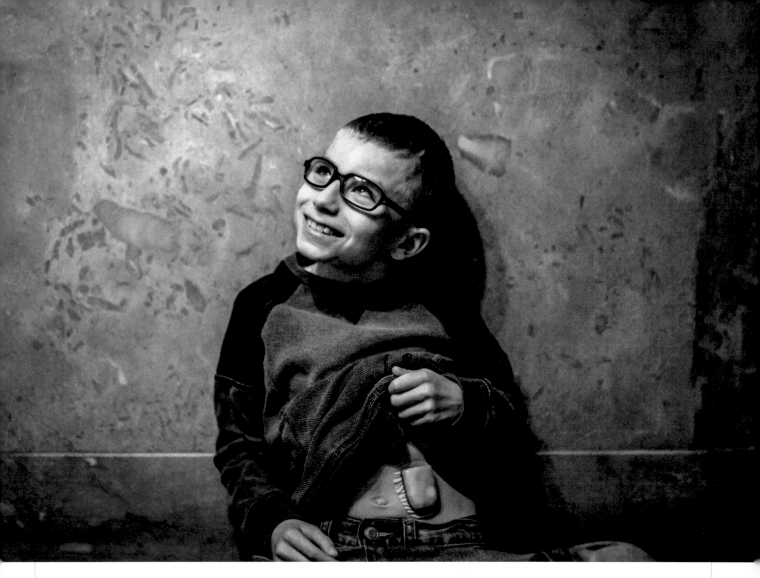

GABE AGE 9

I was born with the cards stacked against me, but I've learned to shuffle the deck and create my own hand.

" **THE ONE THING YOU HAVE THAT NOBODY ELSE HAS IS YOU. YOUR VOICE, YOUR MIND, YOUR STORY, YOUR VISION. SO WRITE AND DRAW AND BUILD AND PLAY AND DANCE AND LIVE AS ONLY YOU CAN.** "

—NEIL GAIMAN

THE HEART IS
EXPRESSIVE

Expressive. I love this word so much. But I love the idea behind it even more. Putting yourself out there—it's essential to moving a society forward. It's what makes our world interesting. In these images, I sought to highlight boys who aren't afraid to have contrary opinions, who aren't afraid to be different, who aren't afraid to show the world who they are, just as they are. Their views are refreshing and heartfelt—like Manuel (page 146), who loves to perform, Ryan (page 155), who is proud to think in alternative ways, and Oisin (page 139), who relishes his difference and understands that it is precisely *that* which makes him stand out.

Our boys need to live in a culture and an environment that allow them to find their own voices and express themselves in the ways they need to—through song, through dance, through dyeing their hair blue or wearing clothes they feel comfortable in. We must articulate a dream for them of a world comprised of more inclusive communities, where different perspectives are tolerated, where a broader notion of how masculinity (and femininity) may be expressed is nurtured.

Everyone has a unique story to tell, and a particular way of sharing it—be it through art, writing, music, sports, or something completely different. The point is that a voice doesn't need to be loud to be heard; it just needs the chance to speak.

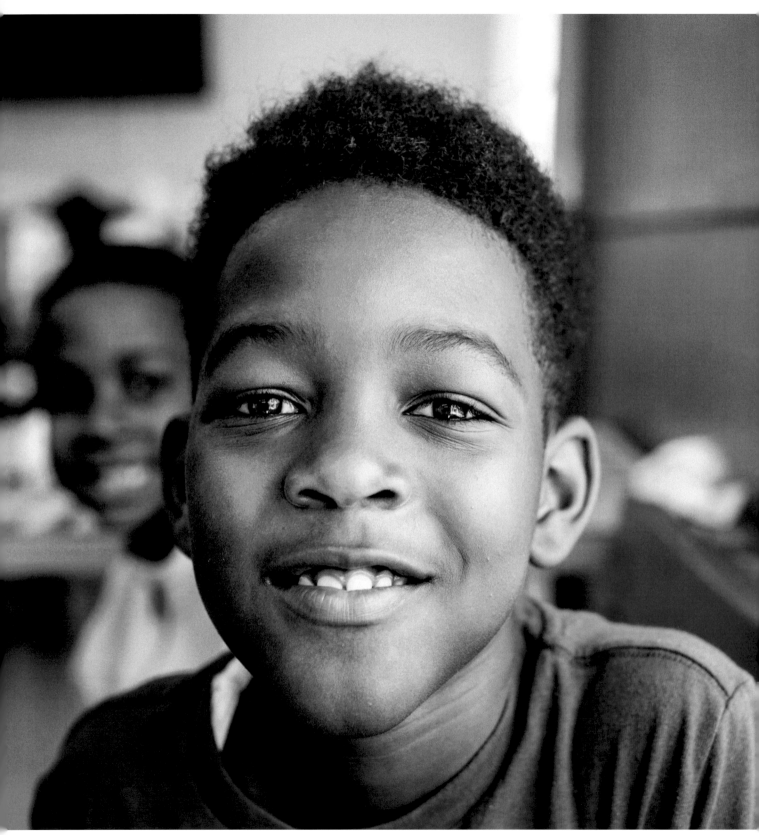

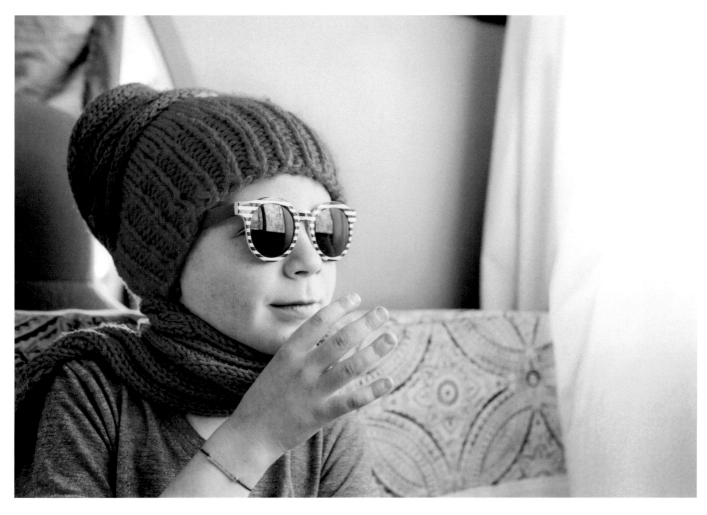

OISIN AGE 6

It would be nice if people who weren't deaf knew sign language like me, but I also like that I am different. Being different is fun. I do not want everyone to be the same. I am signing *Mom* in this picture.

RISHAWN AGE 8

I love to travel. I really want to go to Japan.

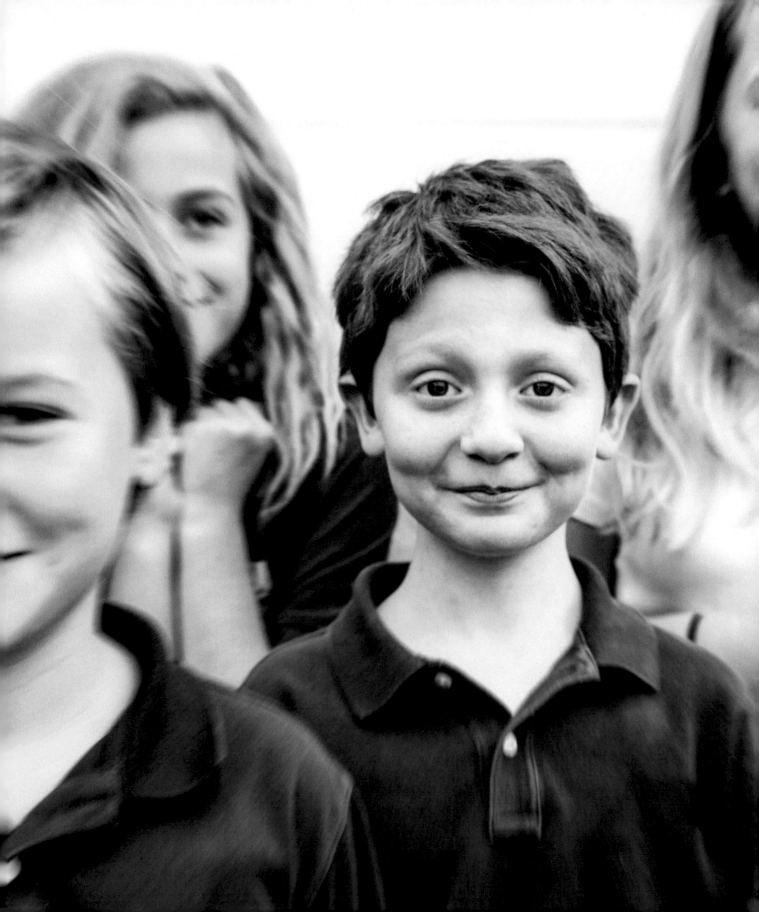

ELI AGE 10

It's not easy to stand up for yourself and others, but doing it is its own reward.

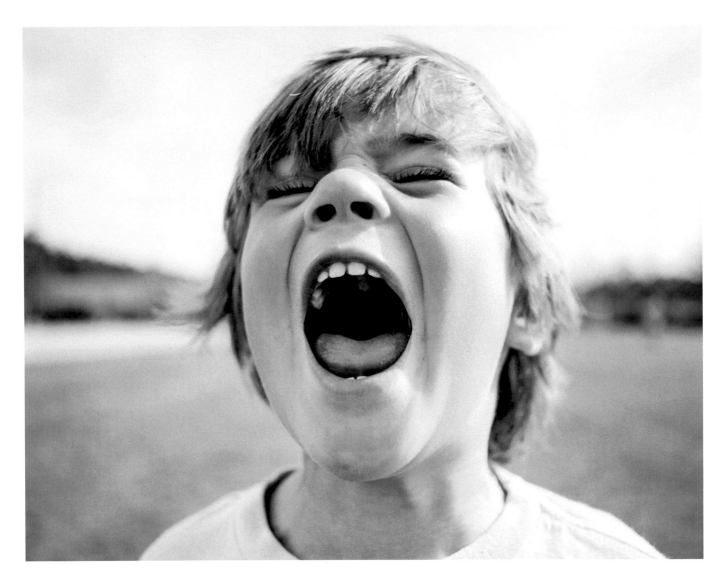

McRAE AGE 4

I am loud. I want to be heard.
When I am heard, I feel strong.

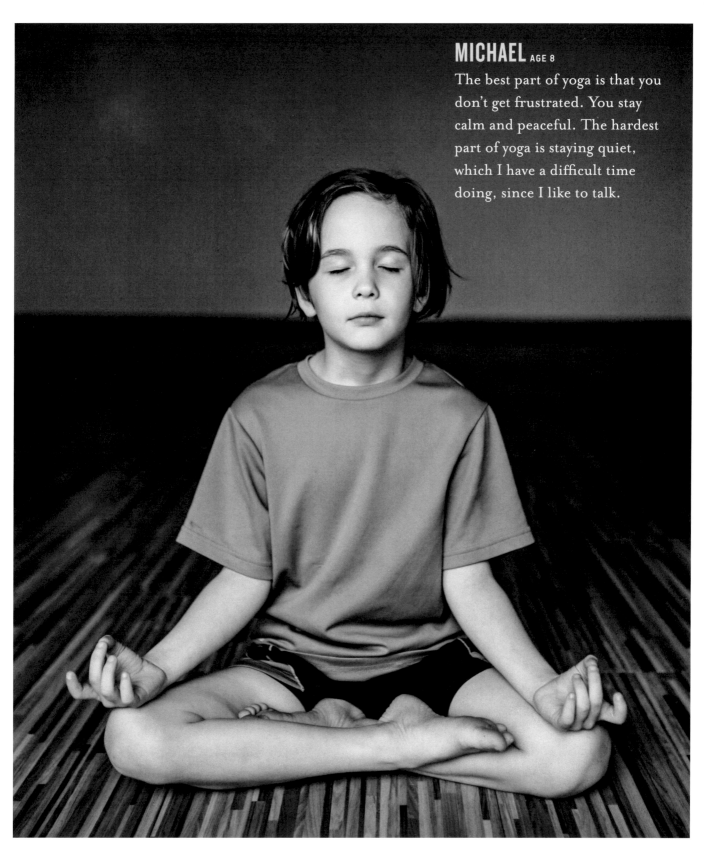

The best part of yoga is that you don't get frustrated. You stay calm and peaceful. The hardest part of yoga is staying quiet, which I have a difficult time doing, since I like to talk.

SPENCER AGE 4

What is ice cream's favorite day? *Sunday!*

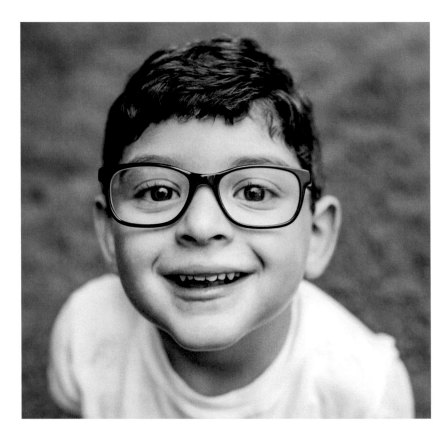

P.J. AGE 9

I had a "Marco Polo" accident in the pool. I'm okay, though.

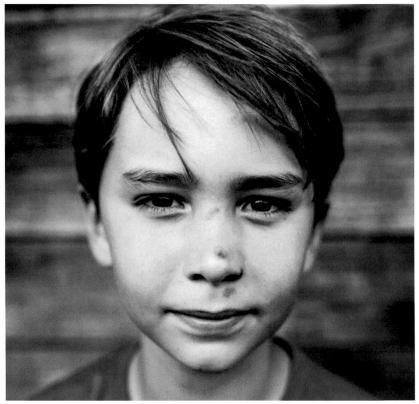

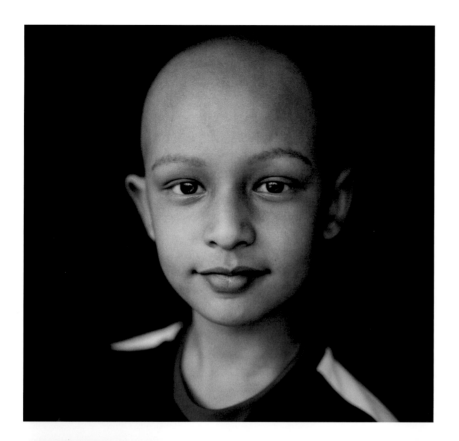

MAHIN AGE 7

I am very proud to be
a big brother to my
baby sister.

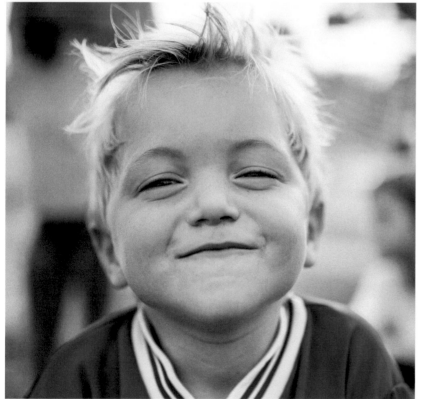

MASON AGE 6

I like to try new things.
I believe in myself.

MANUEL AGE 10

I like to sing, dance, and perform—
but mostly I love to see the joy in
my audience.

MILES B. AGE 9

Being a boy isn't really different
from being a girl, it's just being
yourself. Sometimes I am strong,
but sometimes I am not. Sometimes
I am tough, sometimes I am not.

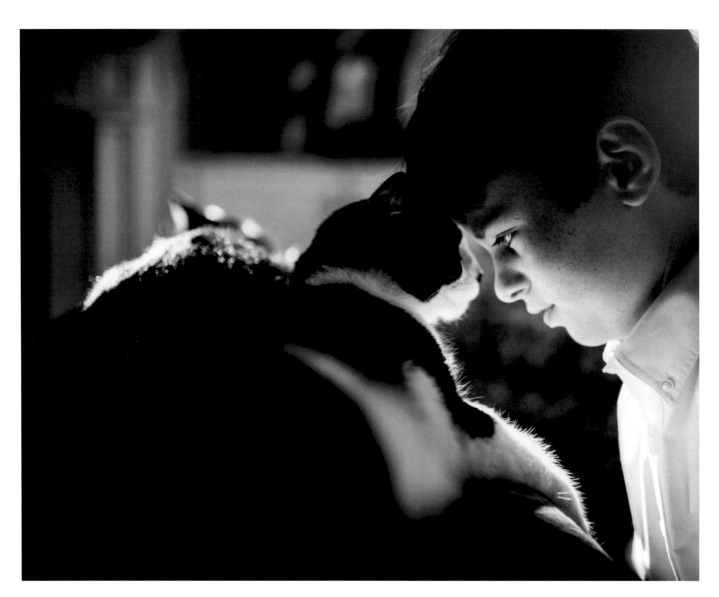

JOEL AGE 11

I love Rain because he's soft and cuddly and sleeps on my top bunk. He likes to give me "noggin" to show how much he loves me, too. Noggin is when we touch foreheads.

ATTICUS AGE 9

People say, "You look like a girl. Your hair is too long, your hair isn't normal, your hair doesn't look like boy hair. Why are you wearing pink leggings? Why do you wear tight clothes? Why do you wear so much jewelry?" But I like the way I am.

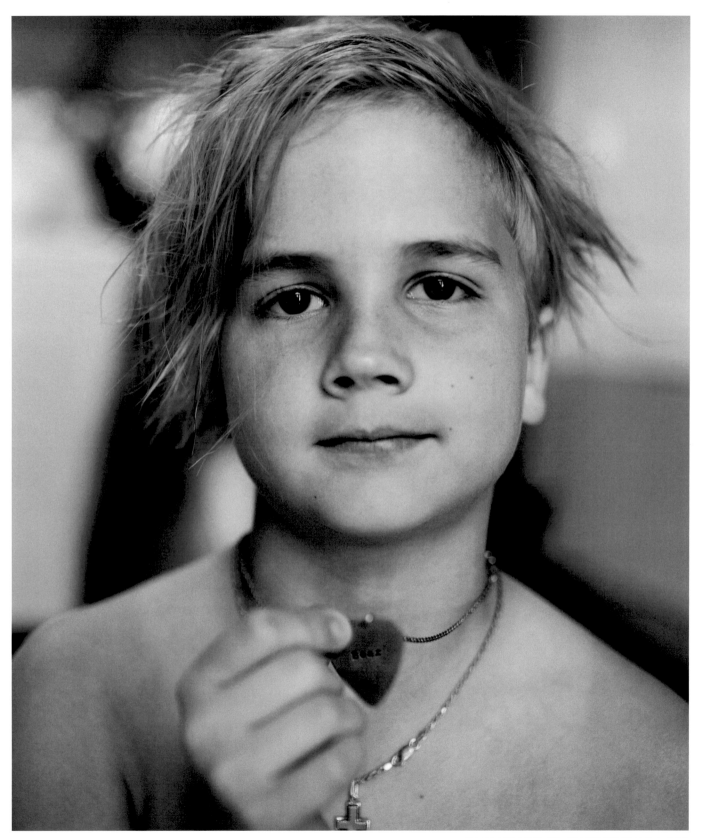

MILES H. AGE 9

Some people don't see my strength when they meet me, and they have to get to know me to find my strength. I'm not that tough and strong with my body, but I am strong in my mind. Chess helps me with my mind.

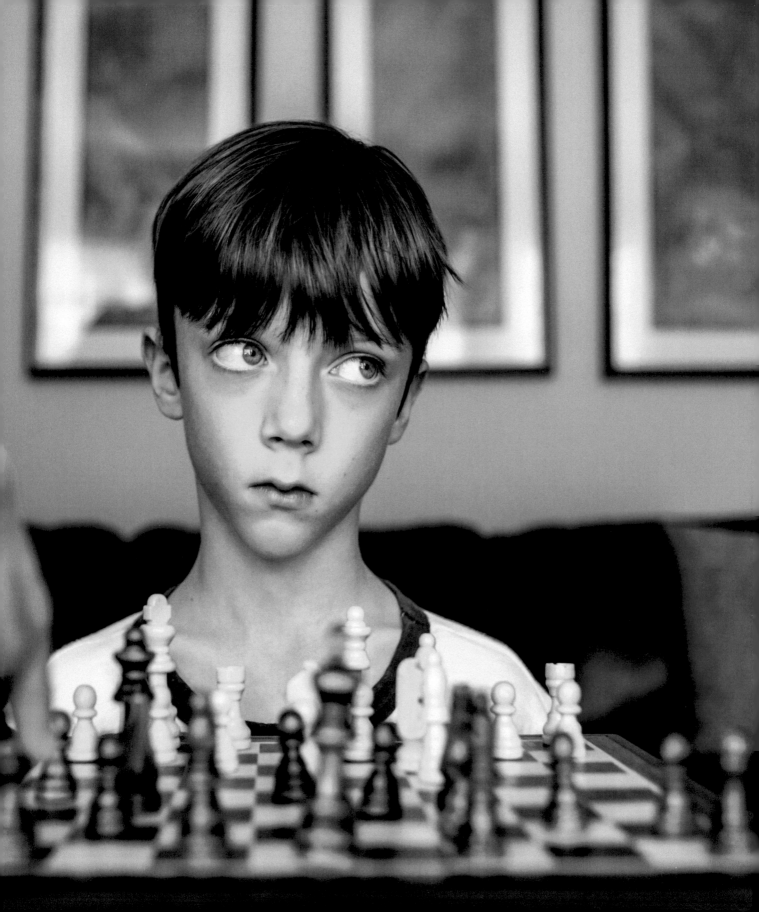

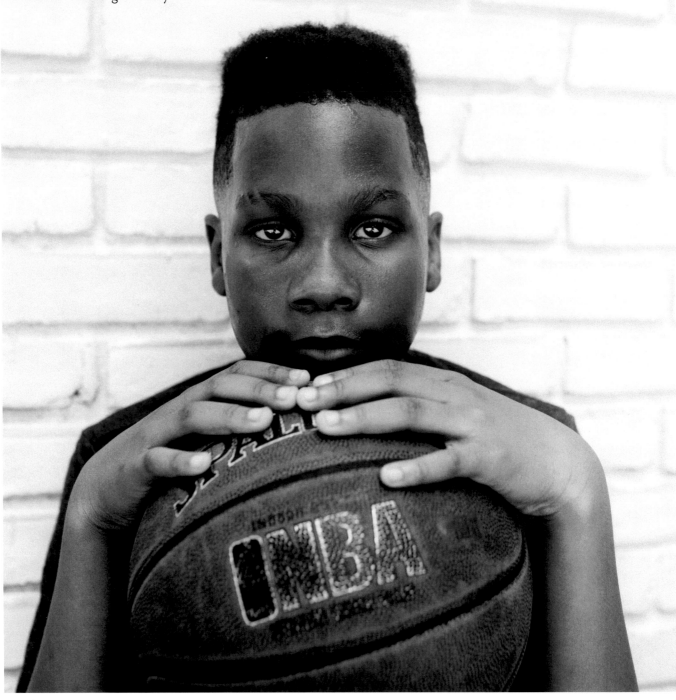

LARENZ AGE 11

Sickle cell doesn't stop me; it reminds me to go hard on the good days.

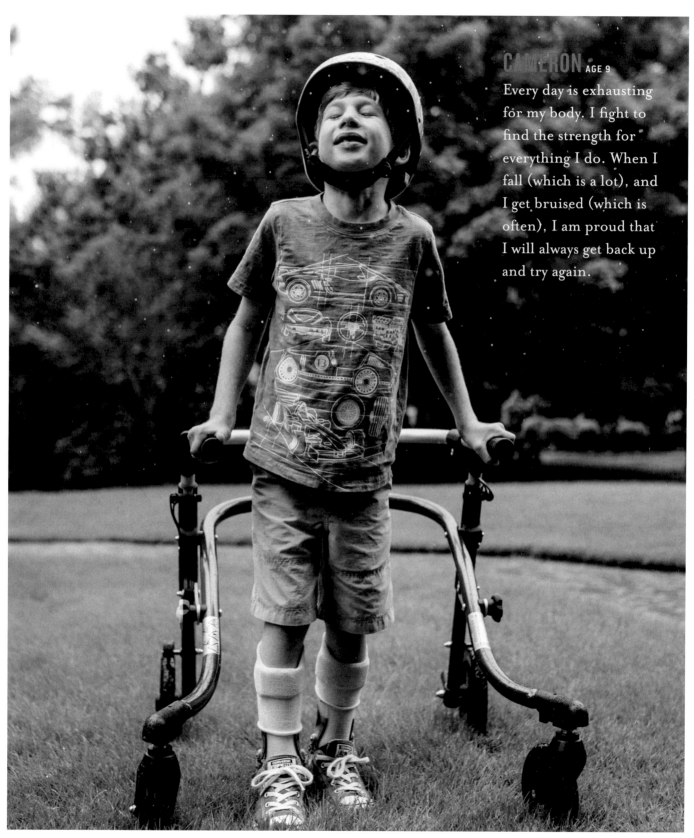

Every day is exhausting for my body. I fight to find the strength for everything I do. When I fall (which is a lot), and I get bruised (which is often), I am proud that I will always get back up and try again.

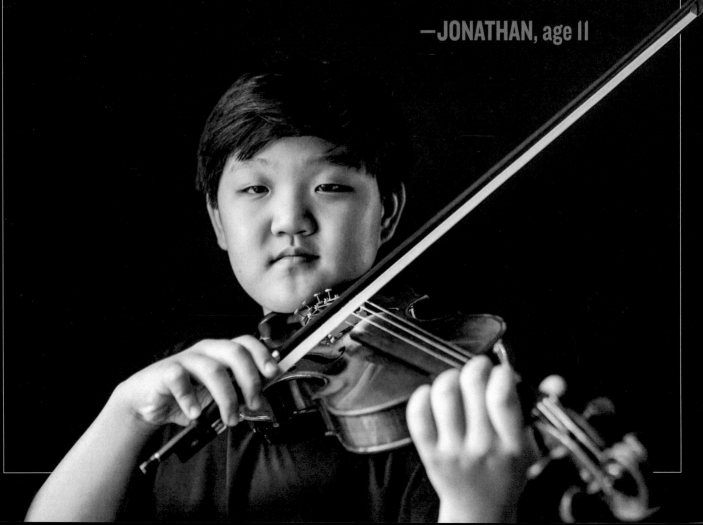

I LOVE PLAYING THE VIOLIN BECAUSE IT'S FUN TO MAKE BEAUTIFUL MUSIC.

—JONATHAN, age 11

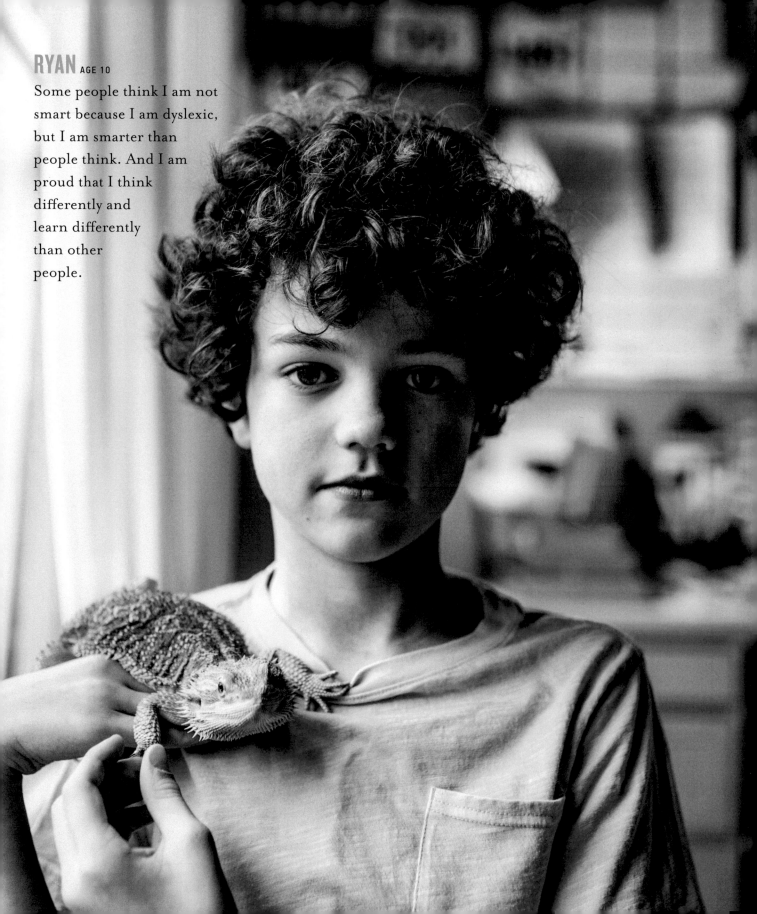

RYAN AGE 10

Some people think I am not smart because I am dyslexic, but I am smarter than people think. And I am proud that I think differently and learn differently than other people.

CHRIS AGE 15

Wrestling taught me perseverance in everything I do. That in order to move a wall, I have to push until I can push no longer. Only then, after giving everything I've got, will that wall move.

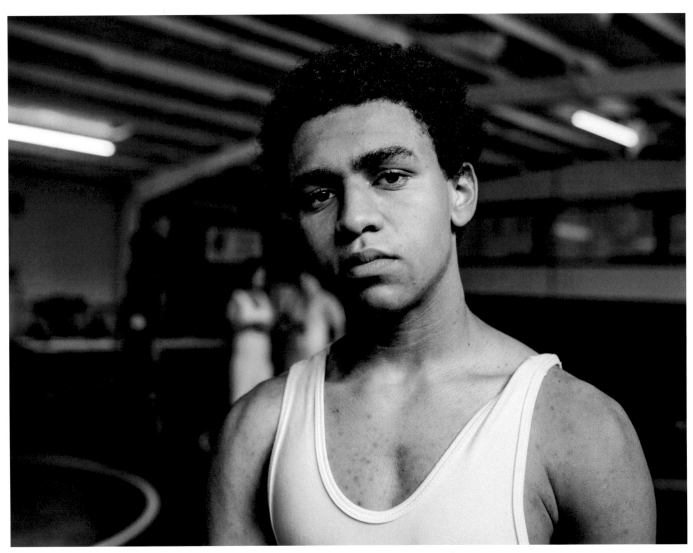

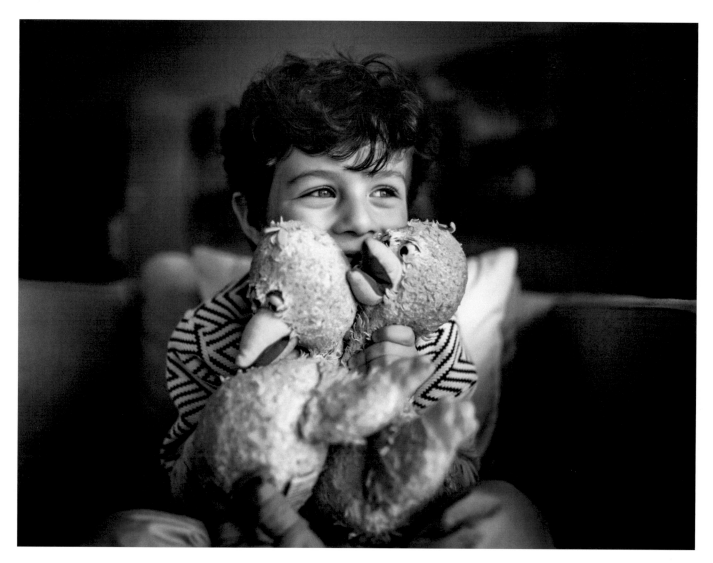

JAX AGE 4

I just want to be me! I want to
love, laugh, cry, scream, run,
and be free to be me.

GAVIN AGE 13

When I was in fifth grade, there was a group of kids who were able to make everyone laugh. I was never able to make anyone laugh, but I can do math really well.

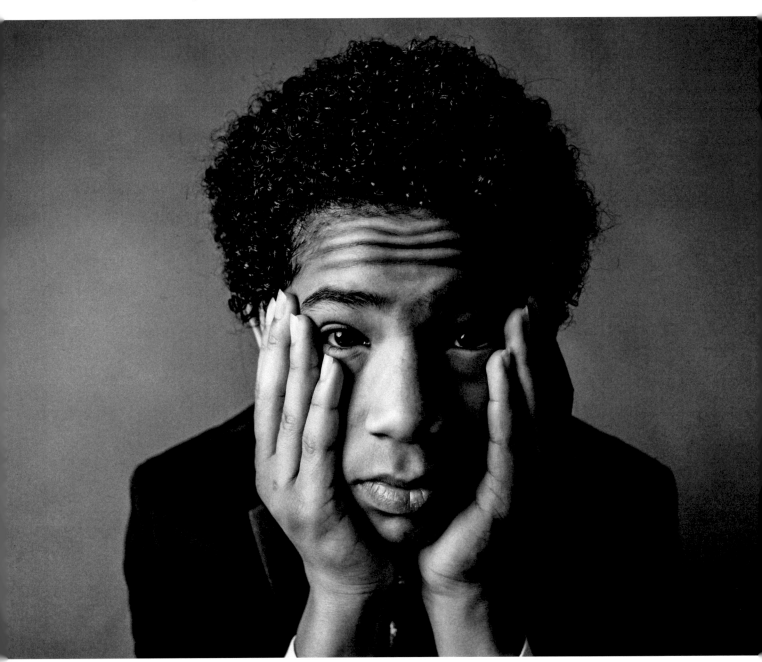

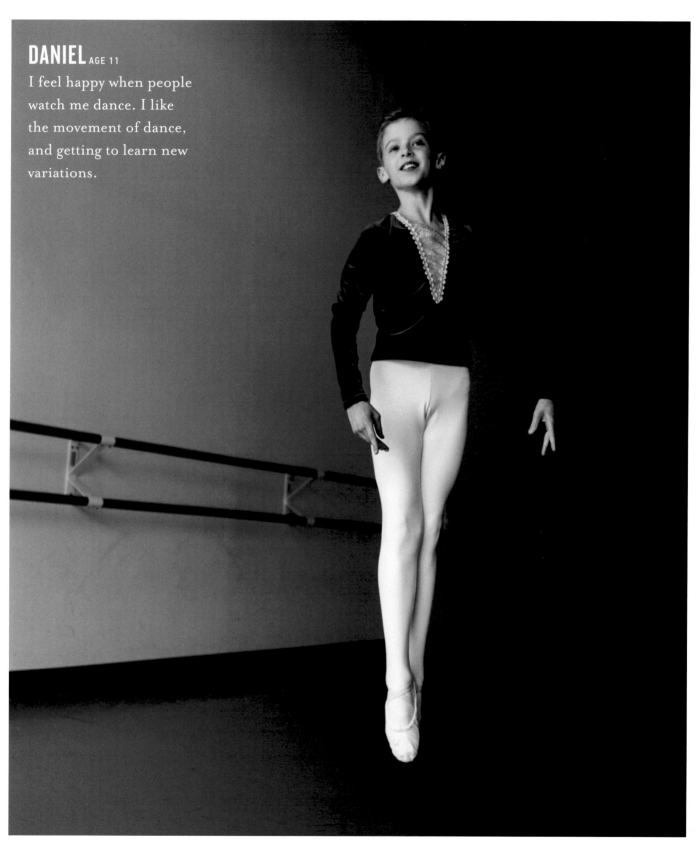

DANIEL AGE 11

I feel happy when people watch me dance. I like the movement of dance, and getting to learn new variations.

NATE AGE 10

Being strong means standing up for yourself and especially standing up for others.

MATTHEW AGE 16

I survived two open heart surgeries
and a traumatic brain injury after
a car accident that took my brother.
I am so thankful my family never
gave up on me.

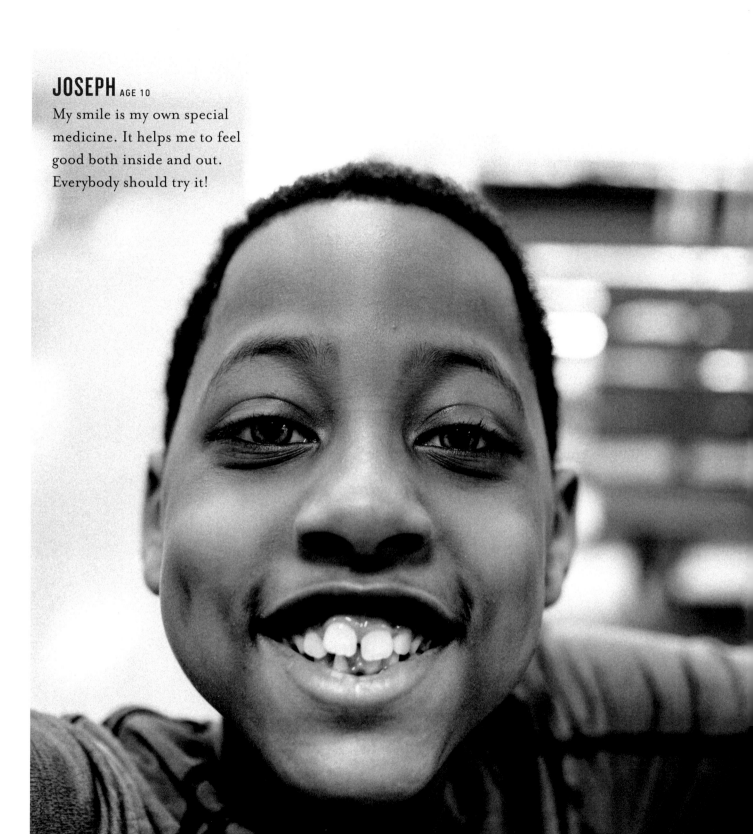

JOSEPH AGE 10

My smile is my own special medicine. It helps me to feel good both inside and out. Everybody should try it!

RYAN AGE 8

I love having brothers
because there is always
someone to play with.

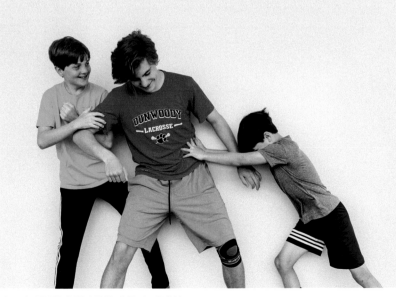

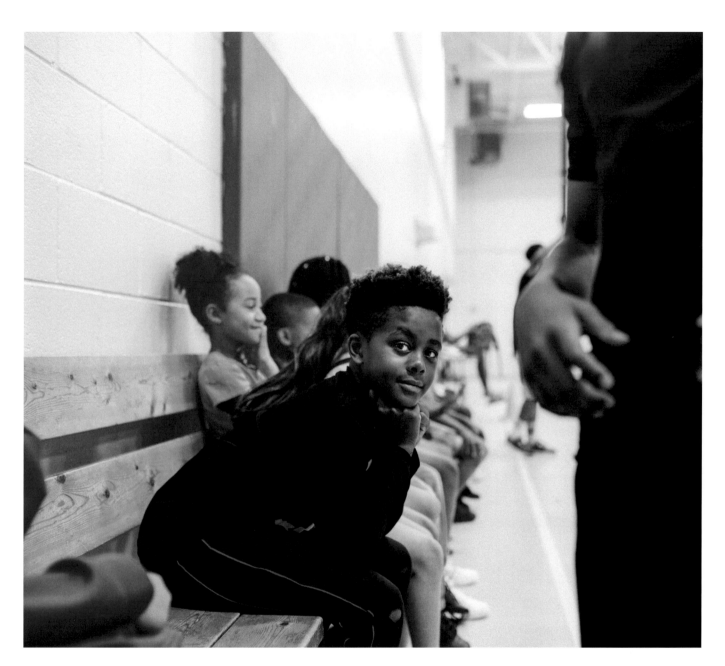

T.J. AGE 10

I love basketball so much.
I never give up and always
try to be a good sport and
as respectful as I can be
when I play.

"**DON'T WASTE YOUR ENERGY TRYING TO CHANGE OPINIONS. DO YOUR THING AND DON'T CARE IF THEY LIKE IT.**"

—TINA FEY

THE HEART IS
INDEPENDENT

What parent doesn't want a child to grow up to be independent? That's kind of our job: to prove to our kids, by always being there for them, that leaving us—for a few seconds, or minutes, or days—is safe. But figuring out your own path can be a struggle. Doing your own thing, being your own person, is hard. Ironically, by pushing our boys to "man up" and be self-sufficient before they are ready—or before they know at their core that we are their safe haven—we are making that task all the more difficult.

Not doing, or saying, or agreeing with, or acting like everyone else can make you stand out from the crowd. And sometimes, we don't want to stand out. We want to blend in. This is true for boys and girls (and adults!), which is why leading by example is so important. We must show our children that standing out because you're standing up—for yourself, for others—is never wrong.

When a boy is independent in body, or spirit, or mind, he believes in himself. He's strong enough, capable enough, smart enough, worthy enough to try new things, to be on his own. Look at Jake (page 174) and Alexander (page 171): They feel the pride that comes with paving your own way.

NASH AGE 4

I love my long hair. You know long
hair isn't only for girls.

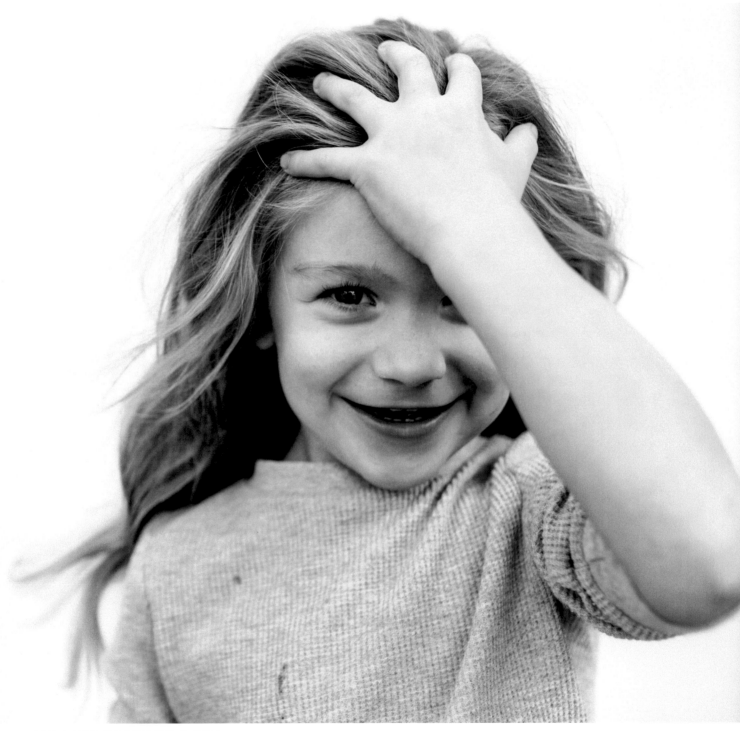

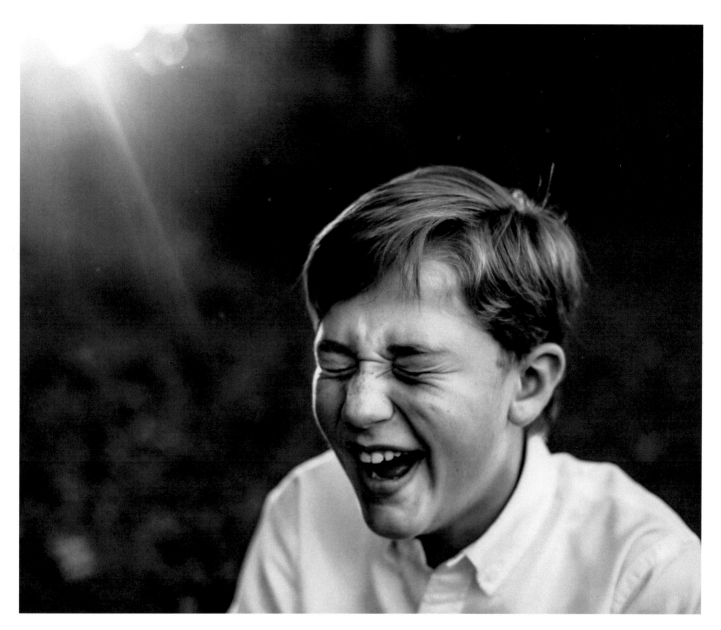

HENRY AGE 13

I laugh with my whole face and body.

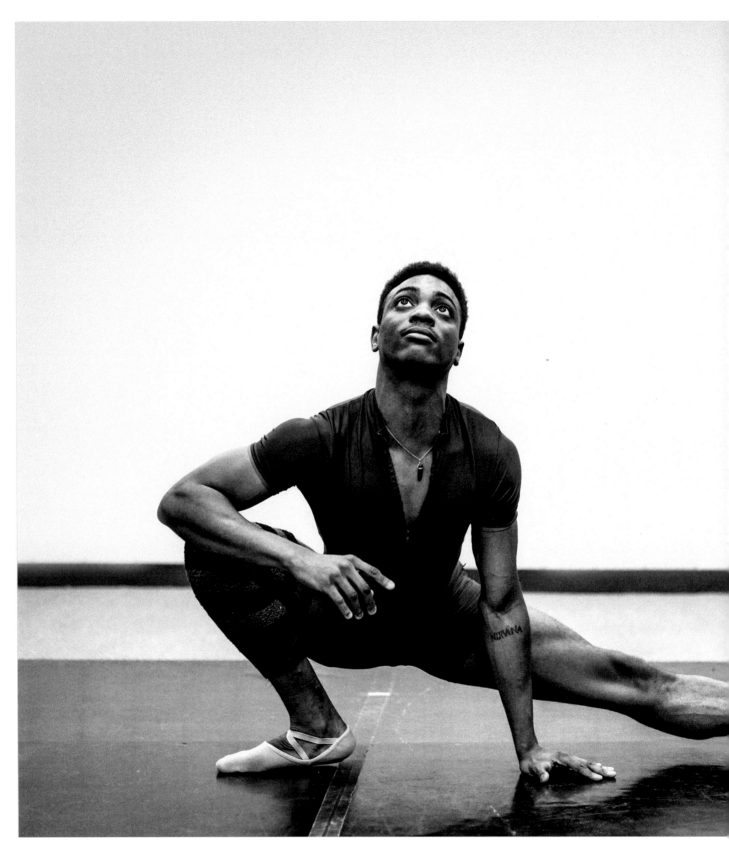

ALEXANDER A. AGE 18

Don't worry about what other people think. Hold your head up high and plunge forward.

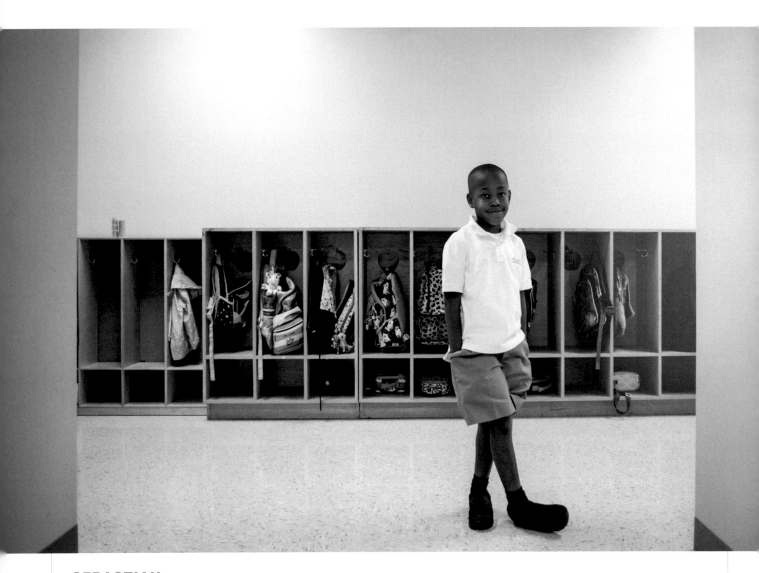

SEBASTIAN AGE 8

Being independent means
being responsible.

ROBERT AGE 10

You can be anything you can see in your mind. You just have to work hard and try.

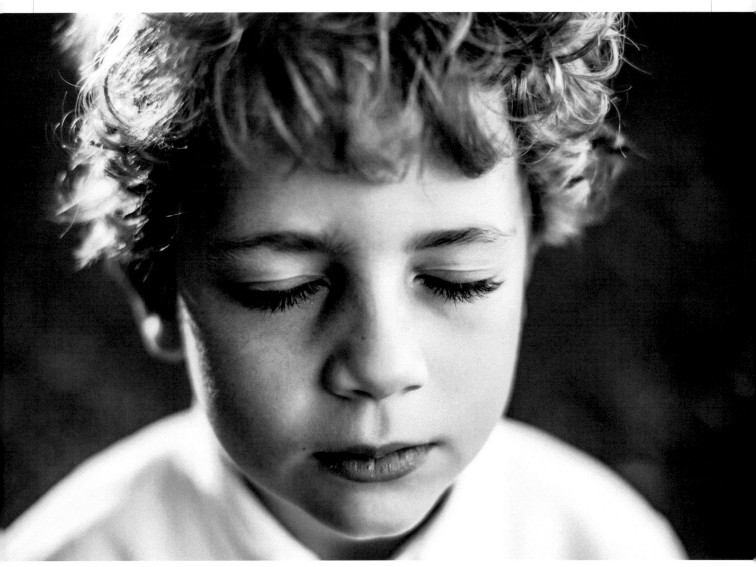

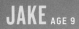

JAKE AGE 9

I make videos about Tourette
Syndrome. I use the stuff that I
learned from my perspective and
teach others about it.

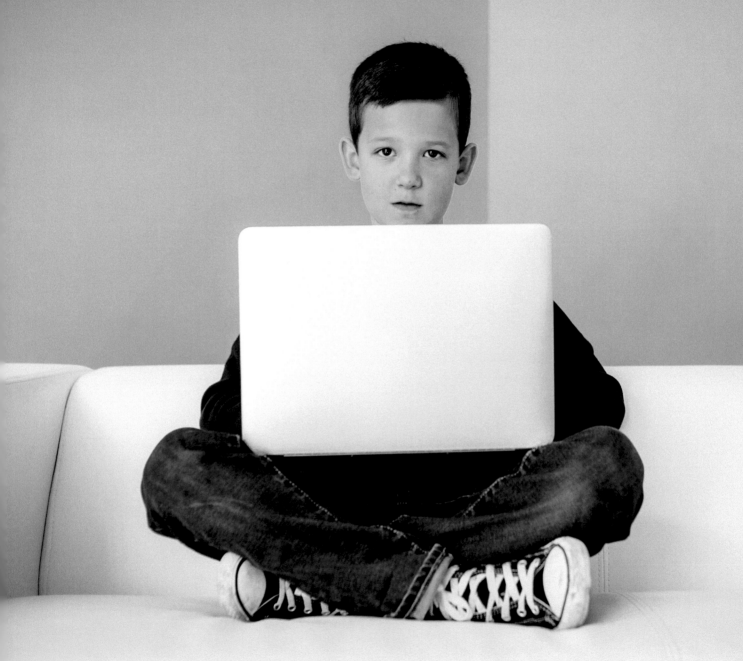

ELIJAH AGE 8

I was told I had a 20 percent chance to live, but I proved them all wrong. Cancer made me sick and put me in the hospital a lot, but it also made me a survivor.

JACKSON AGE 10

Be nice to everyone.

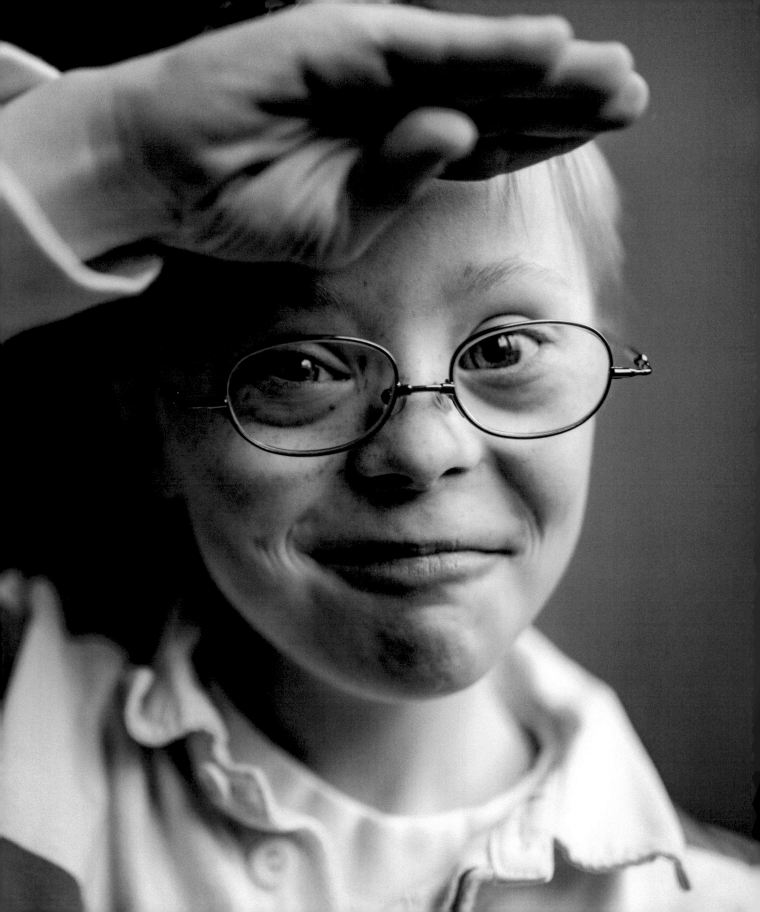

EDWARD AGE 14

My brother and I help each
other be better runners.

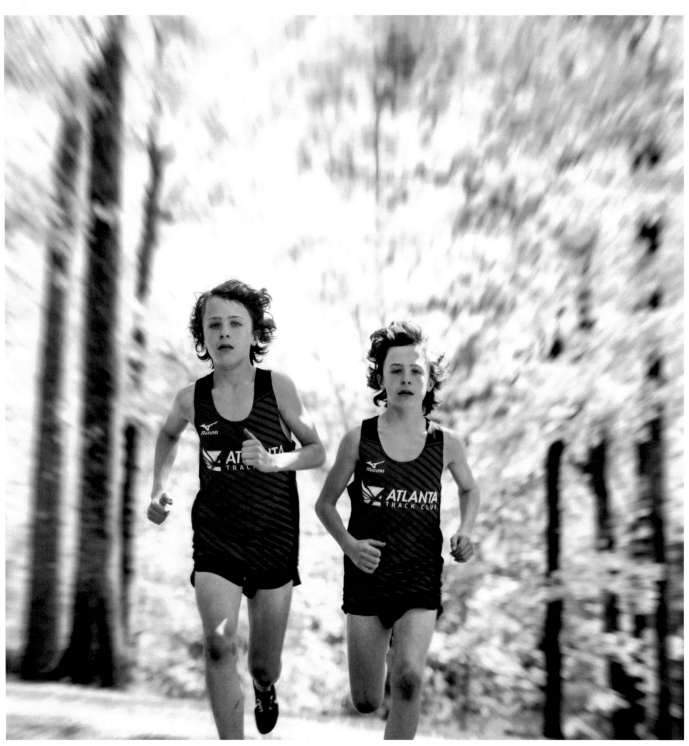

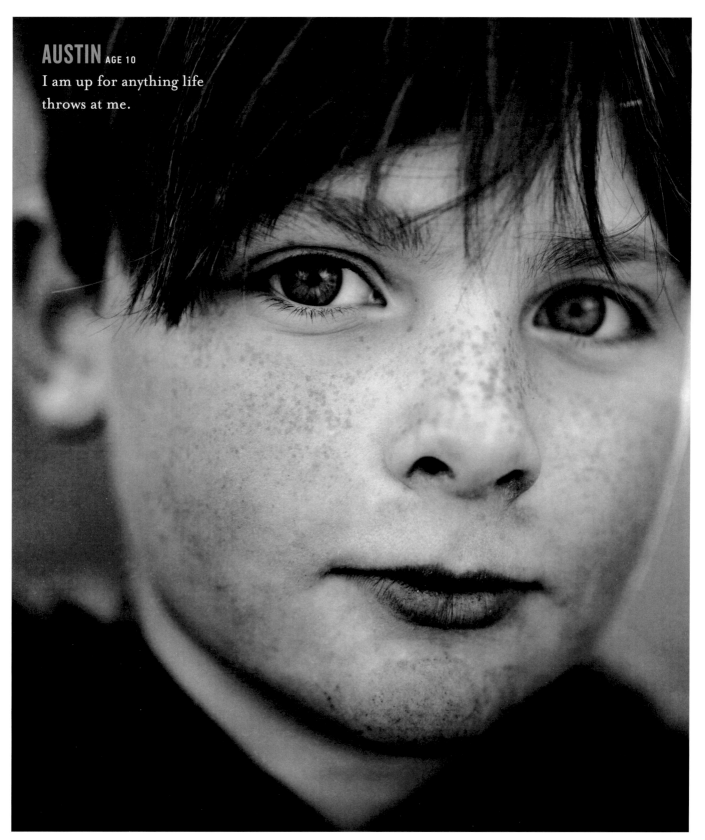

AUSTIN AGE 10

I am up for anything life throws at me.

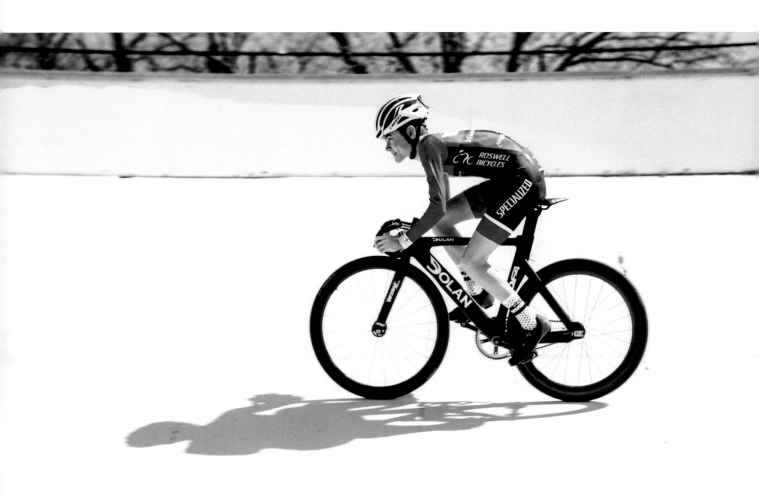

REECE AGE 15

There are two things I love about cycling. We're a pretty
tight-knit group because there aren't a ton of kids who
race bikes in the US. So I have friends from here to DC
to California to Washington. The other thing I love is
traveling. Cycling events are often in less populated areas,
which tend to be the most beautiful places.

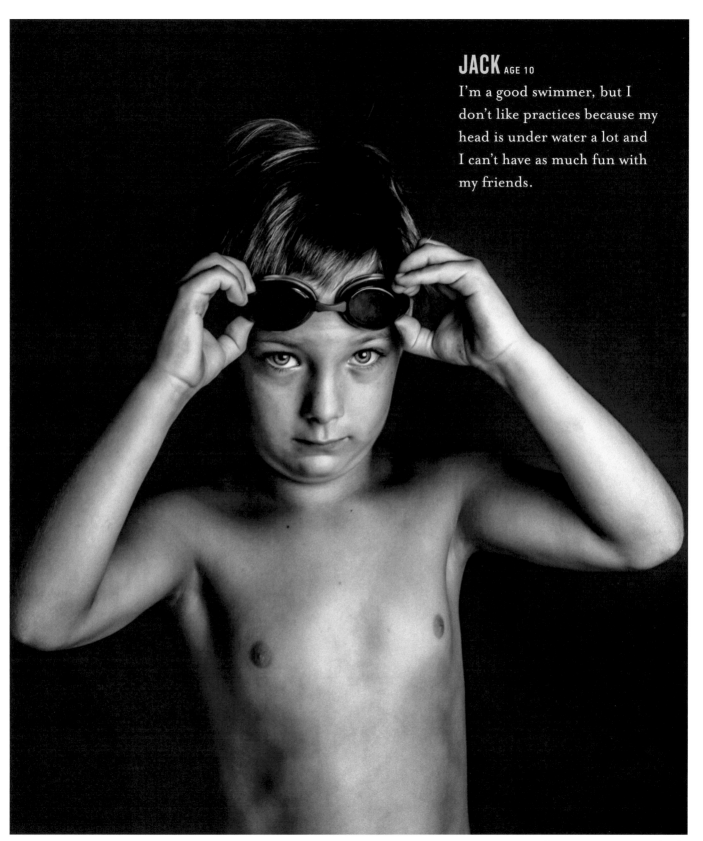

JACK AGE 10

I'm a good swimmer, but I don't like practices because my head is under water a lot and I can't have as much fun with my friends.

WHEN I WEAR MY KIPPAH, I FEEL REALLY CONNECTED.

—JOSH, AGE 9

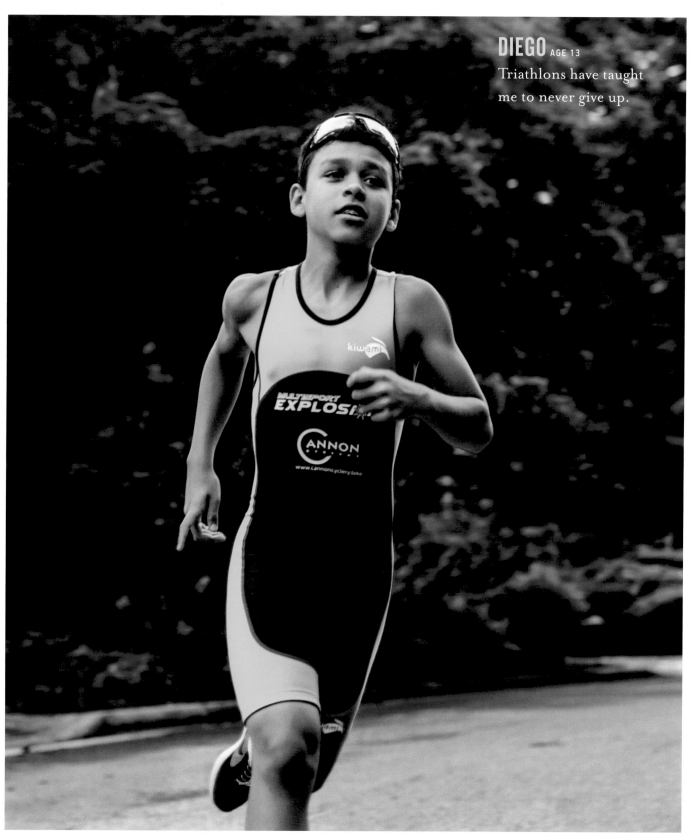

DIEGO AGE 13

Triathlons have taught
me to never give up.

SAM AGE 5

I have a feather. I am ready to fly.

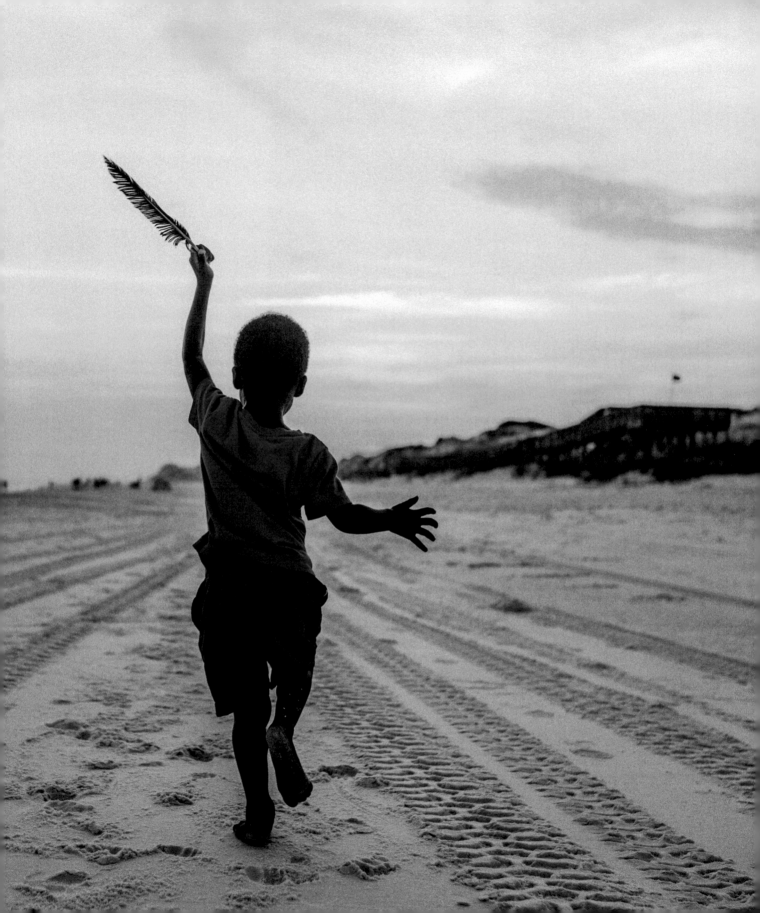

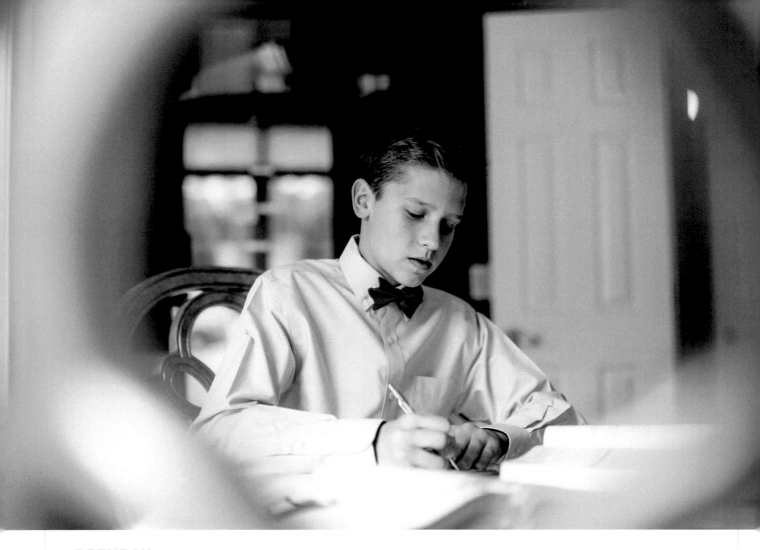

BRENDAN AGE 13

I call myself a "Super Nerd."
There's nothing wrong with
caring about school and
getting good grades. If they
try to label you, turn it into
a positive and *own* it!

BRAYDEN AGE 18

My life is full of possibilities.
I am a senior in high school,
and deciding what to do and
where to go next year is scary,
but exciting.

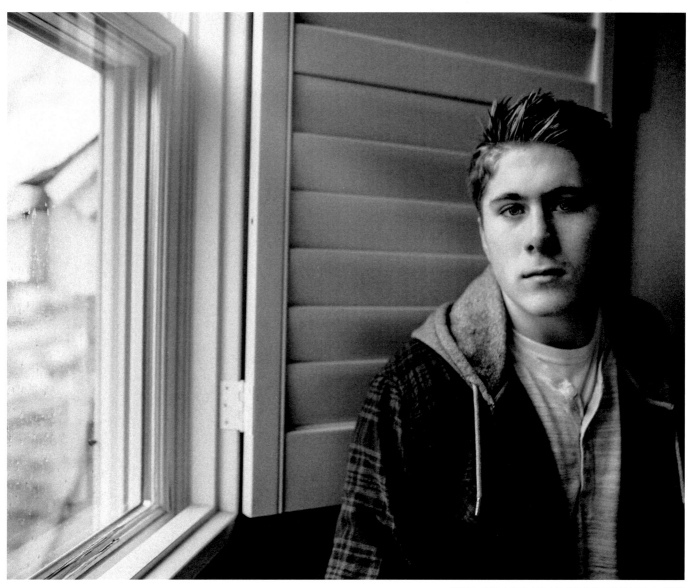

NATHAN AGE 12

Music makes me calm.

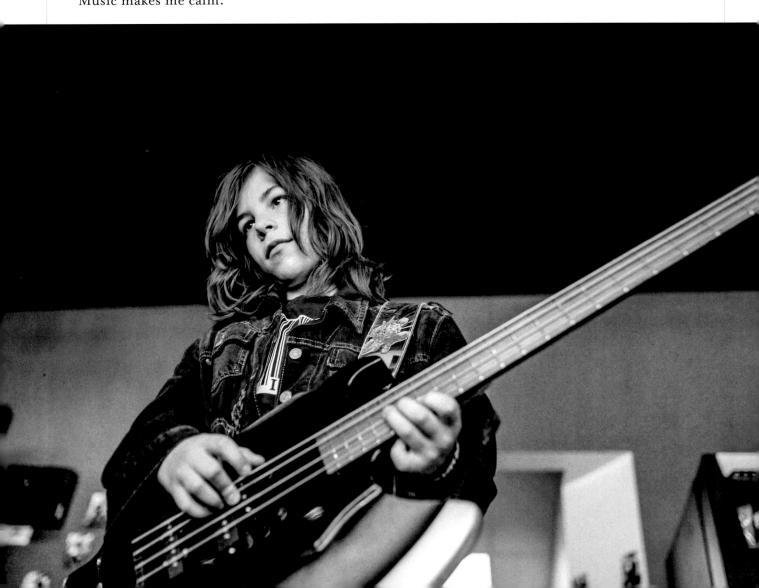

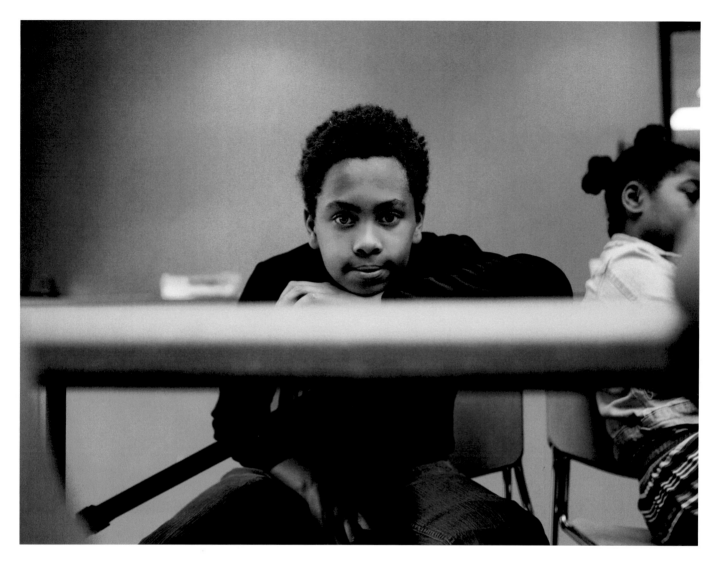

DYLAN AGE 10

I find myself super scared when trying new things, like rock climbing or riding roller coasters. But I found out that if you can get over the fear and do them, they become awesome experiences.

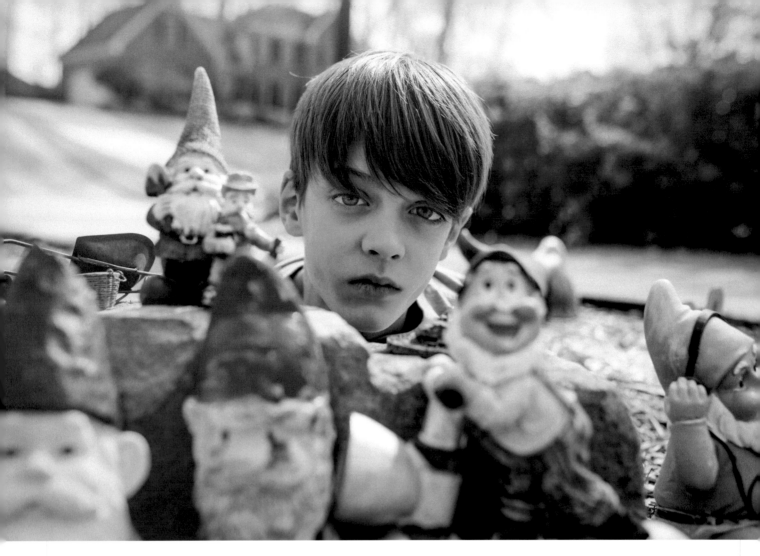

FELIX AGE 8

I collect lawn gnomes.
I don't know any other
kids who do that.

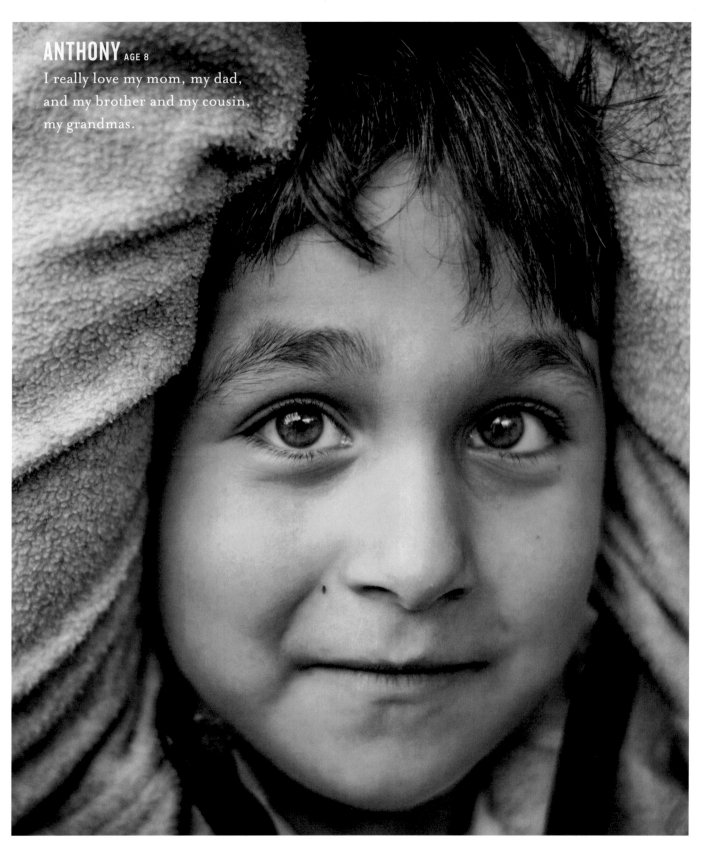

ANTHONY AGE 8

I really love my mom, my dad,
and my brother and my cousin,
my grandmas.

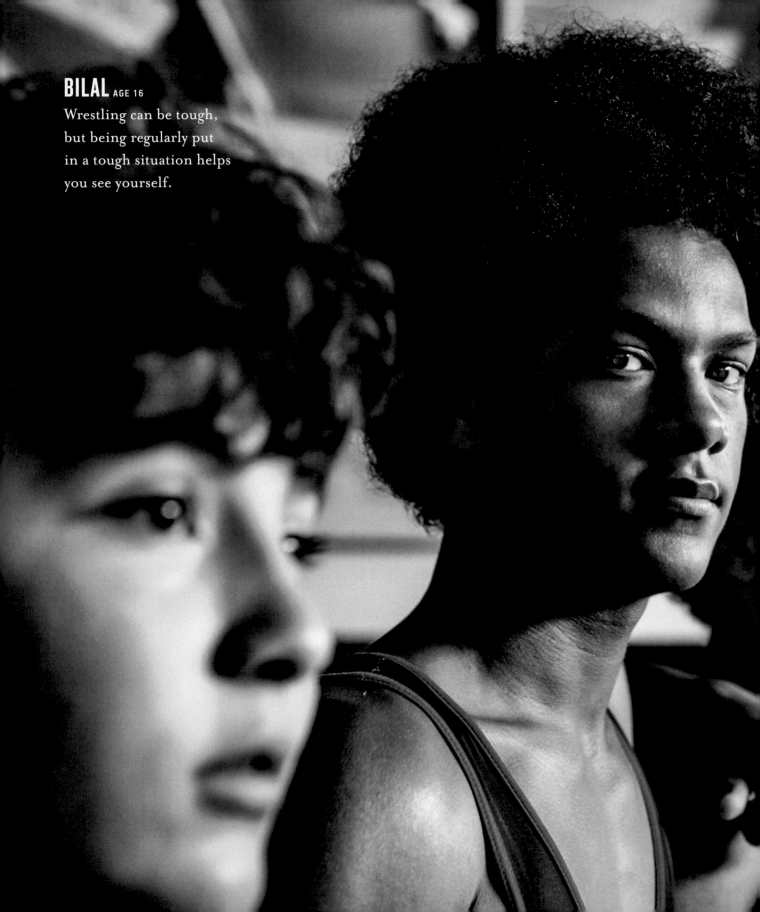

BILAL AGE 16

Wrestling can be tough, but being regularly put in a tough situation helps you see yourself.

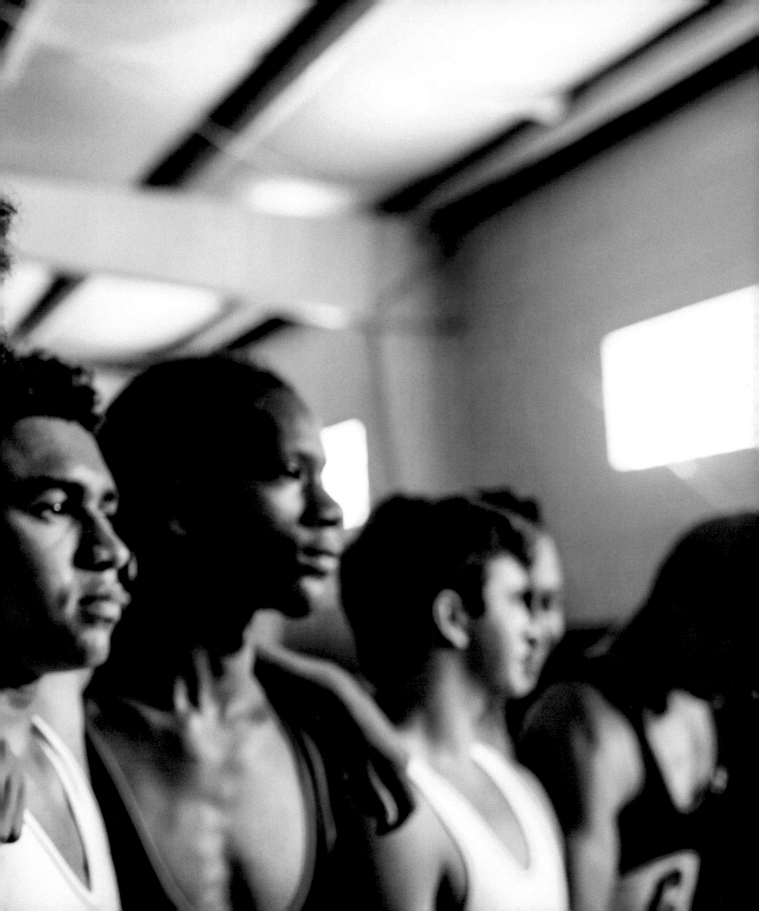

"LOOK UP
AT THE STARS
AND NOT
DOWN
AT YOUR FEET."

—STEPHEN HAWKING

THE HEART IS
CURIOUS

Asking questions is how we learn. How we grow. And kids are naturally curious—it's just how they're made. But as they grow, they tend to lose that sense of wonder with the world. And boys, especially, as they may become expected to have all the answers, can eventually stop questioning *why* and *how*. So how do we continue to foster an environment that allows them to keep asking questions?

We and they need to remember to look for the magic. Look up at the night sky and imagine how far it goes; look down at the earth beneath your feet or at the horizon line where the ocean disappears and imagine all that's in motion beyond your gaze. As adults, we sometimes close our eyes to the wonder of the world, but if we can manage to hold on to a sense of awe, like P.J. (page 211), or recall a time in our life when an activity like painting allowed us to escape to a space that had no rules, like Smith (page 215), we'll be in a better place to guide our children.

Don't stifle the questions (even as the insistent *but why*? repeats like a skipping record). Don't forget to ask questions right back. Engage with your boys openly and honestly. Keep the conversation going. Don't forget to listen to the answers. Keep your mind open. Don't judge. Look around you. Breathe in the moment. Listen for more questions. Value them. Then seek the answers together.

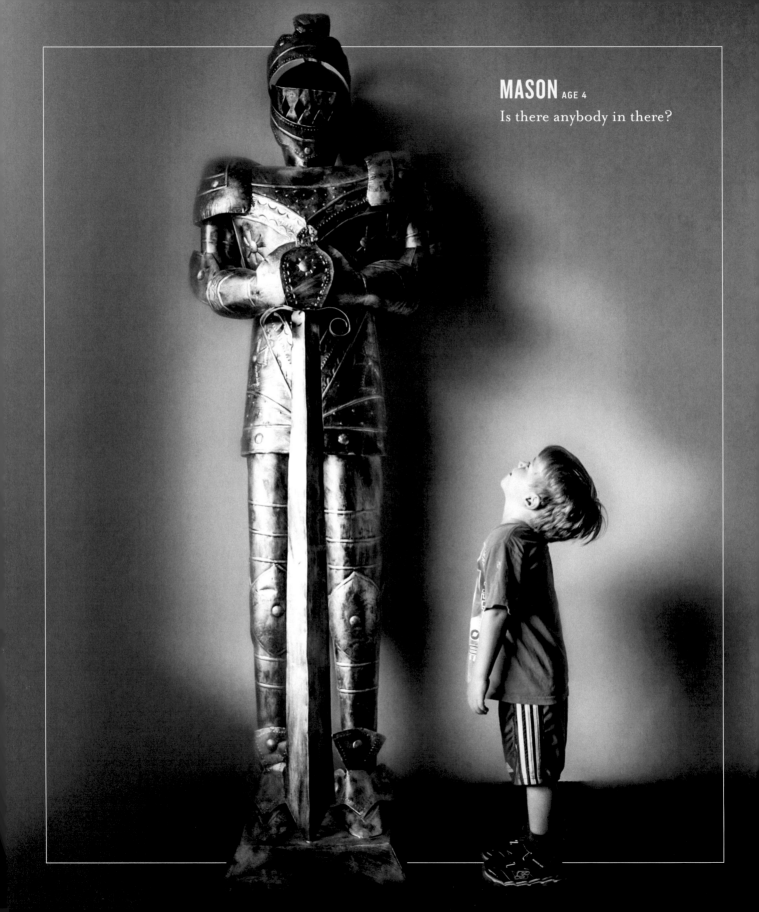

MASON AGE 4

Is there anybody in there?

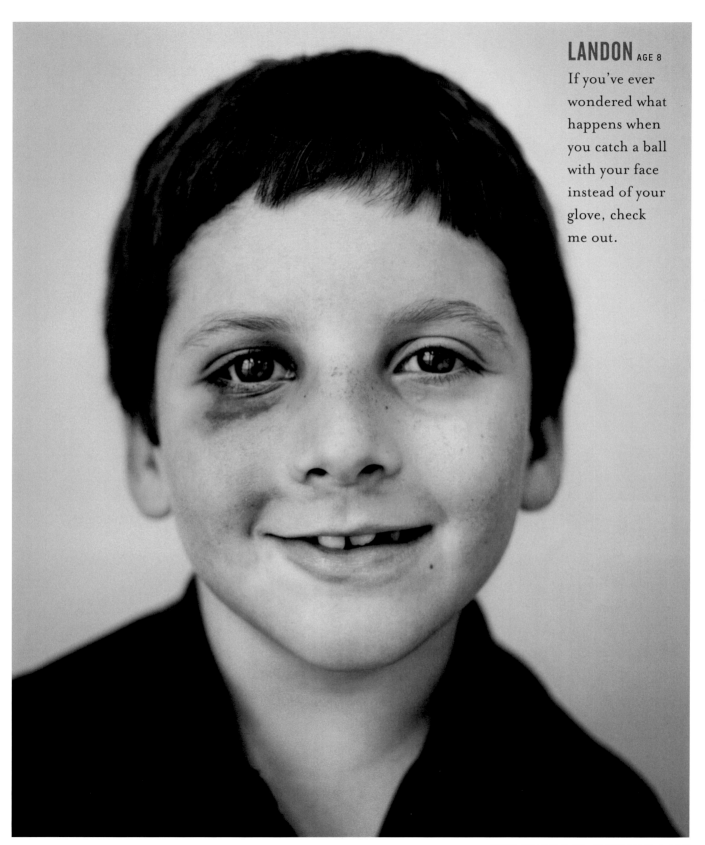

LANDON AGE 8

If you've ever wondered what happens when you catch a ball with your face instead of your glove, check me out.

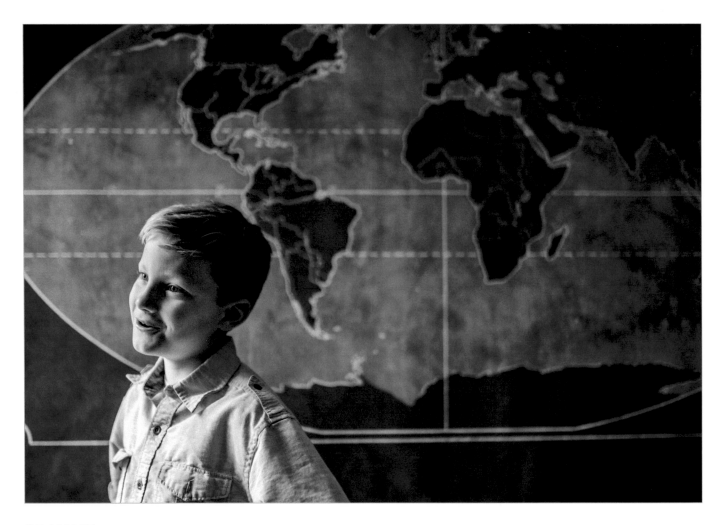

GRAHAM AGE 9

Once, one of my friends got picked on at
my school. He was getting teased by the
fourth graders because he wasn't as fast as
some other kids. I went over to them and
said, "Guys, just leave him alone, he's a
normal kid like you." And the fourth
graders just walked away.

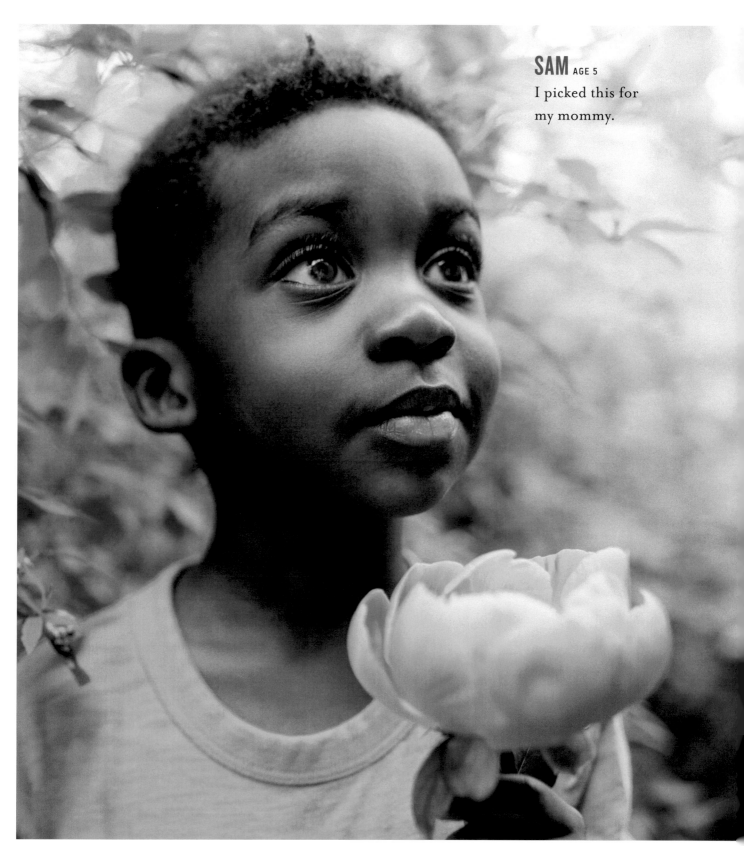

SAM AGE 5

I picked this for
my mommy.

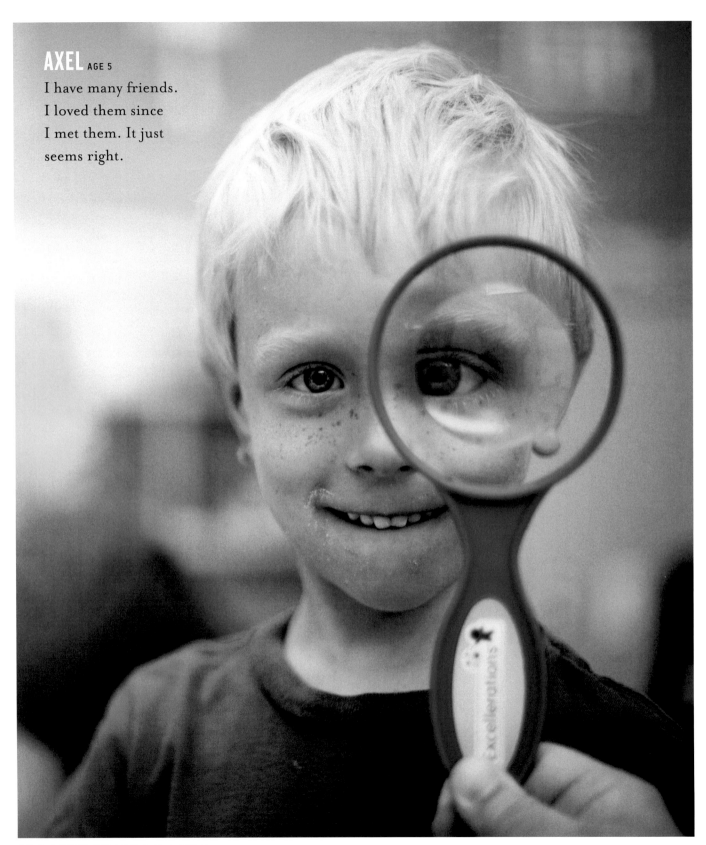

AXEL AGE 5

I have many friends.
I loved them since
I met them. It just
seems right.

DeANGELO AGE 8

I worry about things changing. I wonder if there will be different staff at the Boys and Girls Club, and if so, will the staff be nice, will the kids like me, will the kids be nice? I also don't like cussing, and when I become president, I will ban it.

OJORE AGE 5

The hardest part of swimming is trying
not to count to four. I am only supposed
to count to three and then breathe.

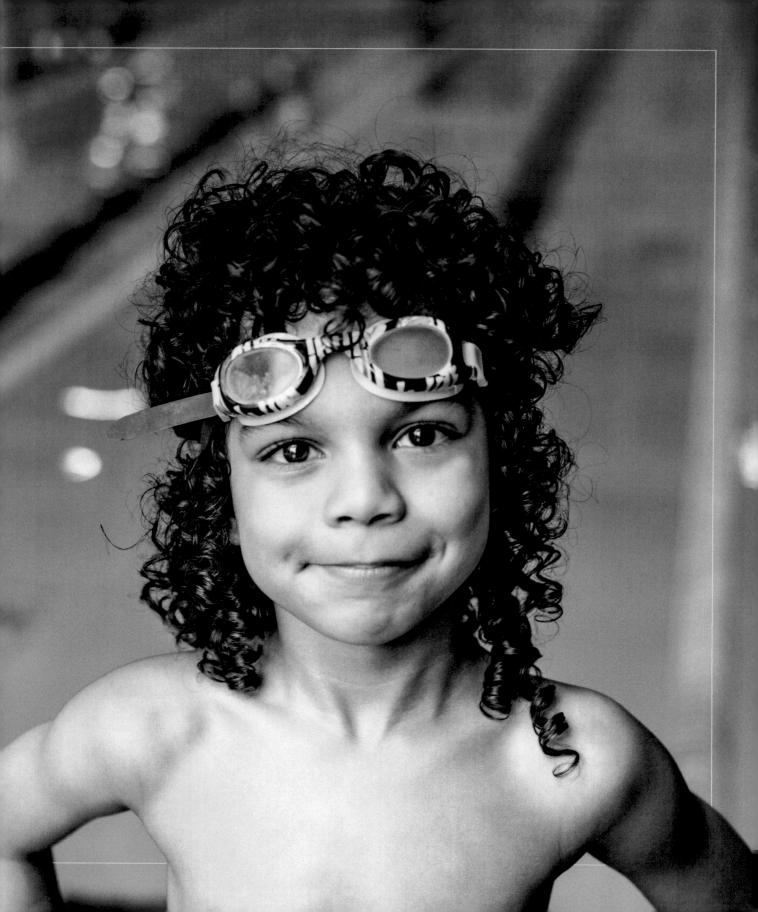

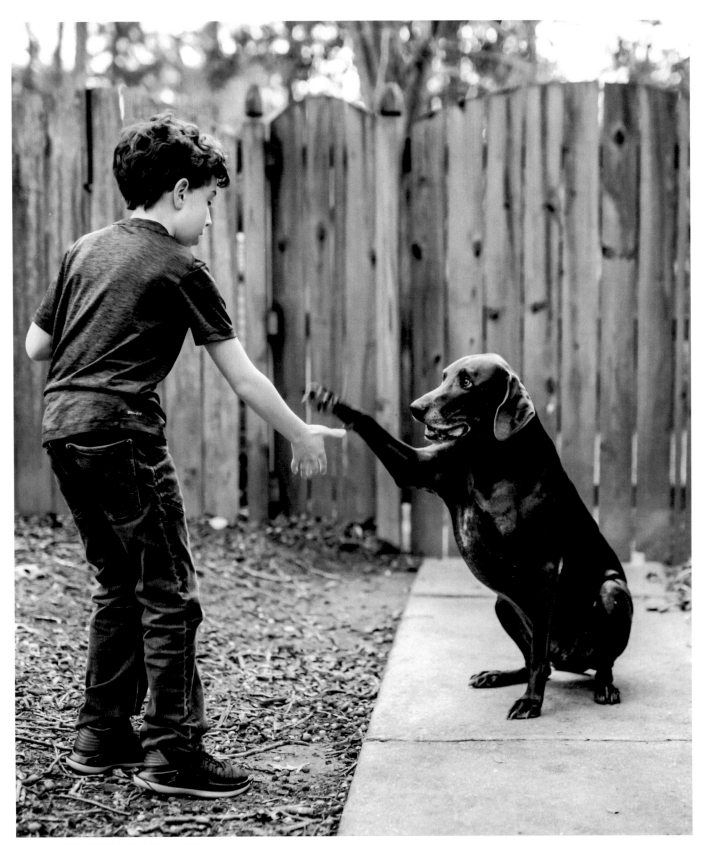

PARKER AGE 11

I thought getting him to shake
would never work, when in reality,
it just took a lot of practice.

HERTFORD AGE 5

I wish I could know more jokes
because making people laugh
makes me feel really happy.

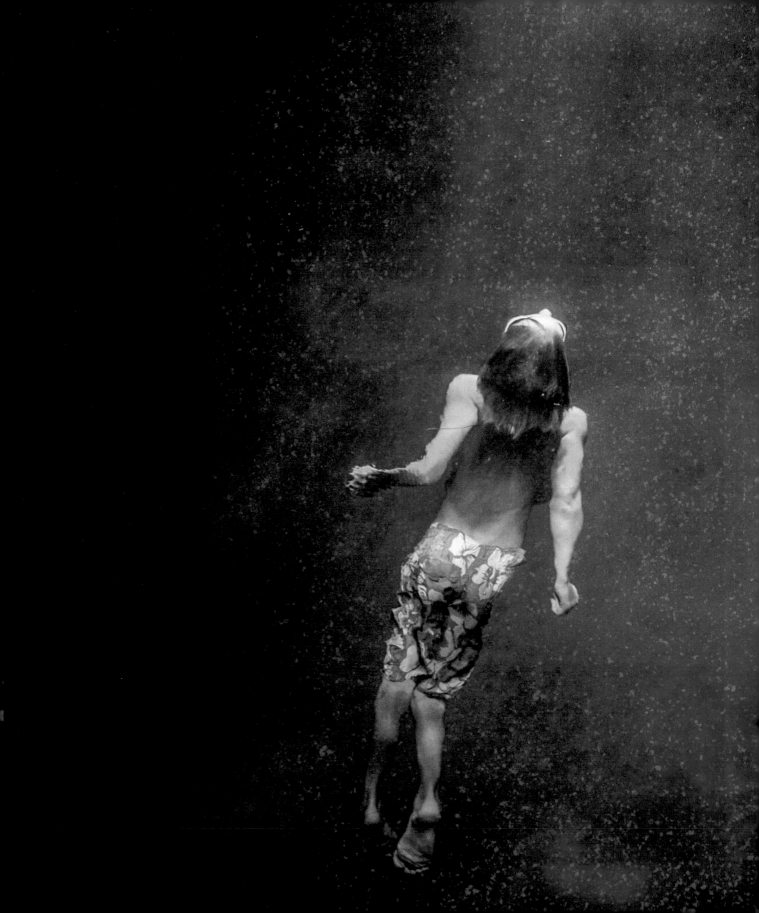

CADE AGE 11

I love swimming and
feeling free in the water.

I'M GROWING FAST. I'M GROWING LIKE A RACE CAR ON A HIGHWAY.

—CHARLES, AGE 7

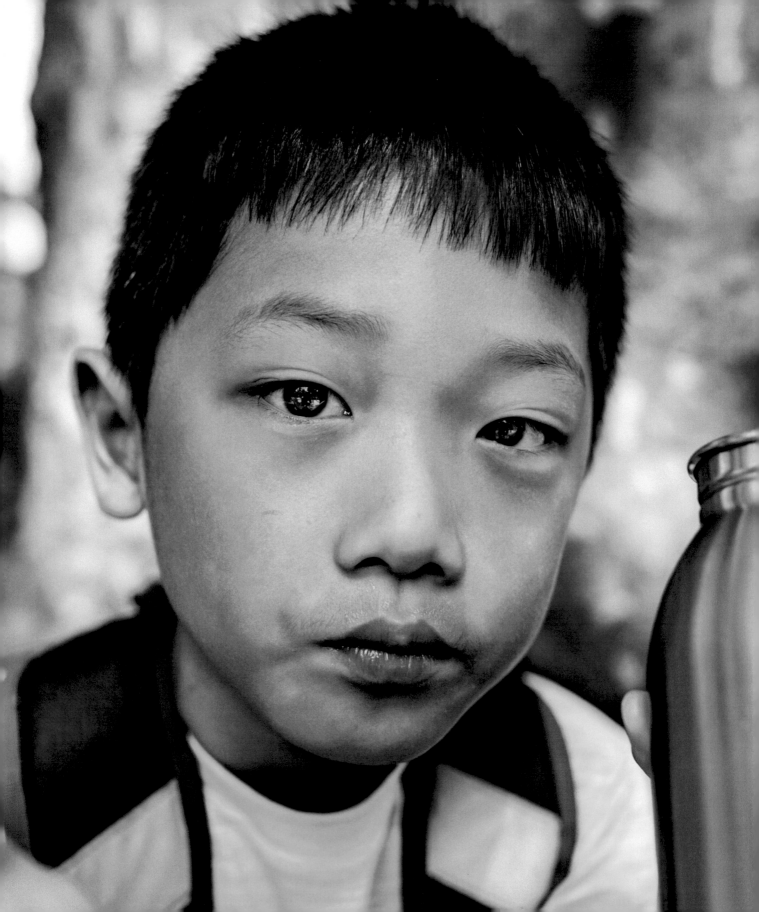

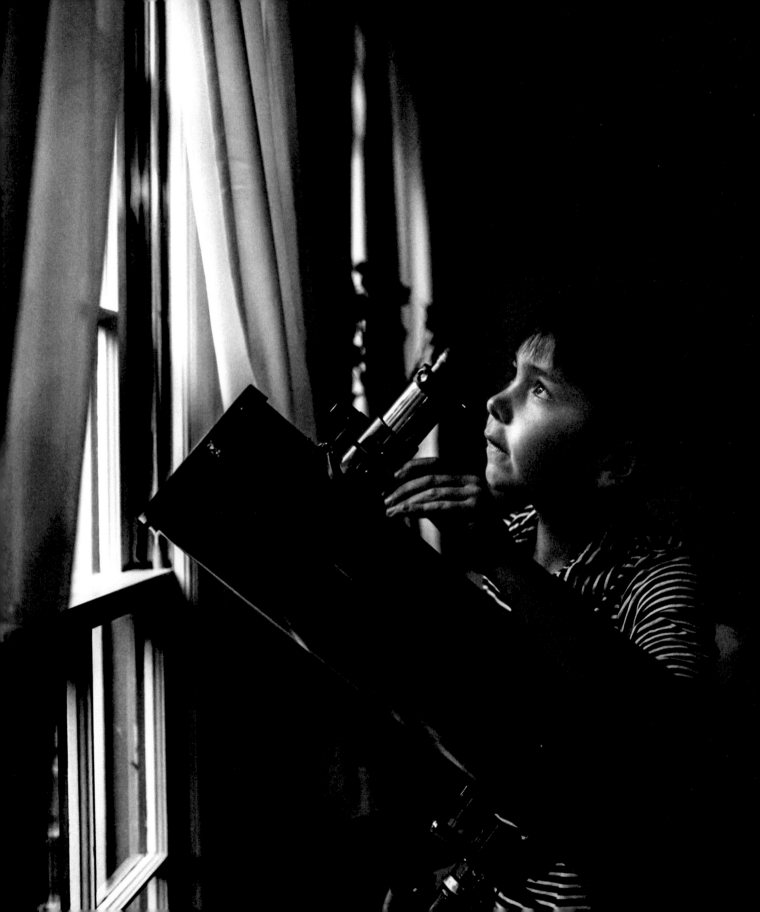

P.J. AGE 9

Space gives us something to dream about.
I love the adventure of space exploration
and thinking of new technologies for rocket
propulsion. It upset me that people lost
interest in space for a while.

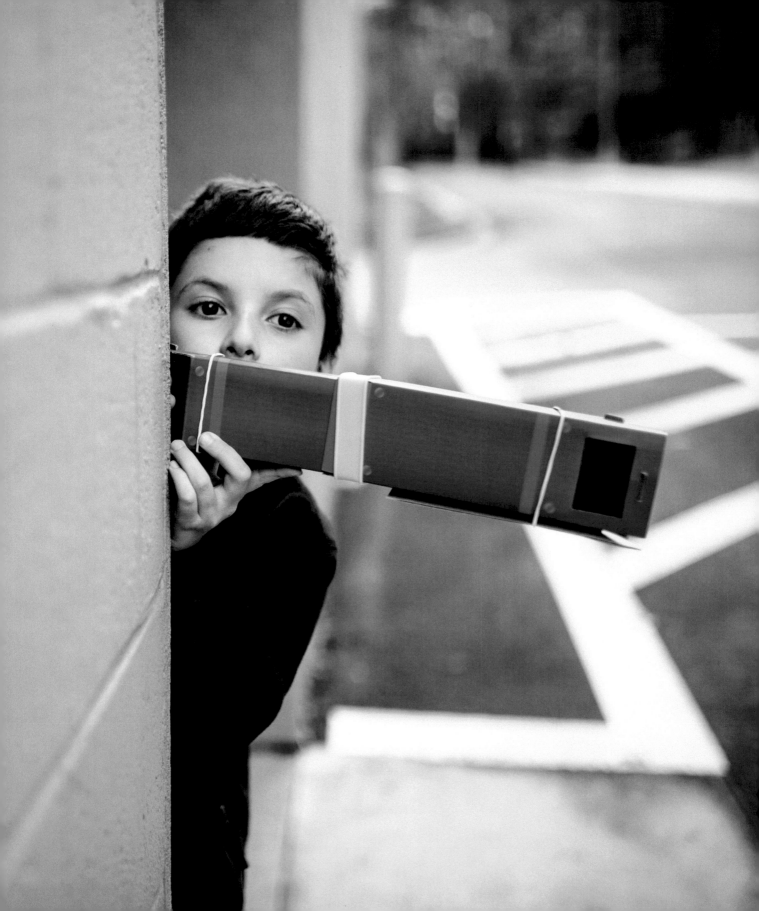

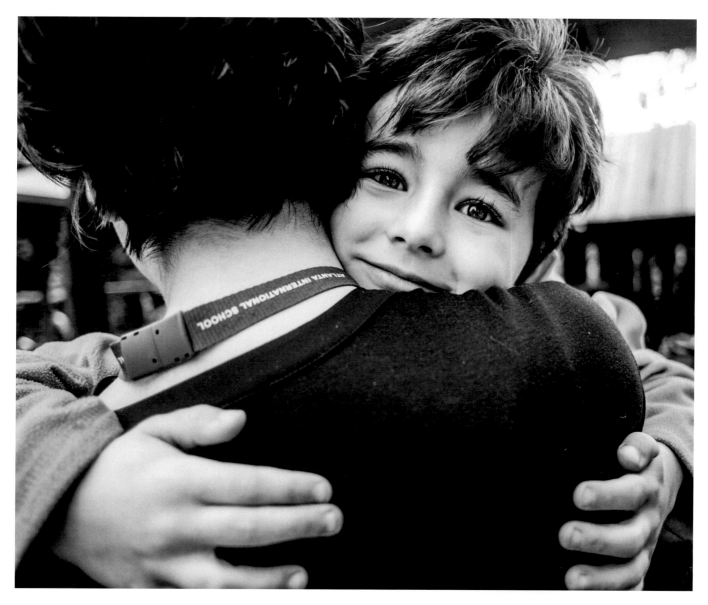

OLIVER AGE 5

Hugs are important because
they are always nice and warm
and cuddly.

LANDON AGE 9

I don't necessarily fit the expectations
of what people expect from boys.
I am okay with that. I do think it's
important to try your hardest, but it's
okay to need support.

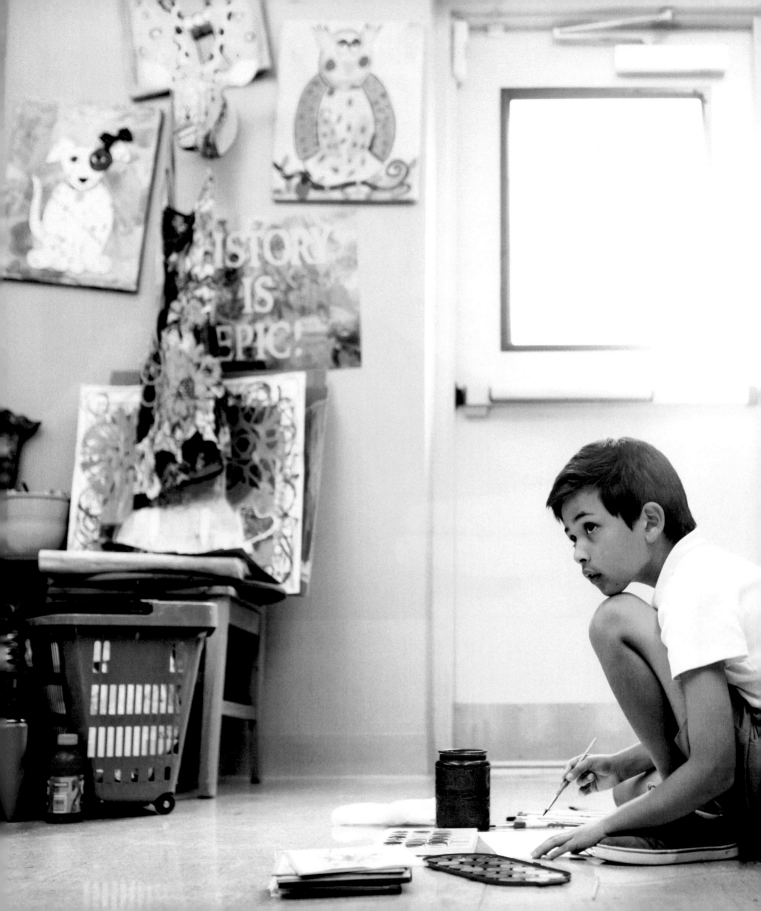

SMITH AGE 8

When I paint, I feel like I can do what I want. I can be creative without someone telling me what to do. It's like there aren't any rules.

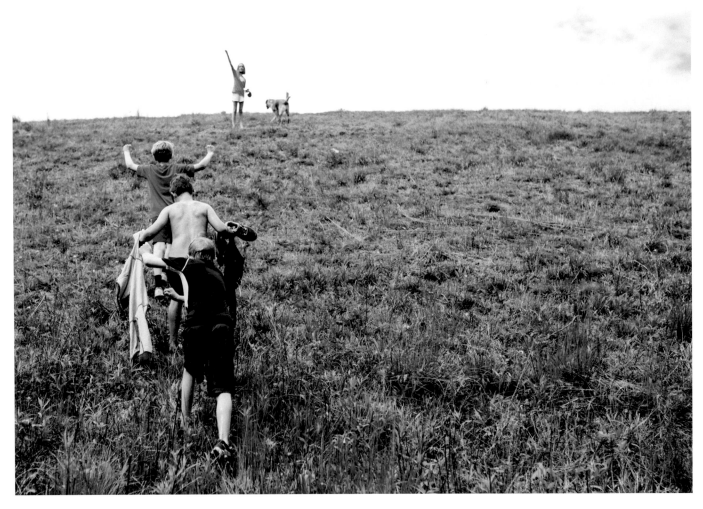

BROOKS AGE 9

Outside is where the
adventures always happen.

MATIAS AGE 9

It is not about what you look
like, it's about your heart.

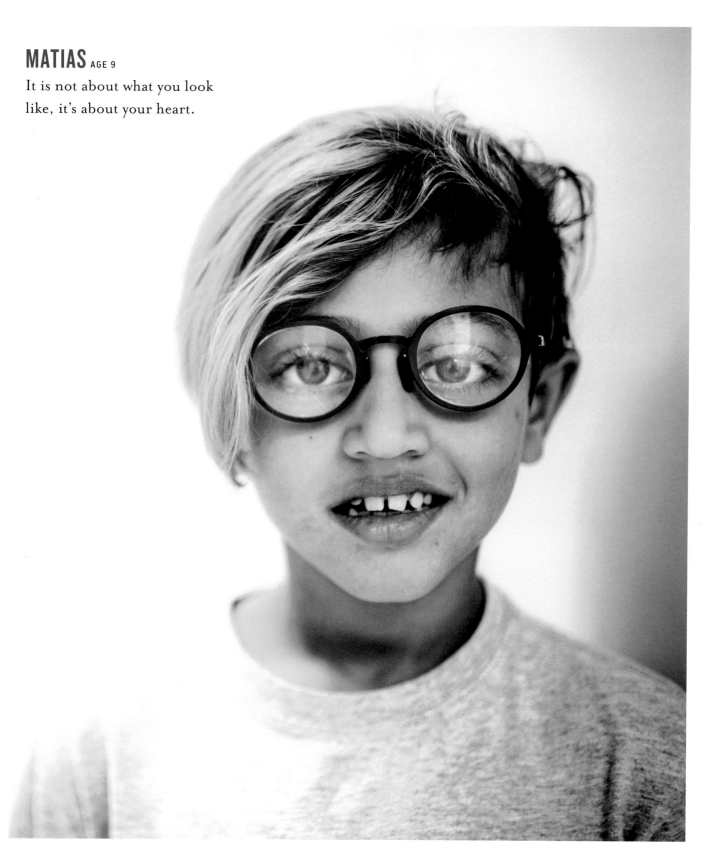

MILES H. AGE 9

Our family doesn't believe too much in gender stereotypes. It's okay to cry if you are a boy because it's kind of a strength. It shows you can get to your emotions.

"LIFE'S MOST PERSISTENT AND URGENT QUESTION IS, WHAT ARE YOU DOING FOR OTHERS?"

—MARTIN LUTHER KING JR.

THE HEART IS
KIND

I've always believed that one of the most important lessons we can teach our kids is that your value resides in how you treat others. We know from experience that kindness isn't always the easy choice. You have to choose it—again and again. Every day: Are you kind or too busy to be bothered? Kind or narrow-minded? Kind or "right"?

The fact is, you never know how far a sympathetic word, or hand, will go in the day of someone who is struggling, but it's pretty safe to say that you will never regret the choice to be kind. It feels so simple, and yet it takes some courage to do it with regularity. The boys in this chapter are committed to being compassionate. They look out for their friends, their pets, their siblings, and even strangers. Jerry (page 239) saw families struggle while their kids were in the hospital. His younger brother was in there, too, and he knew how hard it was to watch someone you love suffer. He decided to save his allowance and pay for their meals—breakfast, lunch, and dinner . . . whatever he could afford. He wanted to relieve their burden, in that place, in that moment, just a little bit. And in making someone's day or week a little better, his act of kindness was world-changing. Boys like him should be applauded and celebrated—until it's no longer necessary to applaud, because compassion has become the norm and the expectation of everyone.

RIED AGE 9

The best part of my day is when I get
a hug from my friend. We have a great
time together and I love teaching him
new things. We are best buds.

TILDEN AGE 9

Sometimes I have a
hard time explaining
to people what I know
in my head.

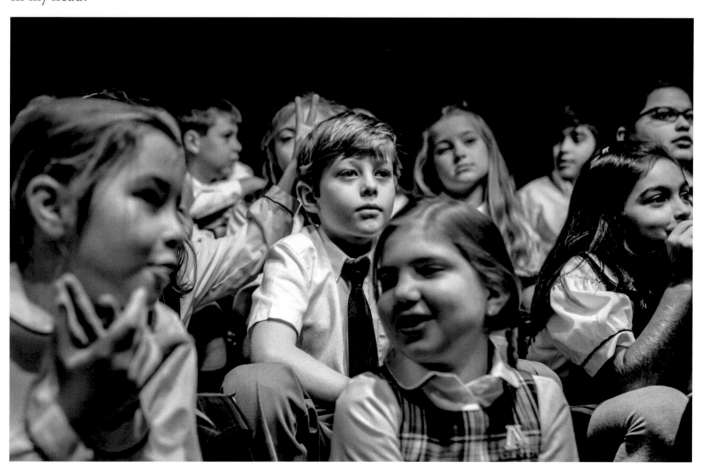

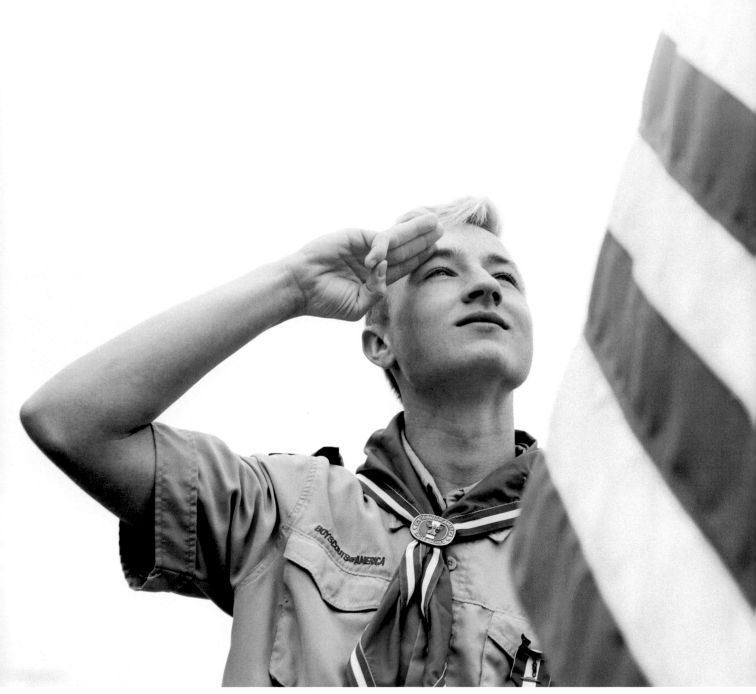

KESLER AGE 16

Strong means doing the right
thing, not the popular thing.

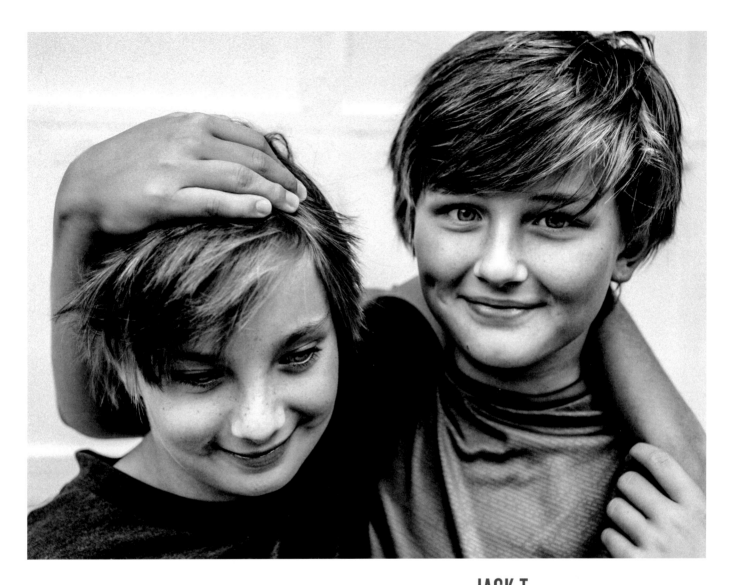

JACK T. AGE 9

Luke is my older brother. I like it when we build forts in our rooms. We leave the forts up for weeks and sleep under them.

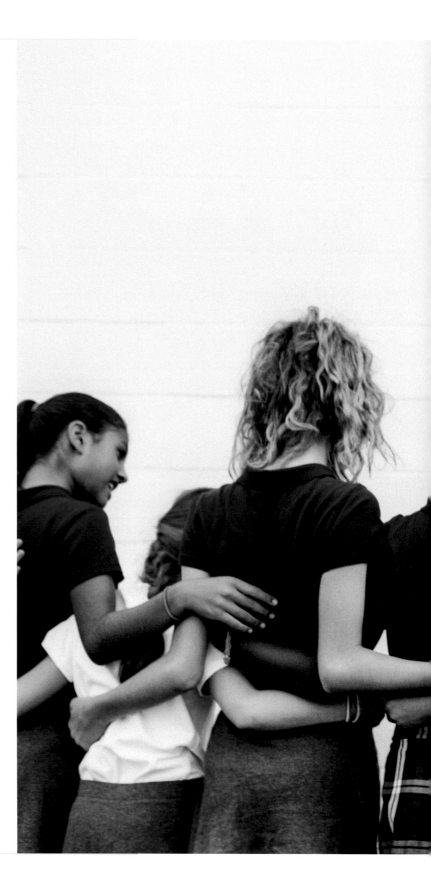

CHRIS AGE 11

Unity in the world is the key to peace
in the world.

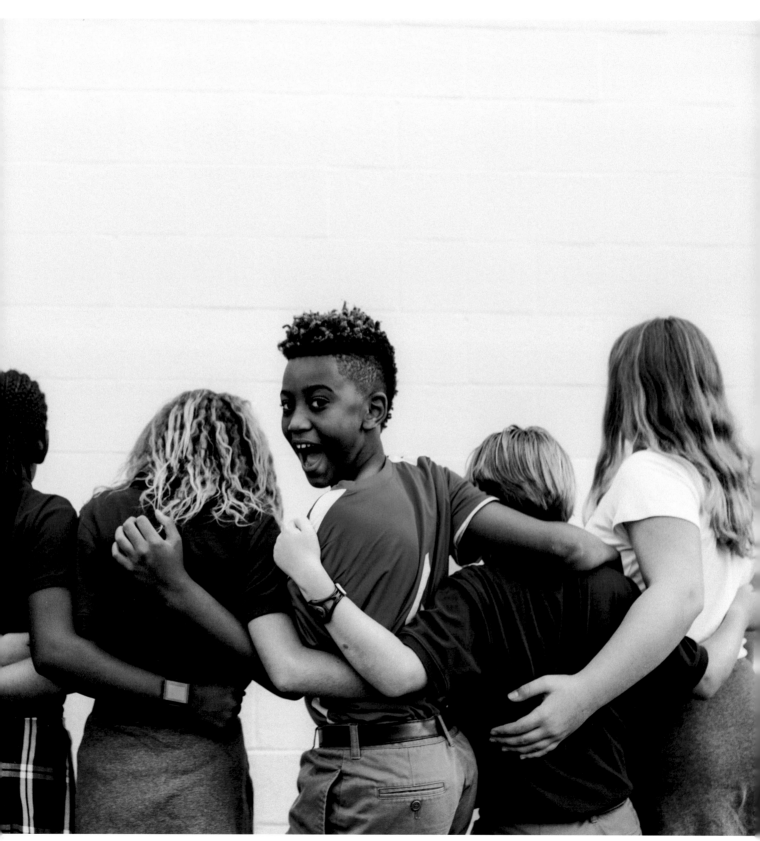

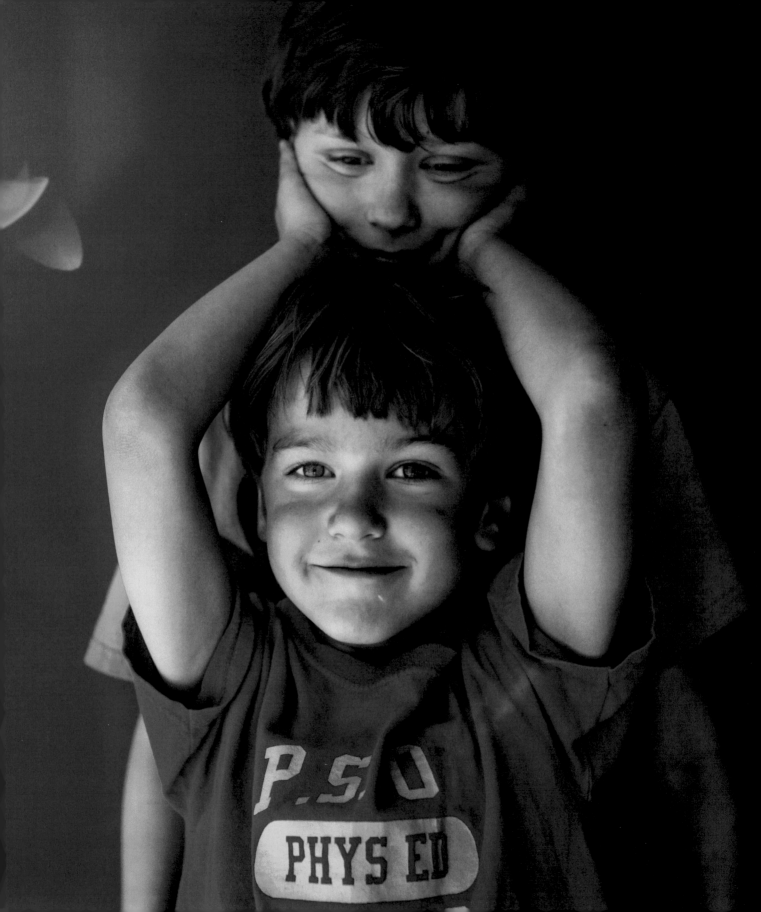

MAX AGE 10

When my friend was being bullied,
I stood up for him. That's what you do.

LES AGE 9

I have a cleft lip and palate. I was
made this way for a reason.

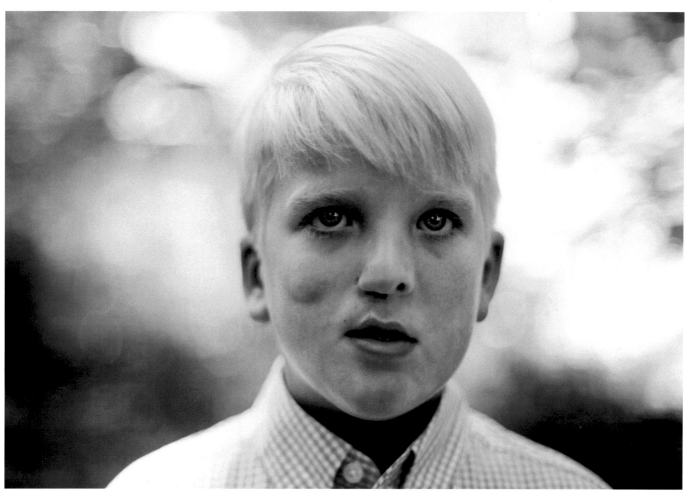

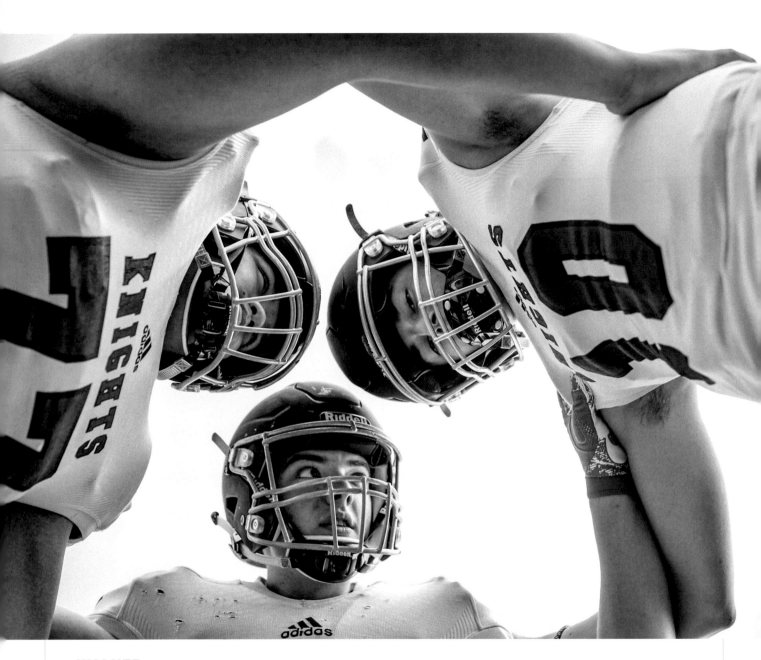

WALKER AGE 17

My teammates are my
brothers—my family.

GRAYSON AGE 9

I volunteer here. There are a lot of cats that
need good homes, and I don't like seeing
them lonely. When we go, we brighten
their day with attention and snuggles.

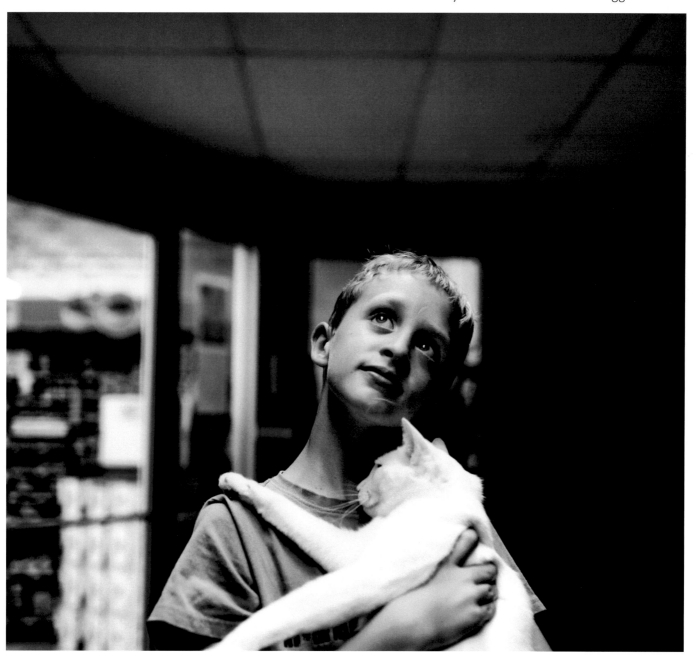

AXEL AGE 5

I like spending time with my
family and having fun.

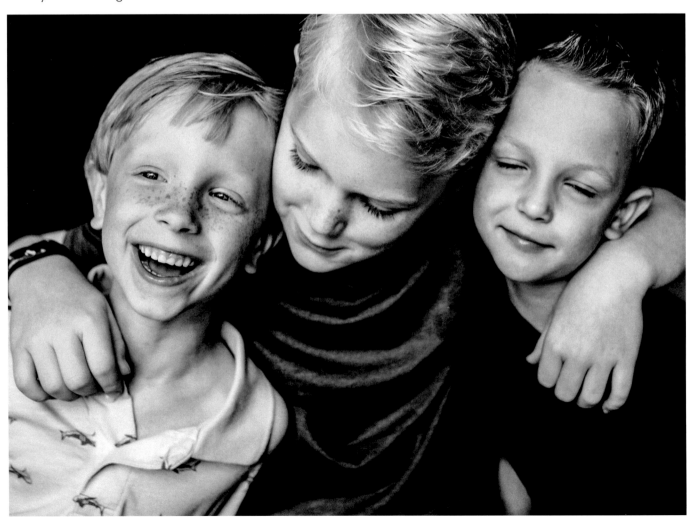

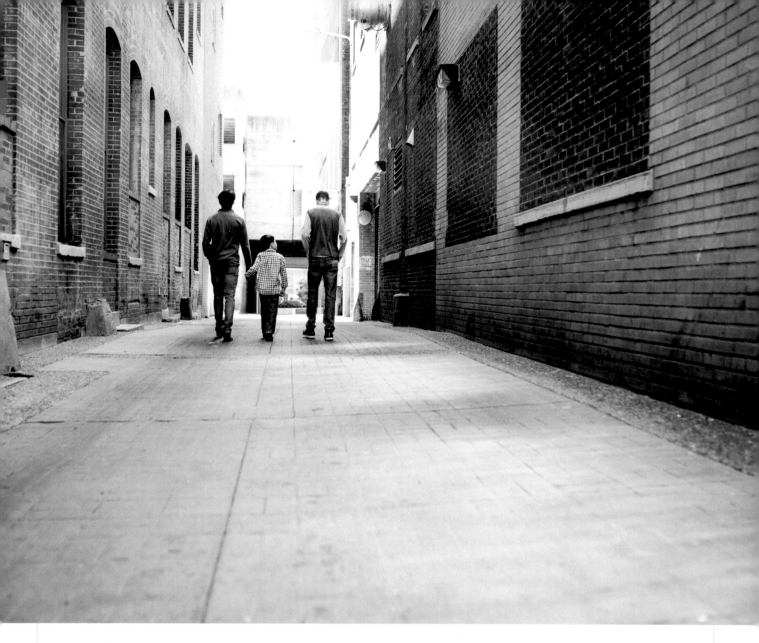

ALEX AGE 16

Being strong means I protect
my family. It means I need to
do the right thing.

AUSTIN AGE 10

We wanted to help pets that don't have a home, so we started this lemonade stand to raise money for a no-kill shelter. We raised sixteen dollars.

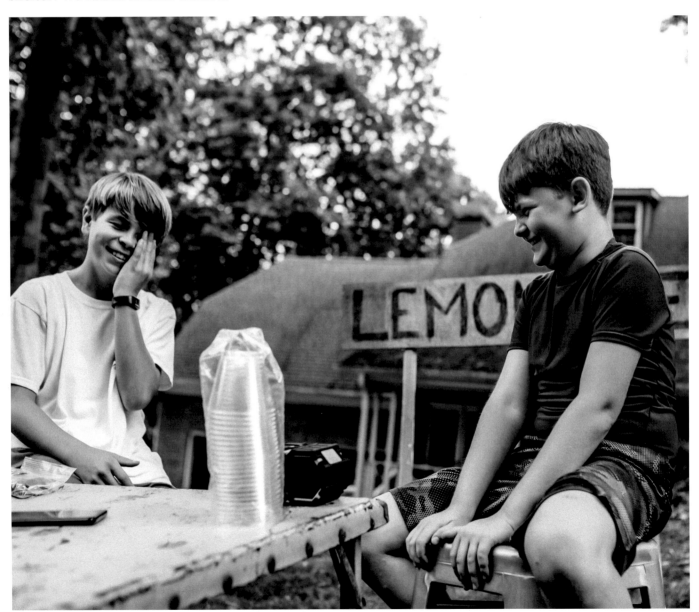

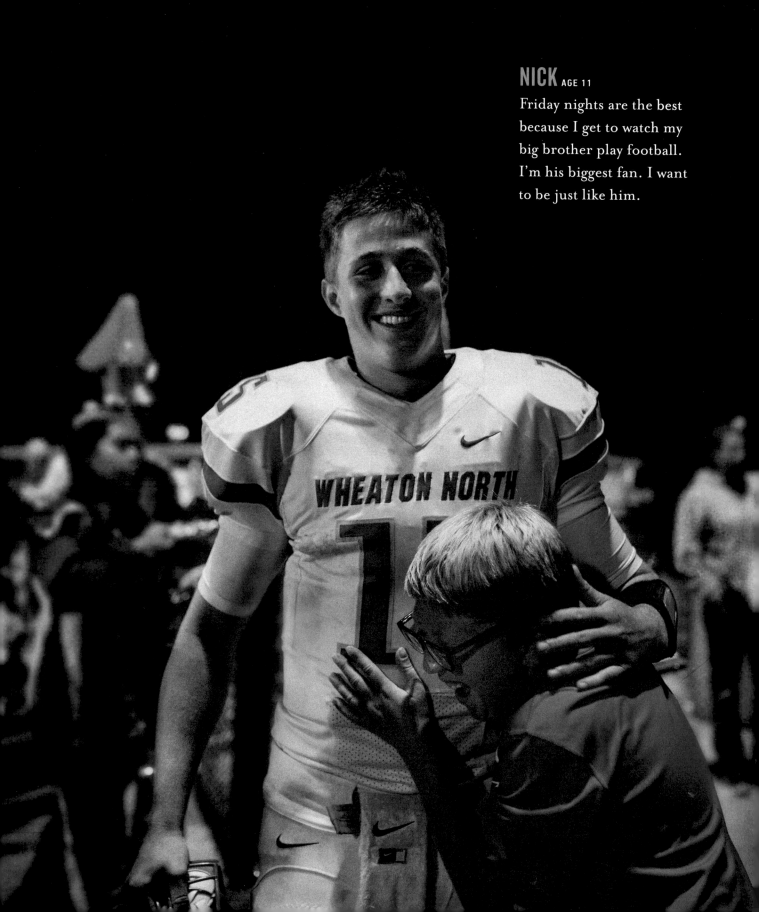

NICK AGE 11

Friday nights are the best
because I get to watch my
big brother play football.
I'm his biggest fan. I want
to be just like him.

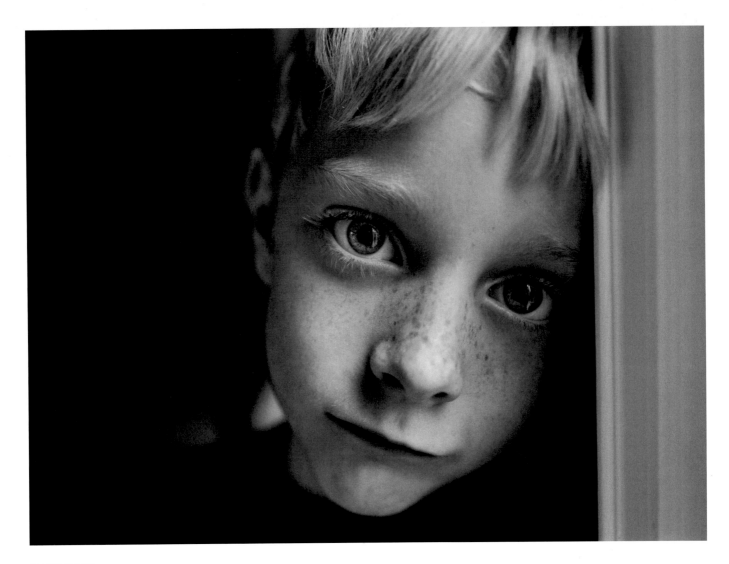

BROOKS AGE 8

It hurts my feelings when I see people being mean to other people. Everyone should be nice to everyone. My brother always lets me play with him and his friends, and they're always really nice to me.

EITAN AGE 13

My family is traveling in this RV across the entire country for a year. It has taught me that I am privileged because we have a home. When on the road, I saw so many towns that were poor or lacking, it made me aware of my privilege and that there are so many out there that need more than I do.

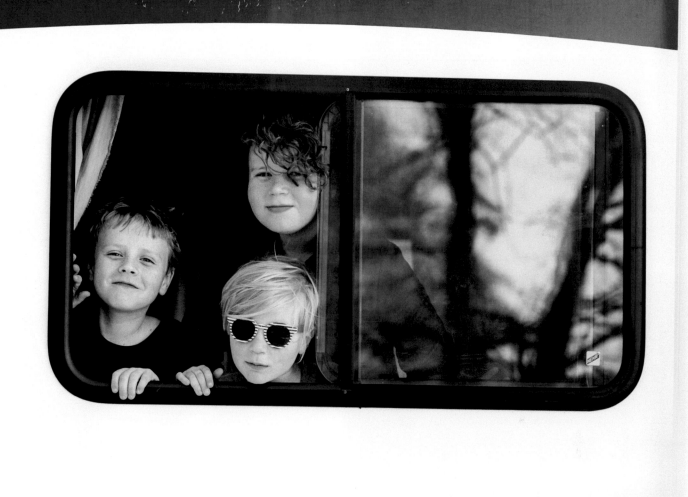

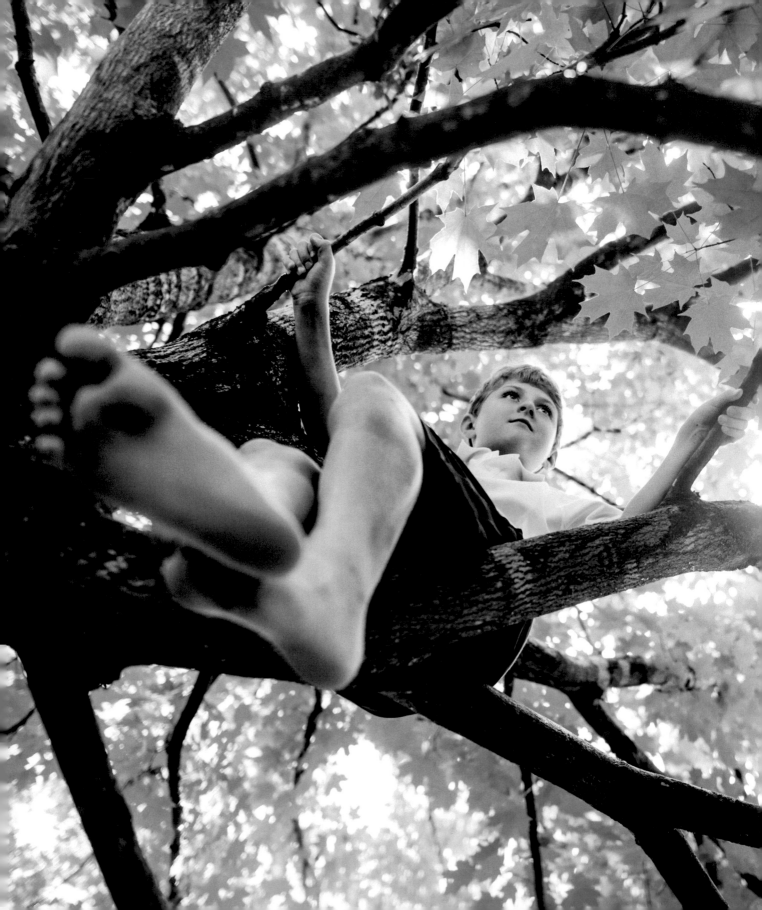

GRAYDEN AGE 9

I'm not scared to do anything.

JERRY AGE 13

The most important thing to me is to care and take care of one another. When my little brother was sick and in the hospital, I wanted to help the other families there and started paying for their food at the hospital cafeteria. I still do, every year during the holidays. It makes me feel good to help.

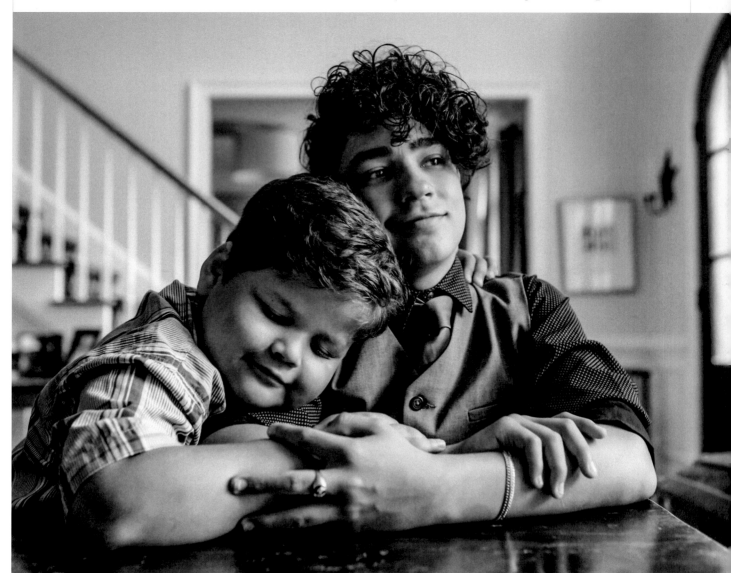

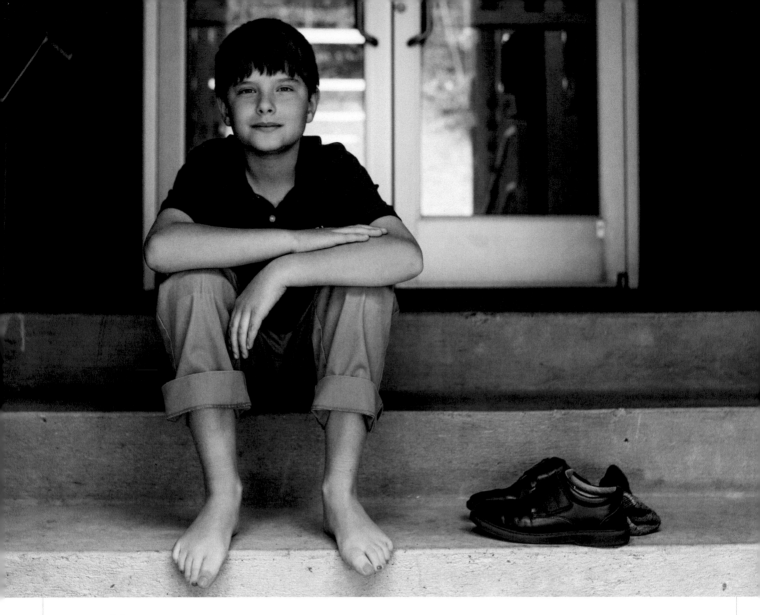

BLAKE AGE 9

Being a boy is no
different than being
a girl. You can do the
same things.

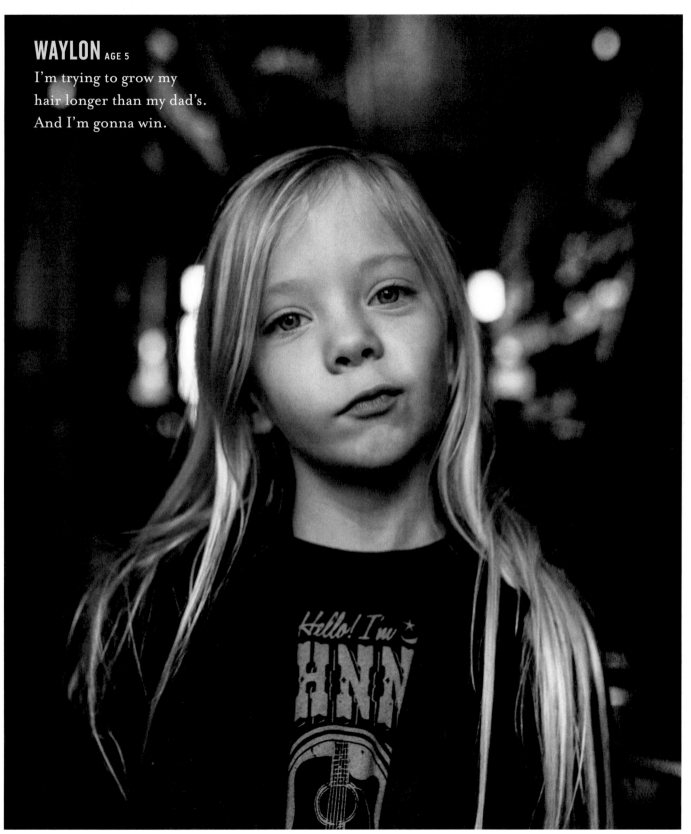

WAYLON AGE 5

I'm trying to grow my
hair longer than my dad's.
And I'm gonna win.

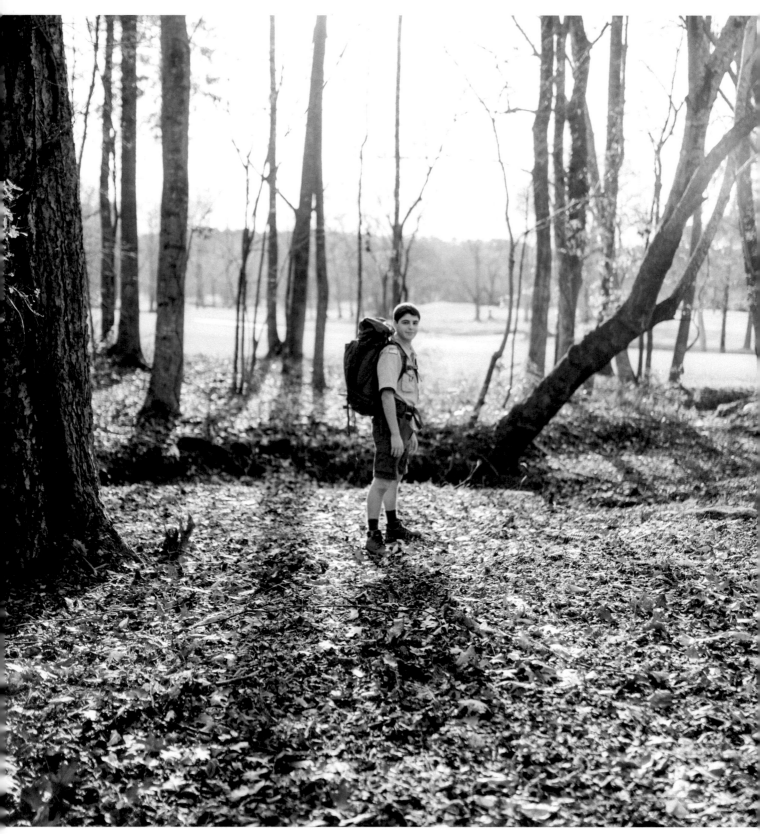

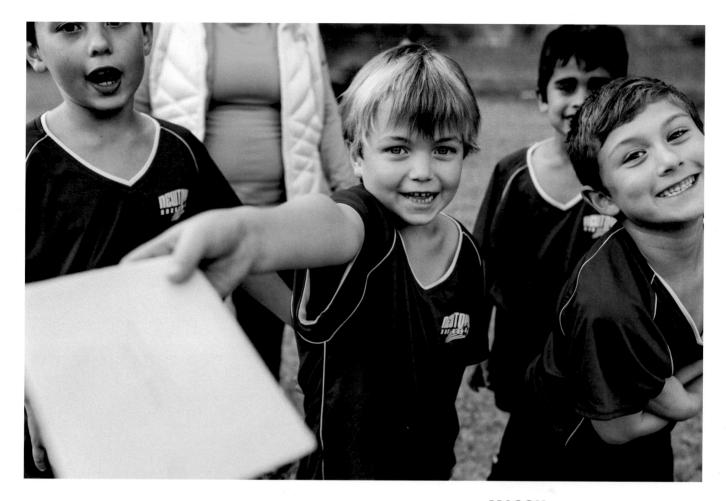

MASON AGE 7

We all wrote and signed this thank-you note. My mom says it's important to write these.

JARON AGE 13

The best part of being a Boy Scout is going on camping trips. I love learning new things, meeting new people, sleeping and cooking outdoors in nature, and using the skills I have learned at meetings and through merit badge work to help me be successful in the wilderness.

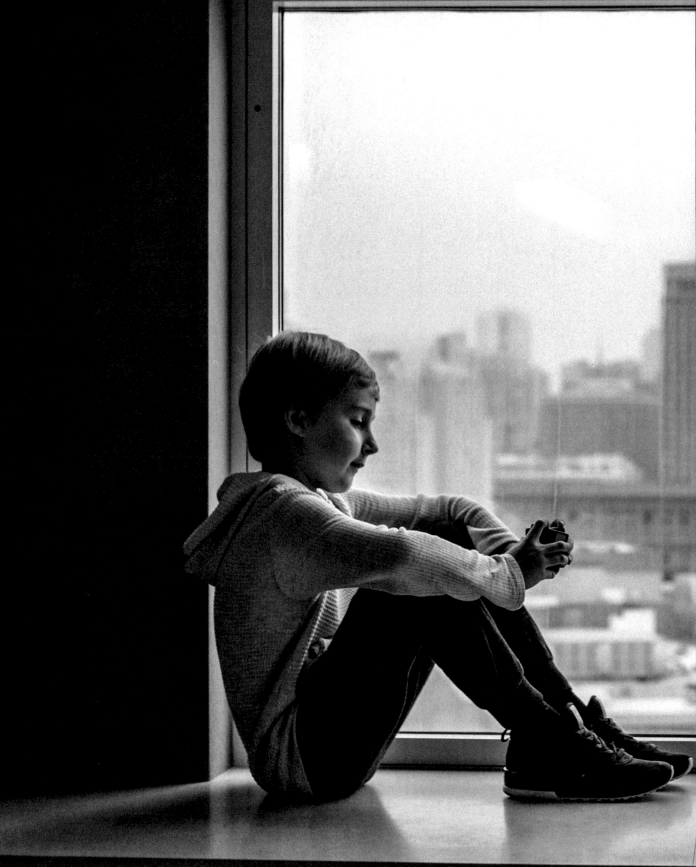

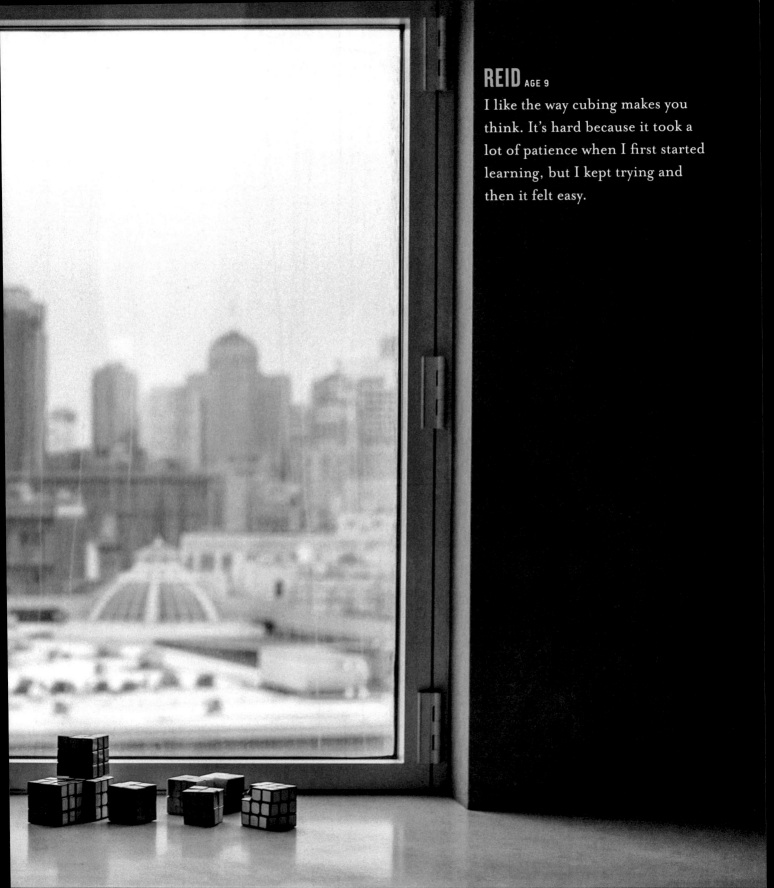

REID AGE 9

I like the way cubing makes you think. It's hard because it took a lot of patience when I first started learning, but I kept trying and then it felt easy.

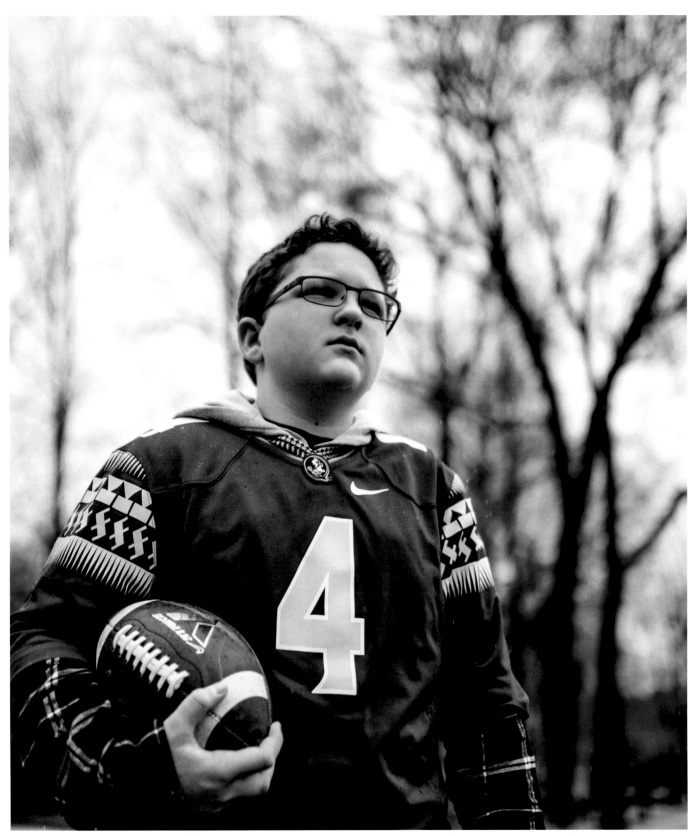

SOMETIMES YOU HAVE TO REALIZE YOU MIGHT NOT BE AS GOOD AS YOU THINK YOU ARE AT SOMETHING AND GIVE IN TO THAT AND JUST ENJOY IT.

—TRENTON, age 14

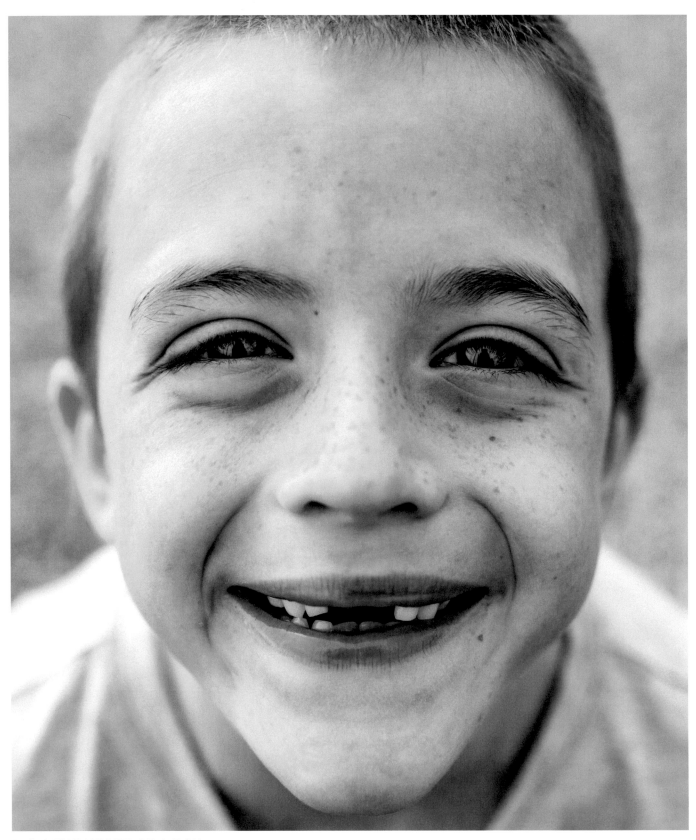

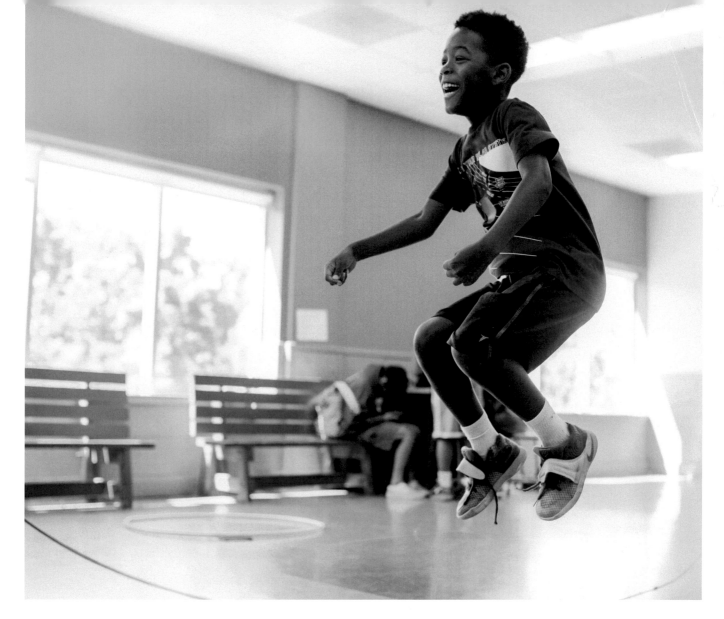

RISHAWN AGE 7

Life is great.

WILL AGE 7

I am pretty happy with
who I am—with or without
my front teeth.

ACKNOWLEDGMENTS

Creating a book is, most definitely, a group effort, and I have been lucky enough to have the help, guidance, and advice of some of the best along the way.

I am so thankful, first and foremost, to the boys who grace these pages. Thank you for your powerful images and words. You are making a difference, and I appreciate your trust. Thank you also to your parents for taking the time and believing in the worth of this project.

Thank you to my family, Mike and the girls; I love you all beyond measure. Mike, your belief in me and refusal to let my (many) fears slow me down is the greatest. Girls, this all started with you, and you continue to be my favorite people to be with. Preferably on the couch, watching *30 Rock*. A giant hug to my very large, very loud (Dave), and very supportive family. Mom and Fran, you did good. I am incredibly lucky to have had brothers who were my role models from day one. Special thanks to the Stones for having one adorably energetic cover boy for this book. Thanks, Sammy. Big thank you to the Parkers for your never-ending support. Big love and hugs to my friends, who have my back and my kids for pickup when we get stuck.

Thank you to Atlanta Academy for your incredible support over the years and for always lending me your beautiful campus for shoots. Go Gladiators! The Boys & Girls Clubs of Metro Atlanta, specifically Adrianne and Brendon, for allowing me in to shoot your amazing clubs and kids. Children's Healthcare of Atlanta—Meaghan, I am forever in your debt for sending me the most inspirational stories of courage and strength. Thank you. Ballet San Antonio, and Evin, thank you for inviting me to shoot your talented dancers. Centennial High School wrestling team, Atlanta International School, Dave Shore at Music Matters, Titan Wheelchair Sports—this book wouldn't have been possible without your support. Thank you.

And to Liz Dilworth, you know I would be lost without your organization and follow-up. Thank you. William Callahan, I always, always appreciate and value your point of view, even if I have to look up words after we talk.

And finally, thank you to everyone at Workman for believing in my work and this project. It's been a joy to create books that matter with you. Megan Nicolay, you spoil me and I appreciate all you do and how much you care. Suzie Bolotin, thanks for taking the baton and getting this book over the finish line; it was a pleasure. Anne Kerman, Chloe Puton, Sarah Curley, Lisa Hollander, Beth Levy, Julie Primavera, Angela Cherry, Barbara Peragine, and the entire team—thank you.